GUIDE TO PHOTOGRAPHS
in the
WESTERN HISTORY COLLECTIONS
of the
UNIVERSITY OF OKLAHOMA

GUIDE TO PHOTOGRAPHS
in the
WESTERN HISTORY COLLECTIONS
of the
UNIVERSITY OF OKLAHOMA

Second Edition

Compiled by
KRISTINA L. SOUTHWELL *and* JACQUELYN REESE

Foreword by DAVID L. BOREN

Introduction by DONALD J. PISANI *and*
DONALD L. DeWITT

UNIVERSITY OF OKLAHOMA PRESS : NORMAN

Library of Congress Cataloging-in-Publication Data

Guide to photographs in the Western History Collections of the University of Oklahoma / compiled by Kristina L. Southwell and Jacquelyn Reese ; foreword by David L. Boren ; introduction by Donald J. Pisani and Donald L. DeWitt.—Second edition.
 pages cm.
Includes index.
ISBN 978-0-8061-4455-9 (pbk. : alk. paper)
1. Oklahoma—History—Pictorial works—Catalogs. 2. Oklahoma—Social life and customs—Pictorial works—Catalogs. 3. West (U.S.)—History—Pictorial works—Catalogs. 4. West (U.S.)—Social life and customs—Pictorial works—Catalogs. 5. Indians of North America—Oklahoma—History—Pictorial works—Catalogs. 6. Indians of North America—West (U.S.)—History—Pictorial works—Catalogs. 7. Frontier and pioneer life—Oklahoma—Pictorial works—Catalogs. 8. Frontier and pioneer life—West (U.S.)—Pictorial works—Catalogs. 9. University of Oklahoma. Western History Collections—Catalogs. 10. Photograph collections—Oklahoma—Norman—Catalogs. I. Southwell, Kristina L. II. Reese, Jacquelyn. III. University of Oklahoma. Western History Collections.
F695.U55 2014
978.0022'2—dc23 2013037277

The paper in this book meets the guidelines for permanence and durability of the Committee on Production Guidelines for Book Longevity of the Council on Library Resources, Inc.

CONTENTS

FOREWORD

David L. Boren

Upon arriving at the University of Oklahoma, I felt it was important for others to understand and be exposed to our heritage, so I turned to the Western History Collections' staff, who soon furnished hundreds of early photographs depicting life on campus and in Oklahoma. We created a university-wide photo album of sorts by putting up historic photographs throughout the buildings on campus. These photographs, now prominently displayed in lecture halls, departmental offices, libraries, and residence halls, give our diverse student body a common "family history" and will help later generations understand the courage and vision of those who preceded them. All who view these pictures will admire the spirit of those men and women who came to a treeless prairie, in some ways barren and uninviting, and saw in it limitless possibilities, which they were determined to realize. The landscape itself became an actor in history, inspiring hopes and nurturing dreams of those who sought new opportunities as unlimited as the unbroken horizon.

The Western History Collections include some of the University of Oklahoma's crown jewels. Housed in historic Monnet Hall, they are among the best collections of their kind in the United States. Nearly two thousand collections are held in the Manuscripts Division alone. It includes the region's premier Native American manuscript resource. Here one can find journals, correspondence, legal documents, drawings, and sound recordings of some of the most influential tribal leaders of the last century. This division also preserves more than five thousand maps of Indian and Oklahoma territories. The transportation manuscript collection, which includes research materials related to railroads and aviation, is virtually unmatched by any library in the area.

Perhaps the Western History Collections' best-known resource is the Photographic Archives, which contain more than two million prints and negatives. The archives feature the work of some of the great early frontier photographers, such as William S. Prettyman, Andrew A. Forbes, William Soule, and W. A. Flowers. Oklahoma's great events and eras, such as the land runs, the growth of agriculture and the cattle trade, and the development of the petroleum industry are captured on film and made available for research.

The Library Division contains the Frank Phillips Collection and thirteen other named collections with some of the world's most impressive holdings on Native American culture. Here one can also find artifacts and literature on Abraham Lincoln, the Civil War, the Louisiana Purchase, the St. Louis World's Fair, and a host of other events in our nation's history.

The Western History Collections play a vital role in our university, the state of Oklahoma, and the nation as a whole. The Collections help preserve our heritage and provide a tremendously valuable resource for researchers of the American West. These collections give us an insight into ourselves and the core values that define us as Americans. I invite all to experience these collections and discover our past.

PREFACE TO THE SECOND EDITION

Kristina L. Southwell

Over a decade ago, the University of Oklahoma Press published a set of guides to the Western History Collections to celebrate the seventy-fifth anniversary of the Collections' founding. In the interim, the Collections have steadily grown in size and scope. Approximately 159,000 images contained in 165 new photograph collections and additions to existing collections have been added to the Photographic Archives and are described in the pages of this revised guide. The new photographs range from images of American Indians of the Southwest and the southern plains, to prints documenting twentieth-century tornado damage in Oklahoma, and the construction of the Alaska-Canadian Highway during World War II. Particularly noteworthy additions include the Elizabeth (Betty) Clark Rosenthal Collection of more than 1,000 images of Episcopal mission work on American Indian reservations in New Mexico, Arizona, and South Dakota; the Lucille Clough Collection of 1,800 prints, postcards, and stereograph cards of American Indians and Alaska Natives, and First Peoples of Canada; and the Nora and Clarence (Badger) Harvey Collection of prints showing views of cowboys and the range cattle industry at Bell Ranch in New Mexico.

The passage of a decade has brought other, more general changes to the Western History Collections. Our researchers today know that our extensive microfilm collections have been transferred to OU's Bizzell Memorial Library to increase access and make them available through interlibrary loan. Also, a significant new addition to our library is the Conrad Masterson Western Ranch History Collection and Study Room, opened in 2012. The collection contains more than 500 books and journals about the American range cattle industry, including individual ranch histories. Furthermore, our longtime support group, the Associates of the Western History Collections, has been transformed into the Edward Everett Dale Society. While similar in mission to the Associates, the new Dale Society focuses on honoring Professor Dale's commitment to preserving the history of Oklahoma and the West for future generations of scholars. The Society's annual reception and membership provide support for the Western History Collections' programs throughout the year.

Although our collections grow and change over time to accommodate new

areas of study, they will remain true to Edward Everett Dale's original vision of documenting and preserving the history of the American West. We invite all interested researchers to visit the Western History Collections to use these resources for scholarly inquiry and exploration. We hope this revised guide to the Photographic Archives will serve as a successful starting place for many researchers.

ABOUT THE COLLECTIONS

The Western History Collections constitute a special collection within the University of Oklahoma Libraries on the main campus in Norman, Oklahoma. The mission of the Collections is to collect, preserve, and make available rare and special research materials for scholars in the fields of the history of the American West, Oklahoma history, Native American studies, and anthropology. As a member of the University Libraries, part of the Western History Collections' purpose is to support the research and teaching programs of the University of Oklahoma. The materials collected are made available to university students, faculty, and staff, as well as the general public.

The Western History Collections comprise three main departments: the Library Division, the Photographic Archives, and the Manuscripts Division. The Library Division holds more than 80,000 volumes, made up of a central collection known as the Frank Phillips Collection, plus thirteen family library collections that focus on such diverse topics as military history, the life of Abraham Lincoln, and the 1904 St. Louis World's Fair. The Photographic Archives, the most heavily used of the three divisions, maintains two million images. Strengths of the Photographic Archives include the works of frontier photographers, such as W. S. Prettyman and A. A. Forbes, photographs of Native Americans in Oklahoma and the Southwest, and images of the range cattle industry in the West. The Manuscripts Division holds approximately 12,000 linear feet of textual primary materials. In addition, the Manuscripts Division administers 5,500 maps, 2,700 sound recordings, and 900 posters.

The Western History Collections began in 1927, when University of Oklahoma history professor Edward E. Dale started the Frank Phillips Collection of books on western history. Dale began to acquire photograph collections almost immediately by purchasing sixty glass plate negatives from J. B. Kent of Anadarko, Oklahoma, in November 1927. From this purchase, the Photographic Archives has grown to its present size of two million prints and negatives. These images are contained in 826 collections, covering a broad range of subjects related to the history of the American West, including lawmen, outlaws, and gunfighters; Native Americans of Oklahoma and the Southwest; cowboys and the range cattle industry; and the ever-popular Wild West shows of the early 1900s.

Photographs that document the history of Oklahoma, particularly with regard to the juxtaposition of Indian and white settlers' cultures, are consistently

in demand by researchers. The A. P. Swearingen Collection documents this period of Oklahoma history particularly well, with over 150 photographs of the 1889 land run and of the Guthrie, Oklahoma Territory, area. The Frank Phillips Collection, the library's core photograph collection, contains more than 750 glass plate negatives created by Annette Ross Hume of Anadarko, Oklahoma Territory. Her images depict the everyday lives of Indians, settlers, and agency employees at the Kiowa, Comanche, and Wichita Indian Agency in Anadarko, circa 1890. Similarly, the photographs by studio photographers William S. Soule and J. A. Shuck captured images of Indians in Oklahoma and Indian Territories during a critical period of transition, 1870–1900.

Photographs of lawmen and outlaws of the Old West generate much interest among both researchers and the general public. The colorful personalities associated with criminal activity and law enforcement in the American West are well known due to their popularization in western fiction and motion pictures. Images of the Earp brothers, Heck Thomas, Bill Tilghman, and Chris Madsen in full western gear are present in several collections, including the Noah H. Rose Collection of more than 2,000 prints. Also in the Rose Collection are photographs of gunfighters and outlaws, both alive and dead. Featured among them are Frank and Jesse James and the Dalton and Younger brothers.

Cowboys and the range cattle industry are an integral part of the history of the West and, as such, are proportionately represented in the Photographic Archives. The Noah H. Rose, Frank Phillips, and Division of Manuscripts–Southwest Oklahoma collections contain numerous images of cattlemen and ranching scenes that depict the hardships of life on the range. Cattle drivers are pictured with their herds along the trails throughout the Southwest, fording rivers, branding and roping cattle, and crossing the prairies.

Perhaps the most entertaining pictures in the Photographic Archives, however, are those of the Wild West shows of the early 1900s. Images of performers in action in the Miller Brothers 101 and Pawnee Bill Wild West shows are unrivaled for their romantic depiction of life in the Old West. Extravagant western costumes, traditional Indian dress, and dramatic displays of equestrian skills, marksmanship, and mock Indian battles combine to create photographs that are aesthetically pleasing as well as historically significant. The Charles and Margôt Nesbitt/Emil W. Lenders Collection contains more than 3,000 such original prints, including scenes of Indian performers, ranch employees, and groups of cowboys and cowgirls. The Gordon W. Lillie Collection and the Miller Brothers 101 Ranch and Wild West Show Collection add approximately 500 more images of Wild West show performers and ranching scenes.

The history of the University of Oklahoma is particularly well represented in the Photographic Archives by several major collections, including the University of Oklahoma Collection, the University of Oklahoma Electronic Media Photographic

Services Collection, and the University of Oklahoma Photographic Service Collection. These collections alone total more than 539,000 photographs depicting the development of the University of Oklahoma from 1892 to 2007. Images of student life, athletic events, university presidents, faculty and staff, and campus buildings throughout the years are a rich resource for those interested in higher education in Oklahoma and for those with a general interest in University of Oklahoma traditions.

HOW TO USE THE GUIDE

The 826 photograph collections in this guide are arranged alphabetically by collection title. Each entry includes up to seven information fields to help researchers analyze the collections. The following figure illustrates a typical entry and identifies each of the fields. Following the section that describes the collections is an index, keyed to each collection's entry number. Entry numbers appearing in the index in boldface type refer to a collection by the same name. Numbers not in boldface type indicate that the referenced entry contains some information by or about that specific person, place, subject, or event. To find all collections containing information on a specific subject, turn first to the index, find the desired subject listing, and note the entry numbers following it. Then turn to the specific entry cited and read the summary to see if the collection merits further examination.

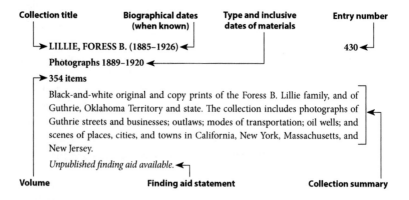

The finding aid statement included at the end of collection entries indicates whether a published or unpublished finding aid is available to researchers. Finding aids provide detailed information about the materials included in a collection, and are particularly helpful in locating specific items in large collections. Unpublished finding aids are available onsite in the Western History Collections reading room. Published finding aids are available for sale at the Western History Collections, or from the publisher.

ACKNOWLEDGMENTS

The compilation of this guide to the Western History Collections' photographic resources has been made possible by the cumulative work of our past and present curators, librarians, staff, and student assistants. Curator John R. Lovett, Jr., and former curator Donald L. DeWitt compiled the original 1993 edition of this guide, with the invaluable assistance of Shirley Clark. Their work laid the foundation upon which the 2002 edition, and the current edition, were both created. Special thanks are due to staff assistant Tara Reynolds; graduate assistants Rebecca Barlow, Jennifer Fann, and Eric England; and student assistants Rachel Eikenbary and Elisabeth Branam, who helped update collection descriptions for the current edition of this guide. Their attention to detail is greatly appreciated.

INTRODUCTION

Donald J. Pisani and Donald L. DeWitt

Written in 2002 to commemorate the seventy-fifth anniversary
of the Western History Collections

First-rate universities need good students, an accomplished faculty, and outstanding libraries. The Western History Collections at the University of Oklahoma have provided the university with a national reputation in the study of Oklahoma, the Great Plains, the American Southwest, and the Far West. This guide is a testament to the vision and devotion of people inside and outside the university. The vision and devotion of E. E. Dale and Frank Phillips in the 1920s endure today in the many benefactors, library staff, and faculty who consider the Western History Collections vital to the intellectual life of this state and region.

That many of the most notable western history collections date to the early decades of the twentieth century is not accidental. The definition of the American West as a distinct region depended on the widely held belief, developed during the 1890s, that the frontier phase of United States history had ended. Simultaneously, the Spanish-American War (1898) marked the emergence of the United States as a world power. The United States entered a militant, nationalist period of its history, and Latin America assumed far greater importance in American diplomacy. Therefore, American universities began to place more emphasis on the history of Mexico, Latin America, and the Southwest, as well as the West. Only when the West was incorporated into the nation, and only when the United States began to look overseas, did the region's history begin to attract historians as well as collectors.

Only a handful of distinguished university libraries focus on the study of the American West. They include the Beinecke Library at Yale University, the Bancroft Library at the University of California, Berkeley, the Barker Texas History Collection at the University of Texas, and the Western History Collections at the University of Oklahoma. These institutions have much in common. All depended on the dreams and shared values of dedicated faculty members, private donors, university administrators, and library staff. Without that common purpose, many collections would have been broken up and scattered before they could be consolidated and made available to scholars. Most began as private collections.

For example, William Robertson Coe gave the core of Yale's celebrated Western Americana Collection, a treasure of rare books, maps, and manuscripts related to the Trans-Mississippi West, to the Yale Library in annual installments beginning in 1942. Yale had several advantages over other American universities in the acquisition of western materials. First, the university had been in existence for nearly two and a half centuries when Coe made his gift; therefore, it already possessed a large number of books and manuscripts pertaining to the West. It was logical for private collectors like Coe to turn to Yale rather than newer universities in the West. Second, many Yale faculty members, including Benjamin Silliman, Jr., William H. Brewer, and Othniel Marsh, had been active in exploring and developing the West. Finally, many Yale alumni had collected significant libraries that they or their heirs transferred to the university. The Frederick W. Beinecke collections, which were particularly rich in the area of the Great Plains, Rockies, and Spanish Southwest, complemented as well as built on the Coe Collection, which contained little on the Spanish Southwest outside Texas.

Only one public institution in the West can compete with the collections at Yale. The Bancroft Library at the University of California also owes its existence to private collectors. In an age when few westerners had any interest in preserving documents pertaining to the settlement of the Far West, Hubert Howe Bancroft was the great exception. After trying his hand at a variety of jobs in the goldfields of California, he went into the stationery and book business in San Francisco. But he soon became an academic entrepreneur as well as a collector. His great dream was to write a comprehensive history of the Pacific Coast. To lay the foundation for that project, he began collecting everything he could find on the American West. Within a decade he had acquired sixteen thousand volumes, some of which he acquired on trips east and to Europe. Not only did Bancroft accumulate books, maps, pamphlets, manuscripts, and periodicals, but he had an army of copyists transcribe documents in private hands and in government and church archives. He was also one of the first to transcribe the memories of pioneers. In the 1870s and 1880s, his staff interviewed virtually every important pioneer in the history of California. His "history factory," as he called it, produced dozens of volumes on Northern Mexico, Native Americans, and the settlement of the Far West and California. None of this work would have been possible without the documents he collected.

In 1905, at the end of his writing career, Bancroft, then in his early seventies, sold his collection to the University of California for $250,000. Bancroft reduced the price by giving the university $100,000 and permitting it to pay for the collection over three years. The library was a monument as much to the wisdom of the university president, Benjamin Ide Wheeler, and the university regents, as to Bancroft. Once acquired, the library's growth depended on Professors Herbert E. Bolton, George P. Hammond, and James D. Hart, who began to collect

microfilm of Spanish and Mexican archives, as well as western art and literature, including the famous Mark Twain Collection.

At the University of Texas, the Barker Texas History Collection dates to 1899, when Lester G. Bugbee, a member of the history department, secured the transfer of the Bexar Archives to the University of Texas Library. This collection contained more than eighty thousand documents accumulated in San Antonio during the Spanish and Mexican periods (1700–1836). In 1906, the university wisely decided to cooperate, rather than compete, with other special collections libraries. It signed an agreement with the University of California, the Newberry Library in Chicago, and the Library of Congress to copy and share documents from the Mexican Archives and other repositories. The Stephen and Moses Austin Collections, acquired by the private collector Guy M. Price, also served as the foundation for the Barker Texas History Collection. As with the other libraries, the acquisition of major holdings immediately posed two problems: where to house them and how to catalog them. A full catalog of the Bexar Archives was not completed until 1932, three decades after the university acquired the first collections, and a public catalog to the entire Barker Texas History Collection was not ready until 1963. In this project, the University of Texas history department was greatly involved, particularly George P. Garrison and Eugene C. Barker.

The history of the Western History Collections at the University of Oklahoma has much in common with the experiences of Yale University, the University of California, and the University of Texas. When Edward E. Dale, who came to Oklahoma as a boy and had been a doctoral student of Frederick Jackson Turner at Harvard, became chair of the University of Oklahoma Department of History in 1924, one of his goals was to build up the department's graduate program. Not only was Oklahoma rich in Indian history, but it was at the seams of the American West. One seam joined East and West; another joined South to West; and a third joined the Great Plains to the Rocky Mountain West. Since Oklahoma was one of the last American territories, and one of the last territories to enter the Union, its frontier past was still fresh in the minds of many of its residents. But Dale wanted to create a library devoted to the study of the entire Great Plains and Southwest, not just of Oklahoma.

Dale first attempted to secure an appropriation from the Oklahoma legislature to create his library. That effort failed, and soon thereafter, with the help of the prominent Tulsa attorney Patrick J. Hurley, Dale approached Frank Phillips, an Oklahoma oilman who had begun to assemble a notable Oklahoma history collection during the 1920s. Phillips agreed to give limited financial support to Dale's proposal, and on April 5, 1927, the Frank Phillips Collection of Oklahoma and Indian History was established at the university.

The legal contract that created the new library outlined several goals for the collection. It was expected to celebrate and commemorate the past, not just serve

impartial historians. The contract promised that the Phillips Collection would preserve "memorials of [Oklahoma's] pioneers, and romantic past"; demonstrate the state's progress in "industry, arts, civics, and literature, and all the elements of progressive civilization"; "institute and encourage historical inquiry"; "inculcate interest and pride in our history"; "mark the passing of a race of people and the genesis and growth of a new civilization"; and teach children "our debt to those who have gone before, and our responsibilities to the future." To accomplish these ends, Frank Phillips gave $2,000 annually for five years to acquire "letters, records, documents, books, pamphlets, manuscripts, maps, and prints, pertaining directly or indirectly to the history of that part of the Southwest now included within the state of Oklahoma."

The fund was to be administered by the president of the university, the head of the history department, and a third party to be appointed by Phillips. The first board consisted of President William Bennett Bizzell, Professor Dale, and Patrick Hurley. Initially, the books were housed in a glass case within Dale's Monnet Hall office. Subsequently, the collection was assigned to a room on the east side of the ground floor of Monnet Hall, and by 1936 its size required it to be moved into the main library building.

From the beginning, there was tension over whether the library would focus on Oklahoma, the Southwest, or the entire West. But E. E. Dale, who administered the collection until his retirement in 1952, insisted on taking the broader view. He believed in collecting materials pertaining not only to the entire West but also to Native Americans outside Oklahoma. He was aided by the Brookings Institution, which contributed 625 volumes on Native Americans; these volumes had been collected in the 1920s to aid the work of the Merriam Commission, of which Dale was a member. Other acquisitions were serendipitous. For example, in 1933, Dale purchased three trunks of letters and Ridge-Watie-Boudinot family papers from a woman in Grove, Oklahoma, for $350. He considered this collection, along with the Indian-Pioneer Papers and the Brookings Institution volumes, as the most important acquisitions during his tenure as "director" from 1927 to 1952. When Dale retired, the collection he had built contained 8,500 books and pamphlets, 30,000 manuscripts, 4,500 photographs, and a wide assortment of typescripts, maps, and newspapers.

By the 1940s, Dale recognized the need for a full-time curator and specialized staff to care for the Phillips Collection, but it languished during the 1950s. Cataloging proved impossible. The process had begun with high hopes in 1952, only to stall in 1955 because of financial problems. At the time, private donations had dried up, and the university's top priority was constructing a new library rather than expanding the special collections.

The 1940s, however, brought one significant development for the Phillips Collection. In 1948, the University of Oklahoma received a grant from the

Rockefeller Foundation to establish a Division of Manuscripts within the University Library. Arthur McAnally, the university librarian, appointed Gaston Litton, one of Dale's former students, as archivist for the Division of Manuscripts. Litton proved to be a capable and aggressive collector of personal papers, maps, and photographs. By the time Litton left the University of Oklahoma in 1956, the Division of Manuscripts rivaled the Phillips Collection as a resource for historians.

Although the Division of Manuscripts and the Phillips Collection continued to operate independently of each other, Litton's resignation set the stage for a significant change in the administration of the two collections. In 1957, the University of Oklahoma appointed Arrell M. Gibson as curator of the Frank Phillips Collection and head of the Division of Manuscripts. Jack D. Haley joined Gibson as assistant archivist. Gibson enlisted the support of University of Oklahoma president George Lynn Cross, who hoped that with additional funding the Phillips Collection might one day rival the great collections on the American West at Yale, the University of Texas, and the University of California. Fundraising problems persisted, but the two collections were then under one director.

Despite generous gifts from the Phillips Foundation, the Phillips Collection still needed a permanent endowment. Considering the Phillips Collection a library rather than a specialized research facility, the foundation placed a limit of $100 on any single item purchased with the money it gave the university; this limit precluded the purchase of manuscript collections as well as rare first editions. Earlier in the century, most collections were freely given to libraries, but such donations became less and less common as these collections increased in value and as private collectors and libraries competed to acquire them. In 1958, for example, the Ramon Adams Collection went on sale in Dallas for $30,000. It contained documents on the range cattle industry as well as crime and law enforcement in the West. But before the university could find the benefactors needed to purchase the collection, it was sold to a private collector.

In 1967, in an attempt to provide better support for the two collections, the University Libraries' administration merged the Division of Manuscripts and the Phillips Collection into one unit called the Western History Collections. Since that time, the holdings of the Western History Collections have grown dramatically. These holdings now include the Mary P. Jayne Papers, which chronicle the activities of one of the first missionaries to serve among the Plains Indians; the official papers of the Cherokee, Choctaw, Chickasaw, and Creek Nations; the personal papers of many notable Indian leaders, including D. W. Bushyhead and Lewis Downing of the Cherokees, Peter P. Pitchlynn and Green McCurtain of the Choctaws, J. M. Perryman and Pleasant Porter of the Creeks, and Cyrus Harris and William Byrd of the Chickasaws. The Indian Pioneer Papers, a Depression-era oral history project consisting of 166 bound volumes of

interviews, offer researchers the reminiscences of those white pioneers who took part in Oklahoma's land runs and of Native Americans who were already here.

The Western History Collections are particularly rich in material pertaining to the range cattle industry, agriculture, oil, banking, frontier trading, and other industries. For example, the Collections contain the records of thirty-five representative Oklahoma banks during the territorial and early statehood periods. Scholars interested in Oklahoma agriculture can consult the records of the Oklahoma Wheat Growers Association or of the Pruitt Cotton Gin Company. Researchers seeking mining records can look at the Kali-Inla Coal Company or the Mullen Coal Company collections. Students of social history can consult the archives of the Episcopal Church of Oklahoma, the extensive files of missionaries, the papers of the State Medical Association, or the papers of such notable university presidents as William Bizzell and David Ross Boyd. But researchers interested in regions beyond the borders of Oklahoma also find plentiful material. The library has especially strong holdings of microfilmed records from the U.S. National Archives, from the Mexican and Spanish archives of New Mexico, and from Mexican and Spanish archives related to the northern provinces of New Spain and New Mexico. Holdings of other universities are also available on microfilm, including the entire Bexar Archives from the University of Texas Barker Texas History Collection and the American Indian Periodicals Collection from Princeton University.

In addition to standard works on Oklahoma and Native Americans, the library contains numerous published government reports, including those of the Bureau of American Ethnology. It also contains many scholarly journals on the West, including *Western Historical Quarterly*, *Indian Historian*, and *Plains Anthropologist*, as well as rich holdings of twentieth-century Native American newspapers, such as the *Navajo Times*, *Jicarilla Chieftain*, and *Akwesasne Notes*.

In recent years, many other parts of the Western History Collections have captured attention across the nation. The Collections' Photographic Archives contain over 800,000 glass plate and acetate negatives from the entire West. These are frequently used in television productions and scholarly research. The cartographic section includes over 5,000 maps related to Indian Territory, Oklahoma, the Southwest, and the Far West. The oral history section contains many Indian-related collections such as the Indian Oral History Collection, more than six hundred tapes financed by the Doris Duke Foundation in the 1960s; the "Indians for Indians Hour," sound recordings of a radio program that aired from the 1940s into the 1960s; and numerous other Indian-language recordings collected by linguists and anthropologists. The Western History Collections also contain many other notable audio collections ranging from a series of radio programs, entitled "Oklahoma School of the Air," to lectures by Edward Everett Dale and talks by prominent speakers at University of Oklahoma events. Recently,

the Western History Collections have also begun to acquire collections of Native American art, and continue to acquire microfilm collections from the National Archives, Library of Congress, and commercial vendors.

All special collections pass through phases. They begin as the dream of a few academics and nonacademics who value the past. Next, these founders search for a secure home for the core documents and for the staff to catalog and administer those documents. The founders then seek outside donors and hire archivists and curators who have the energy and talent to maintain the collections and manage an acquisition program. The Western History Collections have followed this pattern. Much has changed during the seventy-five-year history of the Collections. What began as a specialized library of secondary literature has blossomed into a library and archive for all types of documentation of our past. Electronic catalogs have replaced the cumbersome card catalogs, and an increasing number of acquisitions are on microfilm, a medium that costs less, requires less time to catalog, lasts indefinitely, and requires less space to store than other media. Books remain important, but so do art, sound recordings, and Native American newspapers.

Fortunately, the Western History Collections have passed the days when success depended on a handful of individuals or a share of the University Libraries' budget. In the early 1970s, Curator John Ezell and Assistant Curator Jack Haley organized several friends of the Western History Collections into a small support group. Known as the Associates of the Western History Collections, the organization has grown to approximately 125 members and provided the Western History Collections with their own endowment. The Associates purchase rare books, photographs, and manuscripts for the Western History Collections and also support the publication of guides to manuscript collections and traveling exhibits of materials from the Collections. The Western History Collections still depend heavily on state support, but private donors have made an enormous difference in the acquisitions program and the visibility of the library throughout the state.

The present volume will serve many purposes. The most important is to show scholars in Oklahoma and in the rest of the United States the rich and varied materials available at the University of Oklahoma for the study of the West, the Southwest, the Great Plains, and Oklahoma. This guide will also publicize the Western History Collections among potential donors. Anyone who thumbs through the pages of this book will be impressed with the histories yet to be written, anticipating the amateur and professional historians who will write the history of the West in the twenty-first century. Like the people who negotiated with Frank Phillips for that initial gift in 1927, today's readers may realize that these libraries are more about the future than the past.

GUIDE TO PHOTOGRAPHS
in the
WESTERN HISTORY COLLECTIONS
of the
UNIVERSITY OF OKLAHOMA

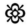

PHOTOGRAPH COLLECTIONS

ADA PUBLIC LIBRARY COLLECTION 1
Photographs 1900–1937
51 items
Black-and-white copy prints of farming scenes, businesses, street scenes, buildings, railroads, families, schools, and recreation in Ada, Oklahoma City, Roff, and Wetumka, Oklahoma and Hot Springs, Arkansas.
Unpublished finding aid available.

ADAMS, GRACE 2
Photographs 1900–1962
23 items
Black-and-white copy prints of the town of Hackberry, which later became Sharon, Oklahoma, including businesses, street scenes, and the railroad depot.
Unpublished finding aid available.

ALBERS, PAT 3
Photographs 1906–1970
98 items
Black-and-white and color copy prints of Arapaho, Cheyenne, Cheyenne-Arapaho, Kiowa, Pawnee, Sioux, and Southern Cheyenne Indians wearing traditional clothing. Personalities include Big Face, Big Hawk, Joe Big Head, Susie Big Horse, Big Wolf, Bird Chief, Bird Head, Black Wolf, Brave Bear, Buffalo Meat, Bull Bear, Burning Face, Cloud Chief, Cut Ears, Dach-O-Me-Yo, Deafy Fletcher, Winona Margery Haury, High Chief, I-See-O, Left Hand, Grant Left Hand, Minnie Left Hand, Little Bear, Little Chief, Lone Bear, Mad Wolf, Nellie Old Man, Edgar Pettyman, Plenty Horses, Standing Bull, Standing Wolf, Thunder Bird, Turkey Legs, Lizzie Turkey Legs, Wenona Turkey Legs, Rev. T. K. Tyson, Walking Woman, Whirlwind, White Eagle, White Shield, Don B. Wolf, Wolf Face, Wolf Robe, and Yellow Boy.
Unpublished finding aid available.

ALCAN MILITARY HIGHWAY COLLECTION 4
Photographs 1942
469 items

Black-and-white original and copy prints of construction of the Alaska-Canadian, or Alcan, Highway during World War II in British Columbia, Yukon Territory, and Alberta, Canada, and Alaska. This collection includes aerial views and scenes of road construction equipment, airplanes, trains, automobiles, barges, boats, ferries, an Independence Day celebration, the Canadian Rocky Mountains, and wildlife. Towns and areas in the collection include Summit Lake, Alaska; Edmonton and Grande Prairie, Alberta; Dawson Creek, Fort Nelson, Fort St. John, Muskwa, and Swan Lake, British Columbia; Watson Lake and Whitehorse, Yukon Territory; and Liard River; Peace River; Sikanni River; and Horse Lake.
Unpublished finding aid available.

ALEXANDER, IRA OLYEN (b. 1906) 5
Photographs 1880–1950
14 items

Black-and-white original prints of the Alexander and Sellers families, and the town of Bennington, Indian Territory.
Unpublished finding aid available.

ALFORD, GENEVIEVE G. 6
Photographs 1898–1908
15 items

Black-and-white copy prints of students at Spaulding College in Muskogee, Indian Territory. The collection also includes photographs of the Garretson and Sanders families.
Unpublished finding aid available.

ALLEN, E. N. 7
Photograph 1910
1 item

A black-and-white copy print of Dr. E. N. Allen, president of the Indian Territory Medical Association.

ALLEN, NEVA 8
Photographs 1890
1 item

A black-and-white copy print of Dewey, Indian Territory.

ALLEN, SUSIE K. 9
Photograph 1936
1 item
A black-and-white original print of attorney Walter Bruce Allen at his desk in Bartlesville, Oklahoma.

ALLEY, JOHN 10
Photograph 1884
1 item
A black-and-white copy print of California politician William M. Dalton.

AMERICAN INDIAN INSTITUTE COLLECTION 11
Photographs ca. 1925–1989
13 items
Black-and-white original prints of an American Indian Institute event. Personalities include U.S. Senator Dan Inouye, Evalu Russell, Wilma Mankiller, Carol Willis, Sharon Harjo, Frank Bushyhead, and Linda Skinner.
Unpublished finding aid available.

AMERICAN LEGION (Thomas C. Reynolds Post No. 303) COLLECTION 12
Photographs ca. 1944–1949
54 items
Black-and-white copy prints of Legionnaires engaged in activities at Thomas C. Reynolds Post No. 303 at the University of Oklahoma. This collection also includes images from American Legion Post 88 in Norman, Oklahoma, and of University of Oklahoma President George Lynn Cross, and musician Tex Beneke.
Unpublished finding aid available.

AMSPACHER COLLECTION 13
Photographs 1909–1935
18 items
Black-and-white original prints of elementary school photographs from Pawnee, Oklahoma, and photographs of unidentified infants.
Unpublished finding aid available.

ANDRUS, SELDEN EUGENE (1858–1941) 14
Photograph n.d.
1 item
A black-and-white original print of Mr. and Mrs. Selden E. Andrus.

ARGO, JIM **15**

Photographs 1889–1901

10 items

Black-and-white original prints of Guthrie, and Oklahoma City, Oklahoma Territory. Included are photographs of streets, horse-racing, railroads and railroad depots, wagons, telephone operators, courthouses, and an election scene in Oklahoma City.

Unpublished finding aid available.

ARMANTROUT STUDIO COLLECTION **16**

Photographs 1889–ca. 1930

124 items

Black-and-white original and copy prints of Guthrie, Oklahoma Territory and state, including street scenes, parades, farming, businesses, railroads, industry, and the inauguration of Oklahoma's first governor, Charles Nathaniel Haskell. The collection also includes portraits of Oklahoma's sixth governor, Martin E. Trapp.

Unpublished finding aid available.

ARMSTRONG, CHARLES E. **17**

Photographs 1903–1915

14 items

Black-and-white original and copy prints of the Kingfisher College track team, football team, and men's glee club in Kingfisher, Oklahoma. This collection also includes images of gymnastics teams, the 1913 Notre Dame basketball team, and Ernest Hemingway as a member of the 1915 Oak Park High School football team in Oak Park, Illinois.

Unpublished finding aid available.

ARNOLD, (Mr. and Mrs.) A. A. **18**

Photographs 1898

2 items

Black-and-white original prints of Eagle City, Oklahoma Territory.

Unpublished finding aid available.

ATHEY, JOHN VANMORE (b. 1872) **19**

Photograph 1915

1 item

A black-and-white original panorama of the members of the Oklahoma State Medical Association at Bartlesville, Oklahoma.

AVARILL, MELBERT 20
Photograph 1920
1 item
A black-and-white original panorama of Vinita, Oklahoma.

BABCOCK, JAMES M. (b. 1926) 21
Photographs 1930–1960
32 items
Black-and-white original prints of tornado damage at Shawnee, Oklahoma; the
Chickasaw Nation capitol building at Tishomingo, Oklahoma; and the Union Indian
Agency at Muskogee, Oklahoma. Also included are photographs of Franklin D.
Roosevelt on a train tour of Oklahoma, and of Gene Autry.
Unpublished finding aid available.

BACONE COLLEGE COLLECTION 22
Photographs 1950
15 items
Black-and-white copy prints of students and the campus of Bacone College, a col-
lege for American Indians, in Muskogee, Oklahoma.
Unpublished finding aid available.

BADGER, INA 23
Photographs n.d.
3 items
Black-and-white original and copy prints of a group of cowboys, and of an Indian
camp scene.
Unpublished finding aid available.

BAEHR, ANNE RUTH E. 24
Photographs ca. 1908–1955
81 items
Black-and-white copy prints of Cheyenne and Arapaho Indians from the Clin-
ton, Oklahoma, area. The collection features images of Indian church congrega-
tions (mainly Mennonite), encampments, and a powwow held in the early 1950s.
Prominent Cheyennes pictured are Wolf Chief, White Shield, Tall Bear, Wolf
Face, and White Skunk.
Unpublished finding aid available.

BAILEY, IVA 25

Photographs ca. 1891

2 items

Black-and-white copy prints of the Bailey family and their sod house at Tulia, Texas. *Unpublished finding aid available.*

BAILEY, JAY 26

Photographs ca. 1910

79 items

Black-and-white copy prints of businesses in Cordell, Oklahoma. Also in the collection are photographs of tornadoes and buildings destroyed by tornadoes. *Unpublished finding aid available.*

BAILEY, MARY H. 27

Photographs 1880–1900

9 items

Black-and-white copy prints of Quanah Parker, Frank Bailey, the Fort Sill (Oklahoma) Indian School, and an Indian parade at Anadarko, Indian Territory. *Unpublished finding aid available.*

BAKER, J. A. (Jesse Albert) (1853–1925) 28

Photographs 1902–1907

7 items

Black-and-white original prints of the Oklahoma Constitutional Convention in session at city hall, Guthrie, Oklahoma, in 1907. The collection also includes scenes of Fort Sill, Oklahoma, and the town of Wewoka, Oklahoma. *Unpublished finding aid available.*

BAKER, (Mrs.) R. P. 29

Photographs ca. 1895

2 items

Black-and-white copy prints of early Pauls Valley, Oklahoma, businesses. *Unpublished finding aid available.*

BALDWIN LOCOMOTIVE WORKS COLLECTION 30

Photographs ca. 1877

10 items

Black-and-white copy prints of locomotives. *Unpublished finding aid available.*

BALDWIN, DELMAR 31
Photographs 1884–1900
16 items
Black-and-white original prints of the Rough Riders Reunion and Rodeo at Oklahoma City, Oklahoma Territory, 1900, featuring Theodore Roosevelt. The collection also includes photographs of Lucille Mulhall; captured bank robbers at Medicine Lodge, Kansas; and El Reno, Oklahoma Territory, during the land lottery.
Unpublished finding aid available.

BALLENGER, T. L. 32
Photographs 1874–1894
36 items
Black-and-white original prints of the Cherokee Male Seminary and the Cherokee Female Seminary at Park Hill, Indian Territory. The collection also contains prints of Cherokee tribal government officials, Cherokee students, and Fort Gibson and Tahlequah, Indian Territory. Included are photographs of Bluie Adair, Elias Boudinot, Patsy Mayes, Julia Phillips, Lulu Starr, and Buck Watie.
Unpublished finding aid available.

BALYEAT, FRANK A. (1886–1971) 33
Photographs ca. 1853–1907
4 items
Black-and-white copy prints of the first Cherokee Female Seminary at Tahlequah, Indian Territory; the Bloomfield Academy, a school for girls near Achille, Indian Territory; and the Southwestern Baptist College at Hastings, Indian Territory.
Unpublished finding aid available.

BAMBAS, RUDOLPH C., and FRIEDA DERDEYN BAMBAS 34
Photographs 1929–2005
149 items
Black-and-white and color original and copy prints of Bambas family members and friends in everyday life and on vacation. Locations include Chicago, Illinois; Alaska; India; the University of Oklahoma campus in Norman, Oklahoma; and Calvary Cemetery in Fort Smith, Arkansas. This collection also includes images of Elderhostel at the University of Oklahoma, Rudolph Bambas in military uniform during World War II, and Frieda Derdeyn Bambas's induction into the Centenarian Club of Oklahoma.
Unpublished finding aid available.

BARKER, N. L. 35
Photographs 1915–1926
5 items
Black-and-white original prints of Dr. N. L. Barker during World War I, in his first medical office at Harrison, Arkansas, and driving his wagon at Eagletown, Oklahoma. The collection also contains studio portraits of Barker.
Unpublished finding aid available.

BARKLEY, ALEXANDER 36
Photographs ca. 1895–1916
3 items
Black-and-white original prints of Pond Creek, Oklahoma, and Barkley's medical office in Hobart, Oklahoma, with one of the first X-ray machines in Oklahoma.
Unpublished finding aid available.

BARNES, SUDIE McALESTER (1873–1953) 37
Photographs 1880–1920
16 items
Black-and-white original prints of Sudie McAlester Barnes, J. J. McAlester, railroad locomotives, and the town of McAlester, Oklahoma.
Unpublished finding aid available.

BARRETT, PAULA COLBY 38
Photographs ca. 1911–1914
57 items
Black-and-white copy prints of the Colby Motor Company of Mason City, Iowa, which operated from 1911 to 1914, along with numerous photographs of Colby automobiles and race cars, views of the factory, and company employees. Tourist snapshots of Devil's Lake and Grand Forks, North Dakota, and Wolf Creek, Montana, are also included.
Unpublished finding aid available.

BARTLETT, C. M. 39
Photographs 1914–1930
6 items
Black-and-white original panoramas of lead and zinc mining activities near Picher, and Miami, Oklahoma.
Unpublished finding aid available.

BARTON, EVERETT 40
Photograph 1918
1 item
A black-and-white original print of the interior of Everett Barton's Dodge Agency garage in Chickasha, Oklahoma.

BASLSEN, FRANCES TENNEY 41
Photograph 1906
1 item
A black-and-white original print of the University of Oklahoma campus in Norman, Oklahoma Territory.

BASS, HENRY B., POSTCARD COLLECTION 42
Postcards 1939–1965
127 items
Black-and-white and color postcards from Birmingham, Alabama; Colorado Springs, Colorado; Stone Mountain, Georgia; Chicago and Evanston, Illinois; Hiawatha and Wichita, Kansas; New Orleans, Louisiana; Boston, Cambridge, and Hingham, Massachusetts; Hibbing and Rochester, Minnesota; Vicksburg, Mississippi; Arrow Rock, Joplin, Springfield, Poplar Bluff, and Kansas City, Missouri; Nebraska City, Nebraska; New York City, New York; Blackwell, Norman, and Tulsa, Oklahoma; Aiken, South Carolina; Watertown, South Dakota; Lookout Mountain, Tennessee; San Antonio, Texas; Hot Springs and Roanoke, Virginia; Howard University in Washington, D.C.; White Sulphur Springs, West Virginia; Ripon, Wisconsin; Amsterdam, Netherlands; Rome, Italy; and Mexico. This collection also includes postcards from the New York World's Fair, 1964–1965.
Unpublished finding aid available.

BATES, S. R. 43
Photograph n.d.
1 item
A black-and-white original print of S. R. Bates.

BATTEY, THOMAS C. (1828–1897) 44
Photograph 1874
1 item
A black-and-white original print of Thomas C. Battey.

BAUM, F. J. (b. 1870) 45
Photographs 1914–1929
3 items
Black-and-white original prints of Dr. and Mrs. F. J. Baum and their home at
Savanna, Oklahoma.
Unpublished finding aid available.

BEAIRD, MARGARET C. 46
Photographs 1902
10 items
Black-and-white copy prints of Tonkawa, Oklahoma Territory, and of Apache and
Tonkawa Indians.
Unpublished finding aid available.

BECK FAMILY COLLECTION 47
Photographs 1928
4 items
Black-and-white copy prints of U.S. Senator Charles Curtis's visit to Ponca City,
Oklahoma. Curtis later became the 31st Vice President of the United States.
Unpublished finding aid available.

BECKER, A. J. 48
Photographs 1900–1938
37 items
Black-and-white original and copy prints of Quanah Parker and Comanche Indi-
ans; the Post Oak Cemetery at Fort Sill, Oklahoma; and a mission in Comanche
County, Oklahoma. The collection also contains images of baptismal scenes and a
meeting place of the Choctaw Nation Council.
Unpublished finding aid available.

BEDFORD, R. S. 49
Photograph 1895
1 item
A black-and-white copy print of Bartlesville, Indian Territory.

BENEDICT, JOHN D. 50
Photograph n.d.
1 item
A black-and-white original print of Donald Benedict.

BENTON, JOSEPH HORACE (1898–1975) 51
Photographs 1901–1907
31 items
Black-and-white original prints of the towns of Riverton (now Sayre), El Reno, and
Doxey, Oklahoma Territory. Also included are photographs of the Benton family,
businesses, railroads, and University of Oklahoma students.
Unpublished finding aid available.

BERRY, VIRGIL (1866–1954) 52
Photograph n.d.
1 item
A black-and-white original print of Virgil Berry's home at Okmulgee, Oklahoma.

BERRY, WILLIAM AYLOR (b. 1915) 53
Photograph 1950
1 item
A black-and-white original print of William Berry.

BERRYMAN, WANDA BRANNAN 54
Photographs ca. 1940s–1950s
106 items
Black-and-white original prints of student life at the University of Oklahoma's
Norman campus. Scenes feature social activities at Lawson House in Cate Center;
homecoming parade floats; and football games and marching band performances
at Oklahoma Memorial Stadium.
Unpublished finding aid available.

BERTHRONG, DONALD J. (1922–2012) 55
Photographs 1846–1877
27 items
Black-and-white copy prints of William W. Bent and John M. Chivington; the
participants of the 1864 Camp Weld Conference at Denver, Colorado, including
its Cheyenne and Arapaho leaders; and photographs of paintings, drawings, and
lithographs by George Catlin, Richard West, J. W. Albert, and John Mix Stanley.
Unpublished finding aid available.

BILBEY, G. N. (1868-1939) 56
Photograph n.d.
1 item
A black-and-white copy print of Dr. G. N. Bilbey of Alva, Oklahoma.

BILES, JOHN H. 57
Photographs 1885-1902
6 items
Black-and-white original prints of William L. Byrd, a governor of the Chickasaw Nation; his store; and the governor's mansion at Stonewall, Indian Territory, along with scenes of a Chickasaw political convention held near Stonewall; and members of the Byrd party.
Unpublished finding aid available.

BIZZELL, WILLIAM BENNETT (1876-1944) 58
Photographs 1914-1944
87 items
Black-and-white original prints of University of Oklahoma president William Bennett Bizzell, and scenes of university faculty, regents, and students. The collection also contains photographs of Yellowstone National Park, the Pioneer Woman statue, Temple Houston, Woodrow Wilson, and Bizzell's travels to Egypt, Greece, and France.
Unpublished finding aid available.

BLACHLY, LUCILLE SPIRE (d. 1959) 59
Photographs 1908-1930
188 items
Black-and-white original prints of Lucille Spire Blachly, and postcards from various states and countries, predominantly Kansas, New Mexico, Oklahoma, and Utah. Among the cities and landmarks noted are Hot Springs, Arkansas; Redlands, Santa Catalina Island, Sonora, Columbia, Pasadena, and Los Angeles, California; Pike's Peak, Colorado; Chicago, Illinois; Indianapolis, Indiana; Ellsworth, Emporia, Pittsburg, and Manhattan, Kansas; Boston, Massachusetts; Frankfort, Michigan; Rochester and Duluth, Minnesota; Lincoln, Nebraska; Aztec Ruins National Monument, Red River, Santa Fe, and Taos, New Mexico; Chillicothe, Ohio; Bartlesville, Guthrie, Muskogee, Norman, Oklahoma City, and Tulsa, Oklahoma; San Antonio, Texas; Zion National Park, Utah; and Havana, Cuba.
Unpublished finding aid available.

BLACKBURN, W. W. 60
Photographs 1892–1926
33 items
Black-and-white original prints of the towns of Berlin, Oklahoma Territory, and
Elk City and Cheyenne, Oklahoma. The collection also includes photographs of
cotton marketing, fairs, railroad construction, rodeos, businesses, and photographs
of the Blackburn family and Robert S. Kerr.
Unpublished finding aid available.

BLANTON, (Mrs.) JAMES T., JR. 61
Photographs ca. 1941
9 items
Black-and-white original prints of the 1941 flood at Pauls Valley, Oklahoma.
Unpublished finding aid available.

BLEDSOE, RICHARD 62
Photographs ca. 1880–1950
6 items
Black-and-white copy prints of early families of Independence, Kansas. Charles
Henry Jones, a Civil War veteran, is pictured along with his family.
Unpublished finding aid available.

BOGGS, HERBERT OTHO 63
Photographs 1880–1900
54 items
Black-and-white copy prints of Choctaw Indians, including studio portraits; the
Choctaw mounted police known as the Lighthorse; schools; and tribal government
officials. The collection also includes photographs of participants of the Choctaw
Indian conflict known as the Locke-Jones War, or the Antlers War, along with
scenes of the towns of McAlester, Antlers, and Ti, Indian Territory. Jonas Durant,
Green McCurtain, W. B. Pitchlynn, and Dennis Carr are among the personalities
noted in this collection.
Unpublished finding aid available.

BOIRUN, G. D. 64
Photographs 1897–1922
11 items
Black-and-white original prints and tintypes of the Boirun farm, and of Macomb,
Oklahoma.
Unpublished finding aid available.

BOND, GEORGE M. (1847–1922) 65
Photograph 1907
1 item
A black-and-white original print of George M. Bond as a county judge in Jefferson County, Oklahoma.

BOOMER LITERATURE COLLECTION 66
Photographs n.d.
10 items
Black-and-white original and copy prints of broadsides and posters advertising land openings. Also included are images of the Santa Fe depot in Pauls Valley, Oklahoma, and a portrait of Captain D. L. Payne.
Unpublished finding aid available.

BOORSTIN, RUTH F. 67
Photographs ca. 1981
5 items
Black-and-white and color copy prints of Daniel J. and Ruth F. Boorstin with politicians and leaders, including Ronald and Nancy Reagan, George H. W. Bush, and Joan A. Mondale.
Unpublished finding aid available.

BOREN, DAVID L. (1941–) 68
Photographs 1948–2001
432 items
Black-and-white and color original prints, negatives, and copy prints of David L. Boren. The collection includes images of the Boren family, Carrie Boren, Christine McKown Boren, and Molly Shi Boren; United States and world leaders; Oklahoma gubernatorial and University of Oklahoma presidential inaugurations; and events and ceremonies at the University of Oklahoma.

BOREN, LYLE H. (1909–1992) 69
Photographs 1943–1945
18 items
Black-and-white original and copy prints of U.S. Representative Lyle Boren with government officials. Portraits of Harry S. Truman, Clinton P. Anderson, David L. Boren, and Peruvian President Manuel Prado are included in this collection, along with a photograph of servicemen in front of the Eiffel Tower in Paris, France.
Unpublished finding aid available.

BOSWELL, H. D. 70
Photograph n.d.
1 item
A black-and-white original print of Dr. H. D. Boswell.

BOWER, BERTHA MUZZY (1871–1940) 71
Photographs 1882–1911
34 items
Black-and-white original and copy prints of western fiction author Bertha Muzzy Bower writing, riding horses, and with her family in San Jose and Monterrey, California, and in Big Sandy, Montana. This collection also includes images of Bower's second husband, Bertrand W. "Bill" Sinclair, also known as "The Fiddleback Kid."
Unpublished finding aid available.

BOWLES, ORA LEE 72
Photographs 1900–1925
9 items
Black-and-white original and copy prints of Cushing, Oklahoma, and the oil industry in the Cushing area.
Unpublished finding aid available.

BOWLING, (Mrs.) R. E. 73
Photographs 1919–1930
3 items
Black-and-white original prints of R. E. Bowling and the Methodist Men's Sunday school class, Pauls Valley, Oklahoma. The collection also contains a panorama of Company G, Second Infantry, Oklahoma National Guard, Pauls Valley, Oklahoma.
Unpublished finding aid available.

BOYD, DAVID ROSS (1853–1936) 74
Photographs 1885–1930
175 items
Black-and-white original prints of University of Oklahoma president David Ross Boyd, his family, and scenes from the first ten years of the University of Oklahoma, including the first faculty, students, and buildings. The collection also contains images of the Rough Riders Reunion at Oklahoma City in 1910.
Unpublished finding aid available.

BOYD, FRANCIS M. 75

Photographs 1894–1908

3 items

Black-and-white copy prints of the Francis M. Boyd home at Wyman, Arkansas. The collection also includes photographs of the Boyd Confectionery Shop at Fayetteville, Arkansas, and former slaves.

Unpublished finding aid available.

BOYD, GEORGE W. 76

Photographs 1896–1907

8 items

Black-and-white original prints of ranching in Greer County, Oklahoma Territory.

Unpublished finding aid available.

BOYER, DAVE (b. 1874) 77

Photographs 1912–1915

3 items

Black-and-white original prints of the first oil wells in Cotton County, Oklahoma. Also included in the collection are original panoramas of Walters, Oklahoma.

Unpublished finding aid available.

BRANDT, JOSEPH AUGUST (1899–1981) 78

Photographs 1941

50 items

Black-and-white original prints of University of Oklahoma president Joseph A. Brandt. The collection contains scenes of University of Oklahoma students and alumni, of the 1941 matriculation ceremony, and of Brandt with former University of Oklahoma president William Bennett Bizzell. Other University of Oklahoma personalities depicted in the collection are Carleton Ross Hume, Stratton D. Brooks, and Paul Sears.

Unpublished finding aid available.

BRAUNLICH, PHYLLIS COLE 79

Photographs

24 items

Black-and-white and color copy prints of playwright Lynn Riggs and friends, including Ida Rauh Eastman, Enrique Gasque-Molina, Dr. Paul Green, Elizabeth Green, Willard "Spud" Johnson, George O'Neil, and Gilbert Seldes. The collection contains views of Yaddo writers' colony in Saratoga Springs, New York; and the Villagra Book Shop and Sunmount Sanitarium in Santa Fe, New Mexico.

Unpublished finding aid available.

BROKEN BOW LIONS CLUB COLLECTION 80
Photographs n.d.
2 items
Black-and-white original prints of Herbert (William H.) Chandler.

BROOKS AND SCHREINER COLLECTION 81
Photographs 1889–1908
764 items
Black-and-white negatives and contact prints of horse-drawn carriages.
Unpublished finding aid available.

BROOME, BERTRAM C. 82
Photographs ca. 1922
15 items
Black-and-white original prints of young boys at a summer camp, and general camping scenes.
Unpublished finding aid available.

BRUNER, W. S. 83
Photographs 1910–1930
245 items
Black-and-white original and copy prints of the Miller Brothers 101 Ranch, including personalities, grounds, activities, and the Miller Brothers 101 Wild West Show. Personalities in the collection include Joe C. Miller, Jack Hoxie, Dixie Starr, Vince Dillon, and Tex Cooper. Performance venues include Arkansas City, Kansas; and Marland and Shawnee, Oklahoma; general scenes from Ponca City and Fairfax, Oklahoma, are also present. Additionally, the collection contains several images of an Osage Indian camp near Gray Horse, Oklahoma, and Pawnee Bill's "Indian congress" at Brush Arbor.
Unpublished finding aid available.

BRYAN, FRANK 84
Photographs 1903–1906
2 items
Black-and-white copy prints of Frank Bryan and the E. B. Bryan Store at Nelson, Indian Territory.
Unpublished finding aid available.

BRYDIA, CATHERINE 85
Stereograph cards 1910
129 items
Color original stereograph cards produced by Dr. S. I. Rainforth depicting various skin conditions, including syphilis, lupus, psoriasis, dermatitis, and eczema.
Unpublished finding aid available.

BUCHANAN, F. R. 86
Photograph n.d.
1 item
A black-and-white original print of Dr. F. R. Buchanan in his office at Canton, Oklahoma.

BUFFALO (Oklahoma) MUSEUM COLLECTION 87
Photographs 1870–1980
83 items
Black-and-white copy prints of the towns of Augusta, Brule, Buffalo, Charleston, Dacoma, Doby Springs, Fargo, Selman, and Wakita, Oklahoma, and Savonburg, Kansas. The images include scenes of businesses, families, farming, ranching, sod houses, schools, and schoolchildren in and around these Oklahoma and Kansas communities.
Unpublished finding aid available.

BUREAU OF LAND MANAGEMENT COLLECTION 88
Photographs 1889–1901
33 items
Black-and-white copy prints of the towns of Lawton, El Reno, Perry, and White Rock, Oklahoma Territory. The collection includes scenes of businesses; railroads; the opening of the Cherokee Strip to white settlement; the land lottery drawing at El Reno; and a wagon train of settlers during the land run of 1889.
Unpublished finding aid available.

BURNS, A. P. 89
Photograph 1915
1 item
A black-and-white copy print of farm equipment in front of the Burns Brothers Hardware Store, Pauls Valley, Oklahoma.

BURNS, SAMUEL LEE (b. 1876) 90
Photographs 1944–1950
5 items
Black-and-white original prints of Dr. Samuel L. Burns and his family.
Unpublished finding aid available.

BUSBY, OREL (ca. 1890–1965) 91
Photograph 1926
1 item
A black-and-white original print of the University of Oklahoma board of regents,
university president, and the deans of the law and engineering colleges at spring
baccalaureate services.

BUTCHER, NAHUM ELLSWORTH (b. 1872) 92
Photographs 1896–1920
2 items
Black-and-white copy prints of the University of Oklahoma's first student, Nahum
E. Butcher, and a group of Norman, Oklahoma, teachers in 1896.
Unpublished finding aid available.

BUTCHER, W. H. 93
Photographs 1890–1930
66 items
Black-and-white original prints of Geronimo; the Butcher family butcher shop
in Oklahoma City, Oklahoma; and a San Francisco earthquake. The collection
includes scenes of World War I aviation and battlefields, mostly in France.
Unpublished finding aid available.

BYRD, HIRAM, and WALLACE BYRD 94
Photograph 1945
1 item
A black-and-white original studio portrait of Dr. Wallace Byrd.

CAGLE, (Mrs.) W. W. 95
Photograph 1927
1 item
A black-and-white original print of Hollis, Oklahoma, in 1927.

CALIFORNIA MISSIONS COLLECTION 96
Photographs ca. 1925
22 items
Black-and-white original prints of Spanish missions in California, including San Juan Capistrano, San Diego, San Gabriel, and Los Angeles Mission Chapel. *Unpublished finding aid available.*

CALL'S STUDIO COLLECTION 97
Photographs 1901–1910
10 items
Black-and-white original prints of Lawton, Oklahoma Territory; Geronimo; and the grave of Cynthia Ann Parker in the Post Oak Cemetery at Fort Sill, Oklahoma. *Unpublished finding aid available.*

CALLAHAN, J. O., and W. K. CALLAHAN 98
Photographs 1875
2 items
Black-and-white studio portraits of Drs. W. K. Callahan and J. O. Callahan. *Unpublished finding aid available.*

CAMARGO, OKLAHOMA, COLLECTION 99
Photographs 1910–1915
33 items
Black-and-white copy prints of Camargo, Oklahoma, featuring scenes of railroad construction, railroad accidents, sod houses, businesses, and farming activities. *Unpublished finding aid available.*

CAMP, EARL F. (b. 1892) 100
Photograph n.d.
1 item
A black-and-white original print of Dr. Earl F. Camp, mayor of Buffalo, Oklahoma.

CAMPBELL, C. D. (Charles Duncan) (b. 1877) 101
Photographs ca. 1915
2 items
Black-and-white copy prints of oil wells in Apache, Oklahoma. *Unpublished finding aid available.*

CAMPBELL, J. F. (1876–1934) 102
Photograph n.d.
1 item
A black-and-white copy print of Dr. J. F. Campbell.

CAMPBELL, JOHN McKOY 103
Photograph 1919
1 item
A black-and-white original print of John McKoy Campbell in military uniform.

CAMPBELL, O. B. 104
Photographs ca. 1885–1930
330 items
Black-and-white copy prints of Indian students and buildings at Carlisle Indian School, Riverside Indian School, Dwight Mission, Cherokee Female Seminary, and Fort Sill Indian School; and a street scene in Bluejacket, Oklahoma. Also included are photographs of Red Cloud, Quanah Parker, and Elias Cornelius Boudinot; Wichita grass houses; street scenes from Marble City, Oklahoma; and unidentified cowboys.
Unpublished finding aid available.

CAMPBELL, WALTER STANLEY (1887–1957) 105
Photographs 1870–1935
2,910 items
Black-and-white original and copy prints of Apache, Arapaho, Assiniboine, Blackfoot, Cheyenne, Cheyenne-Arapaho, Comanche, Crow, Flathead, Kiowa, Nez Percé, Omaha, Osage, Pawnee, Potawatomi, Pueblo, Sac and Fox, Shawnee, Shoshoni, Sioux, Umatilla, Ute, Wichita, and Yakima Indians. Also included are photographs (1865–1891) of the U.S. Army during the Indian Wars; western forts and military posts; the Little Big Horn battlefield; trails and settlements of the Southwest; firearms; campsites and tepees; dust storms; lawmen; soil conservation techniques; mountain ranges; national parks; wildlife; Southwestern State College in Weatherford, Oklahoma; University of Oklahoma campus in Norman, Oklahoma; Miss Indian America pageant; All American Indian Days; Seger Indian School; and Oklahoma towns. Personalities in the collection include American Horse, Bear Soldier, William W. Bent, Frederick W. Benteen, Big Mouth, Black Coyote, Acee Blue Eagle, Heck Bruner, Buffalo Hump, Victor Bushyhead, Walter S. Campbell, Chief Joseph, Circle Left Hand, William F. Cody, J. Frank Dobie, Dull Knife, Gall, John Grass, Heap of Birds, Louis L'Amour; One Bull; John Joseph Pershing, John "Portugee" Phillips, Plenty Coups, Rain in the Face, Red Cloud, Roman Nose, Theodore Roosevelt, Satank, Sitting Bull, Alfred H. Terry, Two Moons, Joseph White Bull, and

White Wolf. Oklahoma towns pictured in the collection include Cantonment, Colony, Corn, Fort Sill, Guthrie, Norman, Weatherford, and Wyandotte. Other places depicted are Chicago, Illinois; Dodge City, Fredonia, and Severy, Kansas; Princeton, New Jersey; Taos and Santa Fe, New Mexico; Hartville and Dubois, Wyoming; and England, France, Germany, Italy, the Netherlands, Scotland, and Switzerland. *Unpublished finding aid available.*

CAPSHAW, MADISON T. J. (1856–1920) 106
Photographs n.d.
3 items
Black-and-white and hand-colored original prints of Dr. Madison T. J. Capshaw and his family.
Unpublished finding aid available.

CARLOCK, ARLIE ERNEST (1873–1936) 107
Photographs 1896–1910
4 items
Black-and-white original prints of Dr. A. E. Carlock and Missouri Medical College students.
Unpublished finding aid available.

CARSON, FRANK L. 108
Photograph ca. 1918
1 item
A black-and-white original print of Dr. F. L. Carson in his automobile at Shawnee, Oklahoma.

CARTER, M. L. (d. 1923) 109
Photographs 1895–1921
3 items
Black-and-white original prints of Mr. and Mrs. Charles A. Denison; the first drugstore in Idabel, Oklahoma; and of Dr. M. L. Carter at a Tulane University reunion in New Orleans, Louisiana.
Unpublished finding aid available.

CARTWRIGHT, (Mrs.) OTTO 110
Photographs 1920–1924
3 items
Black-and-white copy prints of Otto and Alan Cartwright farming near Roosevelt, Oklahoma.
Unpublished finding aid available.

CASE, GEORGE 111
Photographs 1905–1918
20 items
Black-and-white original prints of Dewey, Indian Territory and Oklahoma. The collection includes photographs of street scenes; oil drilling activities in the Weber Pool near Dewey; schoolchildren; and an airplane manufactured by the Dewey Airplane Company.
Unpublished finding aid available.

CASE, VERNON, and CLARA CASE 112
Photograph ca. 1900
1 item
A black-and-white original print of James Case.

CATE, ROSCOE SIMMONS (1876–1954) 113
Photographs 1861–1865
10 items
Black-and-white original prints of U.S. Army officers during the Civil War.
Unpublished finding aid available.

CHAAT, ROBERT P. 114
Photograph 1942
1 item
A black-and-white copy print of an Easter congregation at the Comanche Mission Church, Lawton, Oklahoma.

CHANEY, WARREN P. (1878–1963) 115
Photographs 1863–1909
23 items
Black-and-white original prints of Warren P. Chaney at work in the Choctaw and Chickasaw Nations as a field agent for the Dawes Commission, along with scenes of El Reno and Anadarko, Oklahoma Territory.
Unpublished finding aid available.

CHAPMAN, T. SHELBY 116
Photographs 1895–1912
7 items
Black-and-white original and copy prints of Dr. T. S. Chapman, his family, and his medical offices at McAlester, Oklahoma.
Unpublished finding aid available.

CHARLTON, (Mrs.) H. F. 117
Photograph 1906
1 item
A black-and-white original print of the Dr. J. E. Jones home in Hollis, Oklahoma.

CHEW, MURIEL 118
Photographs 1906–1907
3 items
Black-and-white original and copy prints of oil wells near Ramona, Oklahoma.
Unpublished finding aid available.

CHI UPSILON COLLECTION 119
Photographs ca. 1940
3 items
Black-and-white original prints of women in the Chi Upsilon sorority.
Unpublished finding aid available.

CHICKASHA MILLING COMPANY COLLECTION 120
Photographs ca. 1910
6 items
Black-and-white original prints of the Chickasha Milling Company offices at
Anadarko, Carnegie, Fort Cobb, Gotebo, and Gracemont, Oklahoma.
Unpublished finding aid available.

CHOATE, MAY TREADWELL (b. 1884) 121
Photographs 1890–1910
5 items
Black-and-white original prints of the Dixie Store, and the Jolley, House, and Akers
families of Erick, Oklahoma; and of Kiowa chief Ahpeatone and family.
Unpublished finding aid available.

CHRISTOPHER, E. R. (Ernest Randell) (1897–1967) 122
Photographs and postcards 1909–1959
107 items
Black-and-white original prints and postcards from the life and career of Bartles-
ville, Oklahoma, postmaster E. R. Christopher. Subjects covered by the photo-
graphs and postcards include business operations and social organizations, such
as the U.S. Postal Service and its rapid delivery system ABCD Mail (Accelerated
Business Collection and Delivery); the American Legion; and Oklahoma Boys
State. The collection also contains images of E. R. Christopher; autographed
portraits of Wesley E. Dewey, Ed Edmondson, Stewart Edmondson, and Mike

Monroney; locomotives; Bartlesville, Oklahoma; the Mormon Temple and Salt Lake City, Utah; monuments and buildings in Washington, D.C.; the Yale University campus in New Haven, Connecticut; and the University of North Carolina campus in Chapel Hill, North Carolina.
Unpublished finding aid available.

CITIES SERVICE OIL and GAS CORPORATION COLLECTION 123
Photographs 1885–1979
3,712 items
Black-and-white original and copy prints of Cities Service Oil and Gas Corporation operations, facilities, and employees. Included are scenes of the petroleum industry in Alaska, Alabama, Arkansas, California, Colorado, Florida, Georgia, Illinois, Kansas, Louisiana, Massachusetts, Mississippi, Missouri, Montana, New Jersey, New York, North Carolina, Ohio, Oklahoma, Tennessee, Texas, Utah, Washington, and Wyoming, and in Canada and Colombia; along with photographs of Bartlesville, Indian Territory and Oklahoma; and Cushing, Dilworth, Oklahoma City, Okmulgee, Pleasant Valley, Ponca City, Seminole, Tallant, and Tulsa, Oklahoma. There are also photographs of numerous Cities Service Oil and Gas Corporation employees and Osage Indians, including Bacon Rind, Black Dog, Burdette Blue, Lulu Bowlegs, John Brennan, Henry L. Doherty, Frank Finney, Robert L. Kidd, Charles Mitchell, Mo She To Moi, Frank M. Porter, Merle Thorpe, Jules Thorpe, Jules Trumbly, Tse Mah Hah, and Burl Watson.
Unpublished finding aid available.

CITIZENS NATIONAL BANK AND TRUST 124
OF MUSKOGEE COLLECTION
Photographs ca. 1920
10 items
Black-and-white original prints of depots, parks, businesses, hospitals, and apartments in Muskogee, Oklahoma.
Unpublished finding aid available.

CLARK, CARTER BLUE 125
Photographs 1832–1925
39 items
Black-and-white copy prints of Ku Klux Klan activities and meetings in Oklahoma, and of the Tulsa, Oklahoma, race riot of 1921. The collection also includes photographs of the Clark family and drawings of Tishomingo, a Chickasaw Indian war chief, and John Coffee.
Unpublished finding aid available.

CLARK, JOSEPH J. 126
Photograph 1933
1 item
A black-and-white original print of Dr. J. J. Clark.

CLARK, WILLIAM, and RUTH CLARK 127
Photographs 1904–1951
54 items
Black-and-white copy prints of Lawton, Oklahoma, including scenes of parades,
the railroad depot, post office, businesses, feed mill, schools, and churches. Also
included are photographs of the Clark family, Fort Sill, the artillery school at Fort
Sill, and the Oklahoma National Guard.
Unpublished finding aid available.

CLARKSON, ADDIE W. (1869–1950) 128
Photographs ca. 1930
7 items
Black-and-white original prints of unidentified twin girls at birth and as young
women.
Unpublished finding aid available.

CLASS OF 1900 COLLECTION 129
Photographs ca. 1900
14 items
Black-and-white original and copy prints of early University of Oklahoma build-
ings, students, professors, and organizations. A picture of the first president of the
university, David Ross Boyd, is included, along with a photograph of his daughter,
Alice, and general scenes of Norman, Oklahoma Territory.
Unpublished finding aid available.

CLASS OF 1906 COLLECTION 130
Photographs ca. 1906–1957
30 items
Black-and-white original and copy prints of the University of Oklahoma class
of 1906 at graduation, and later at their twenty-fifth and fiftieth class reunions.
Also included in the collection are photographs of Norman, Oklahoma Territory,
a track meet, the football and track teams, a human anatomy class, and the OU
acrobatic squad. Personalities include Alice Boyd and Guy Y. Williams.
Unpublished finding aid available.

CLASS OF 1911 COLLECTION 131
Photographs 1909
59 items
Black-and-white original and copy prints of buildings, students, teachers, and fraternities and sororities at the University of Oklahoma. Individual photographs of players on the baseball, track, and football teams are included, as well as football team photographs with the players in scrimmage gear.
Unpublished finding aid available.

CLELLAND, J. J. 132
Photograph 1894
1 item
A black-and-white copy print of Osage Mining Company officers in McAlester, Indian Territory.

CLEO STATE BANK COLLECTION 133
Photographs 1918–1934
4 items
Black-and-white original prints of Cleo State Bank, at Cleo Springs, Oklahoma.
Unpublished finding aid available.

CLEVELAND COUNTY HISTORICAL SOCIETY COLLECTION 134
Photographs 1890–1940
84 items
Black-and-white copy prints of Moore, Norman, and Lexington, Oklahoma, including street scenes, businesses, churches, schools, fairs, clubs, and family and individual studio portraits of the Barbour family, Helen Berry, May Bumgarner, Mrs. Arthur G. Evans, Agnes Lindsey, and the Meyer family.
Unpublished finding aid available.

CLOUGH, LUCILLE 135
Photographs 1871–1966
1,807 items
Black-and-white and color original and copy prints, postcards, and stereograph cards of American Indians, Alaskan Natives, and First Peoples of Canada. A wide variety of American Indian subjects are pictured, such as dancing, ceremonies, traditional clothing, children, housing, schools, and cemeteries. The tribes represented are the Apache, Assiniboine, Blackfoot, Chaco, Cherokee, Chippewa, Choctaw, Comanche, Cree, Crow, Hopi, Kiowa, Koshare, Menominee, Navajo, Ojibway, Ponca, Pueblo, Sac and Fox, Santa Clara, Seminole, Shoshone, Sioux,

Siwash, Umatilla, Ute, and Wichita. Among the many individuals pictured are Max Big Man, Bull Bear, William F. "Buffalo Bill" Cody, Hector Crawler, Moskowekam, Mow-Way, Billy Osceola, Spotted Weasel, John Stink, and Weasel Calf. Also included in the collection are general western American images of rodeos, businesses, churches, street scenes, parades, world's fairs and expositions, stage performances, World War II activities in Panama, and landscapes.
Unpublished finding aid available.

COBB, ISABEL 136
Photograph n.d.
1 item
A color original print of Dr. Isabel Cobb.

COE, MARK 137
Photographs and postcards 1905–1965
107 items
Black-and-white and color prints and postcards of street scenes, businesses, parks, government buildings, post offices, banks, houses, schools, refineries, cotton gins, and churches in Ardmore, Indian Territory and Oklahoma. Highlights include the Santa Fe depot, the Carter County courthouse, and the Carnegie Library. The collection also contains images of Turner Falls, Lake Murray, Ardmore Army Air Base, and the Arbuckle Mountains in Oklahoma.
Unpublished finding aid available.

COLCORD, CHARLES FRANCIS (1859–1934) 138
Photographs ca. 1896–1925
6 items
Black-and-white original and copy prints of Charles F. Colcord, his home in Perry, Oklahoma Territory, his mansion in Oklahoma City, and a street scene of the Oklahoma City market in 1912.
Unpublished finding aid available.

COLE, C. W. 139
Photographs 1895–1910
18 items
Black-and-white original prints of Altus, Oklahoma Territory and state. The collection includes scenes of ranching, grain elevators, schools, farming, and the storage and moving trade.
Unpublished finding aid available.

COLE, HELEN (1922-2004) **140**
Photographs 1877-1921
73 items
Black-and-white original and copy prints of naturalist and essayist John Burroughs
and his family and friends, including Frank Sanborn, Henry Ford, J. T. Trowbridge,
and Dr. Clara Barrus at each other's homes, and at Walden Pond, Massachusetts,
and Roxbury, New York.
Unpublished finding aid available.

COLEMAN, EMMA ALBERTA WHITE (1863-1949) **141**
Photographs 1889-1915
60 items
Black-and-white original prints by photographer Emma Alberta White Coleman
of Norman, Oklahoma Territory and state, including street scenes, businesses,
schools, parades, firefighters, University of Oklahoma scenes, and the suspension
bridge over the South Canadian River near Noble, Oklahoma Territory. The col-
lection also contains studio portraits of Choctaw Indian women, and of a Choctaw
Indian family in front of their home.
Unpublished finding aid available.

COLLINS RANCH **142**
Photographs 1932-1949
7 items
Black-and-white copy prints of the foremen of Collins Ranch with their horses.
Unpublished finding aid available.

COLLINS, ARZA BAILEY, and JOHN O. ARNOLD **143**
Photographs 1893-1930
78 items
Black-and-white original prints of Sac and Fox Indians. The collection includes
views of Sac and Fox housing, farms and farming activities, as well as automobiles,
churches, and farm equipment. Sarah Ellis, Silas Grass, Dave Harris, Henry Hunter,
Robert Keokuk, Elmer Manatori, Maggie Mathews, and George Pattock are among
the personalities noted in the collection.
Unpublished finding aid available.

COLLINS, H. DALE 144
Photographs 1948–1989
10 items

Black-and-white and color original prints of Dr. H. Dale Collins in his office and with patients; and Collins family members.
Unpublished finding aid available.

COLLINS, W. H. 145
Photographs 1900–1929
3 items

Black-and-white original prints of miners at the Samples No. 2 Mine and the Masonic Temple on Mt. Moriah, both near McAlester, Oklahoma. The collection also includes a photograph of the attendees at the funeral of Joe McGinnity.
Unpublished finding aid available.

COLLON, JAMES 146
Photographs 1912–1945
612 items

Black-and-white original and copy prints of businesses, tornado damage, and the depot in Lugert, Oklahoma; and images of farming, schools, businesses, agricultural exhibits at a fair; and a World War II scrap metal drive in Altus, Oklahoma. Additional photographs feature numerous scenes of the W. C. Austin Reclamation and Irrigation Project to construct Altus Lake and Dam, including a photograph of Franklin D. Roosevelt shaking hands with Jed Johnson.
Unpublished finding aid available.

COLLUMS, GARNER G. 147
Photographs 1911–1949
8 items

Black-and-white original prints of students, staff, Boyd House, and the 1949 football team at the University of Oklahoma; the Episcopal church in Chickasha, Oklahoma; and the judging of cattle at an Oklahoma state meeting of Future Farmers of America.
Unpublished finding aid available.

COLORADO MINING COLLECTION 148
Photographs 1907
118 items
Black-and-white original prints of mines and mining at Colorado Springs, Cripple Creek, Leadville, Pueblo, and Victor, Colorado. The collection also contains scenes of Pike's Peak, the Rocky Mountains, cattle ranching, and an electric power plant near Cañon City in Colorado.
Unpublished finding aid available.

COMBEST, GEORGE MARION (1866–1926) 149
Photographs 1898–1899
4 items
Black-and-white original prints of Dr. George M. Combest, including scenes of his time in the U.S. Army at Fort Clark, Texas.
Unpublished finding aid available.

CONKLING, RICHARD A. (1885–1952) 150
Photographs 1905–1910
4 items
Black-and-white original prints of the University of Oklahoma orchestra, band, and baseball team.
Unpublished finding aid available.

CONLEY, MABLE 151
Photographs 1900
11 items
Black-and-white copy prints of Custer, Oklahoma Territory, including street scenes, parades, and schools.
Unpublished finding aid available.

CONNOR, WILLIAM J. 152
Photographs 1880–1920
54 items
Black-and-white original prints and tintypes of Caddo, Chippewa, Delaware, Osage, Peoria, Potawatomi, and Quapaw Indians. Also included are scenes of Tulsa, Wyandotte, and Lincolnville, Oklahoma; Topeka, Kansas; and the Carlisle Indian School, with individual portraits of John Beaver, John Crow, John Mohawk, and Joe Whitebird.
Unpublished finding aid available.

COOK, F. L. (d. 1950) 153
Photograph n.d.
1 item
A black-and-white original print of Catherine Brown.

COPELAND, WALTER 154
Photographs ca. 1897
2 items
Black-and-white original prints of Walter Copeland's hardware store at Welch,
Indian Territory, and a scene of ranching activities near Welch.
Unpublished finding aid available.

CORBIN, OUIDA L. 155
Photographs ca. 1890–1928
2 items
Black-and-white copy prints of Mr. and Mrs. William S. Corbin.
Unpublished finding aid available.

CORN HISTORICAL SOCIETY COLLECTION 156
Photographs 1890–1977
180 items
Black-and-white copy prints of the towns of Arapaho, Clinton, Corn, Eakly,
Hooker, and Thomas, Oklahoma, and Goessel, Kansas, including scenes of farms
and farming activities, dust storms, funerals, houses, churches, World War I
soldiers, businesses, factories, tornado damage, and schools. The majority of the
collection is of the Mennonites in Washita County, Oklahoma.
Unpublished finding aid available.

CORNELIUS, E. D. 157
Photograph n.d.
1 item
A black-and-white copy print of a drawing of Choctaw Indian chief Peter Perkins
Pitchlynn.

COTTEN, (Mrs.) CLAUDE 158
Photographs 1900–1927
2 items
Black-and-white original prints of Pauls Valley, Oklahoma, showing a general street
scene, and the downtown area after a 1927 flood.
Unpublished finding aid available.

COURT, NATHAN ALTSHILLER (1881–1968) 159
Photographs 1897–1959
80 items
Black-and-white original prints of schoolchildren and scenes in Poland and Paris, France. This collection also contains images of Sonning-on-Thames, England, and the Baldamus family.
Unpublished finding aid available.

COVEY, ARTHUR S. (1877–1960) 160
Photographs 1880–1920
28 items
Black-and-white original and copy prints of the range cattle industry in Wyoming; bauxite mining in Arkansas; and of Apache, Sioux, and Wichita Indians. The collection also includes a photograph of Covey's drawing of the opening of the Cherokee Outlet to white settlement in 1893.
Unpublished finding aid available.

CRANE, KAREN 161
Photograph 1946
1 item
A black-and-white copy print of Archduke Felix of Austria with Lyle H. Boren and others in Holdenville, Oklahoma.

CREEL, (Mrs.) WILLIAM H. 162
Photographs 1906–1912
7 items
Black-and-white original prints of the University of Oklahoma football team. The collection also includes an image of the interior of a greenhouse in Norman, Oklahoma.
Unpublished finding aid available.

CRISWELL, A. A. 163
Photographs 1880–1908
2 items
Black-and-white original and copy prints of the Seminole Council House and Seminole Nation governor's residence near Wewoka, Indian Territory, along with an image of the first jury convened in Wewoka, Oklahoma.
Unpublished finding aid available.

CROCKETT, NORMAN 164

Photographs ca. 1875–1977

70 items

Black-and-white and color original and copy prints of banks, churches, businesses, buildings, and prominent citizens of the African American communities of Mound Bayou, Mississippi; Boley, Oklahoma; Clearview, Oklahoma; Langston, Oklahoma, including Langston University; and Nicodemus, Kansas. Photographs depict the towns at the time of their founding and also during the 1970s. Individuals pictured include Booker T. Washington, early Boley promoters Thomas M. Haynes and David J. Turner, and Langston leaders Edward P. McCabe, S. Douglas Russell, and Inman E. Page.

Unpublished finding aid available.

CROOK, KENNETH E. 165

Photograph 1910

1 item

A black-and-white original print of postal workers and the post office at Reed, Oklahoma.

CROSS, GEORGE LYNN (1905–1998) 166

Photographs 1890

2 items

Black-and-white copy prints of Quapaw Indians Jack Red Claw and Good Eagle.

CROSTON, GEORGE C. 167

Photograph 1905

1 item

A black-and-white original print of Dr. George C. Croston.

CULL, BOB 168

Photograph n.d.

1 item

A black-and-white original print of flooding in Frederick, Oklahoma.

CUNNINGHAM INDIAN PHOTOGRAPHS COLLECTION 169

Photographs ca. 1860–1960

94 items

Black-and-white copy prints of Apache, Cheyenne-Arapaho, Iowa, Osage, Otoe, Pawnee, and Sioux Indians. Also included in the collection are images of Geronimo; of Quanah Parker's grave at Post Oak Cemetery at Fort Sill, Oklahoma; and of Fort Apache, Arizona.

Unpublished finding aid available.

CUNNINGHAM, ROBERT E. (1906–1991) **170**
Photographs ca. 1870–1938
726 items
Black-and-white original and copy prints of settlers and early residents of towns in Indian Territory and Oklahoma, including American Indians and African Americans. The images depict scenes near the 1889 and 1893 land runs, the oil industry, businesses, schools, farming, voting, the range cattle industry, sod houses, railroad construction, U.S. marshals, photographers and photography studios, and Miller Brothers 101 Ranch industries. Some of the towns featured are Cushing, Guthrie, Jennings, Oklahoma City, Orlando, Paradise, Perkins, Perry, Ripley, Stillwater, Tulsa, and Yale.
Unpublished finding aid available.

CUNNINGHAM, TOM **171**
Photographs 1900–1937
7 items
Black-and-white original prints of Hollis, Oklahoma Territory. Included are scenes of cotton marketing, postal services, the Cunningham family, and blacksmiths.
Unpublished finding aid available.

CUNNINGHAM-DILLON COLLECTION **172**
Photographs 1910–1930
622 items
Black-and-white copy prints by Vince Dillon, photographer of the Miller Brothers 101 Wild West Show and ranch. Included are scenes of farming and ranching operations, circus views, terrapin derbies, cowboys and cowgirls, and Indian performers, along with photographs of Pawnee Bill's Old Town, the Cherokee Strip Cow Punchers Association, the oil industry, and of Ponca City and Fairfax, Oklahoma. Individuals pictured include Joe and Zack Miller; among the tribes represented are the Pawnee, Osage, Iowa, and Ponca.
Unpublished finding aid available.

CUNNINGHAM-FLOWERS COLLECTION **173**
Photographs 1893–1897
26 items
Black-and-white original glass plate negatives and copy prints of photographs made by William Flowers, depicting Iowa, Osage, Otoe, Pawnee, and Sac and Fox Indians. Among the personalities in the collection are Silas Grass, Henry Ingalls, Charlie Pipestem, and Hiram Stark.
Unpublished finding aid available.

CUNNINGHAM-PRETTYMAN COLLECTION 174
Photographs 1880–1910
200 items

Black-and-white original glass plate negatives and copy prints of photographs made by William Prettyman of Apache, Cherokee, Cheyenne, Creek, Iowa, Kaw, Kickapoo, Kiowa, Nez Percé, Osage, Otoe, Pawnee, Ponca, Sac and Fox, Shawnee, Sioux, and Tonkawa Indians. The collection also includes scenes of farming, ranching, wild west shows, railroads, the land run of 1889, oil wells, the Miller Brothers 101 Ranch and Wild West Show, and Guthrie, Oklahoma Territory. Bacon Rind, Eagle Chief, Geronimo, Moses Keokuk, Sitting Bull, Zach Miller, and White Bear are among the individuals noted in the collection.
Unpublished finding aid available.

CURTIS, EDWARD S. (1868–1952) 175
Photographs ca. 1903–1929
40 items

Black-and-white copy prints of images by photographer Edward S. Curtis showing Cheyenne tribal ceremonies, societies, and dances, and the traditional housing types of Indians of the southwestern U.S. Included are photographs of the Cheyenne sun dance, warrior societies, and the individuals Woista and Shot-In-The-Hand.
Unpublished finding aid available.

CUTLIP, C. GUY (1881–1938) 176
Photographs 1866–1932
204 items

Black-and-white original and copy prints of Sayre and Wewoka, Oklahoma, and of Seminole Indians. The collection contains photographs of a 1923 automobile trip through Arizona, California, Colorado, Idaho, Montana, New Mexico, Oregon, Washington, Wyoming, and Canada. Images of Santa Fe, New Mexico, and Yellowstone National Park are also in the collection.
Unpublished finding aid available.

DALBY, P. H. 177
Photographs 1917–1935
7 items

Black-and-white original prints of Dr. P. H. Dalby and his family, along with a panorama of Ramona, Oklahoma.
Unpublished finding aid available.

DALE, EDWARD EVERETT (1879–1972)
Photographs 1878–1940
1,064 items

Black-and-white original and copy prints of Ada, Anadarko, Chickasha, Durant, Edmond, El Reno, Enid, Guthrie, Muskogee, Norman, Oklahoma City, Pawhuska, Tahlequah, Tulsa, Weatherford, and Woodward, Oklahoma; Anadarko and Navajoe, Oklahoma Territory; and Duncan, Spiro, and Okmulgee, Indian Territory. These photographs include street scenes, businesses, theaters, universities, schools, Indian agencies, courthouses, and oil wells. The tribes shown in the photographs are the Apache, Arapaho, Caddo, Chippewa, Cheyenne, Coeur d'Alene, Comanche, Creek, Delaware, Eskimo, Flathead, Havasupi, Hopi, Kalispel, Klamath, Kiowa, Kootenai, Mescalero, Modoc, Navajo, Osage, Paiute, Papago, Pima, Paiute, Quileute, Sac and Fox, Salish, Seminole, Sioux, Spokane, Tonkawa, Umatilla, Ute, Wasco, Wichita, Winnebago, and Yakima. Also seen in the collection are images of Acoma, Isleta, Santa Clara, Santo Domingo, San Juan, and Taos pueblos, and scenes in Santa Fe and Taos, New Mexico. Additional subjects in the collection are post–World War I France, the Washington lumber industry, soil erosion in the United States and abroad, the Miller Brothers 101 Ranch, and the University of Oklahoma. Notable individuals depicted include U.S. Senator Elmer Thomas, Oklahoma governor William J. Holloway, Charles Banks, Quanah Parker, Geronimo, and Frank Canton in the western Philippines.
Unpublished finding aid available.

DALE, ROSALIE GILKEY 179
Photographs 1895–1905
11 items

Black-and-white copy prints of the John Edgar Gilkey family and Edward Everett Dale, along with the towns of Center Point and Norman, Oklahoma Territory.
Unpublished finding aid available.

DALQUEST, (Mrs.) B. L. 180
Photographs ca. 1890–1900
16 items

Black-and-white original prints of writer John Oskison as an undergraduate at Stanford University. Buildings on the Stanford campus are also depicted.
Unpublished finding aid available.

DANNER, CLYDE 181
Photographs n.d.
2 items
Black-and-white original prints of the interior of the Danner Brothers Hardware
Store at Anadarko, Oklahoma.
Unpublished finding aid available.

DARNELL, E. E. 182
Photographs 1909
2 items
Black-and-white original prints of Epworth College of Medicine in Oklahoma
City, Oklahoma, and of E. E. Darnell at an Indian village near Colony, Oklahoma.

DAVIS, GERTRUDE 183
Photograph 1918
1 item
A black-and-white original print of the American Library Association library at
Camp Doniphan, Oklahoma.

DAWSON, J. SILAS 184
Photograph 1949
1 item
A black-and-white original print of J. Silas Dawson and Raymond Dawson with a
hominy block made by a Wyandotte Indian.

DEAL STUDIO COLLECTION 185
Photographs ca. 1906–1936
701 items
Black-and-white original and copy prints of businesses, parades, and street scenes
in Chelsea, Oklahoma, and steam shovels from the Bushyhead and Chelsea coal
companies. Also included are numerous class photographs from Chelsea schools
and Chelsea high school sports teams, and family portraits, and school and church
scenes in Alluwe, Oklahoma. Other scenes depict railroads, floods, bridges, and the
oil industry in Oklahoma, the ranch owned by Will Rogers's parents near Chelsea,
and a stone memorial erected in Rogers's honor in Oologah, Oklahoma.
Unpublished finding aid available.

DEAN, LLOYD E. 186
Photographs ca. 1890–ca. 1920
3 items
Black-and-white copy prints of University of Oklahoma alumnus Lloyd E. Dean in
Oklahoma City, Oklahoma; Mary Elizabeth McAfee in Collinsville, Oklahoma; and
Elmo McAfee near the Pryor and Claremore areas of Oklahoma.
Unpublished finding aid available.

DEAN, SAMUEL C. 187
Photograph 1902
1 item
A black-and-white original print of Dr. S. C. Dean in a horse-drawn buggy.

DEASON, (Mrs.) S. J. 188
Photographs 1900–1920
12 items
Black-and-white original prints of Arapaho, Oklahoma Territory and state, includ-
ing photographs of businesses, street scenes, parades, and a reunion of Union and
Confederate veterans.
Unpublished finding aid available.

DeBARR, EDWIN C. (1859–1950) 189
Photographs 1890–1920
30 items
Black-and-white original prints of Edwin C. DeBarr, and scenes of the University of
Oklahoma, the Hudson River, and landscapes near Niagara Falls, New York.
Unpublished finding aid available.

DeBORD, A. LELAND 190
Photographs 1904–1914
16 items
Black-and-white copy prints of schools in Custer County, Oklahoma. The collec-
tion also includes photographs of the towns of Butler, Custer City, and Eureka,
Oklahoma, along with images of farms and mail carriers.
Unpublished finding aid available.

DeCAMP CONSOLIDATED GLASS CASKET COMPANY COLLECTION 191
Photographs 1930
4 items
Black-and-white original prints of the DeCamp Consolidated Glass Casket Company of Muskogee, Oklahoma, and scenes of a stockholders' meeting.
Unpublished finding aid available.

DECKER, CHARLES ELIJAH (1868–1958) 192
Photographs ca. 1927–1930
46 items
Black-and-white original prints of glaciers and mountains in Colorado, and land formations near Clayton, Overbrook, and El Reno, Oklahoma, and the Arbuckle Mountains. Photographs of fossils and dinosaur bones are also included.
Unpublished finding aid available.

DEEDS, HELEN 193
Photographs 1900–1930
6 items
Black-and-white copy prints of Czech Americans in Oklahoma. Scenes feature a butcher shop, musicians, a wedding, and family portraits.
Unpublished finding aid available.

DENNIS, FRANK LANDT, SR. (b. 1907) 194
Photographs 1927–1985
203 items
Black-and-white original prints of Frank L. Dennis and classmates at the University of Oklahoma. Included are photographs of the campus and campus events, fraternities, sororities, athletic events, and Norman, Oklahoma. Personalities in the collection are Carleton Ross Hume, John Jacobs, Savoie Lottinville, Harold Keith, and Hal Muldrow.
Unpublished finding aid available.

DENVER, JAMES WILLIAM (1817–1892) 195
Photograph ca. 1884
1 item
A black-and-white original print of General James W. Denver, a Union Civil War veteran and politician.

DEPENBRINK, ADA 196
Photographs 1902–1909
13 items

Black-and-white copy prints of Anadarko and Binger, Oklahoma, including businesses, railroads and railroad depots, social activities, and family portraits.
Unpublished finding aid available.

DES CHAMPS, JOHN LEFEBER 197
Photographs ca. 1875–1963
239 items

Black-and-white original and copy prints of train depots in Oklahoma, Kansas, and Arkansas, and engines from the Midland Valley Railroad Company and from the Kansas, Oklahoma & Gulf Railroad Company. Also included are photographs of railroad employees, railcars, work crews, and train wrecks.
Unpublished finding aid available.

DETRICK, C. H. 198
Photographs 1880–1930
16 items

Black-and-white original prints of Apache, Comanche, and Kiowa Indians, including Geronimo, Quanah Parker, Big Tree, White Wolf, and the Indian school at Fort Sill, Oklahoma Territory.
Unpublished finding aid available.

DEUPREE, WILLIAM 199
Photograph ca. 1900
1 item

A black-and-white copy print of a cattle roundup at Carpenters Ranch in the Osage Nation.

DeVENNEY, SAM 200
Photographs ca. 1910–1930
65 items

Black-and-white copy prints of Comanche Indians at Cache Creek Mission near Apache, Oklahoma. The collection also includes photographs of a parade at Craterville Park, students at Carlisle Indian Industrial School in Pennsylvania, Creek stickball players and dancers, and studio portraits of Kiowa Indians.
Unpublished finding aid available.

Photographs 1890–1915

21 items

Black-and-white copy prints of homesteads, farms, law enforcement, and farming activities in Dewey County, Oklahoma; the towns of Camargo, Putman, Seiling, and Taloga, Oklahoma, with business and transportation scenes; and personalities including Frank Butler, Mary and Otto Dickens, John Kimball, Tom Parkhurst, Milo Shepherd, and Wilbur Weir.

Unpublished finding aid available.

DIVISION OF MANUSCRIPTS COLLECTION 202
Photographs 1880–1955

576 items

Black-and-white original and copy prints of Apache, Cherokee, Cheyenne, Choctaw, Comanche, Creek, Kiowa, Osage, Otoe, and Sioux Indians. Also included are scenes from the Indian Territory towns of Century, Coalgate, Lehigh, Purcell, and Tahlequah; the Oklahoma Territory towns of El Reno, Guthrie, Lexington, Norman, and Oklahoma City; and the Oklahoma towns of Bartlesville, Blackburn, Coyle, Davis, Fort Gibson, Guthrie, Henryetta, Holdenville, Hollis, Lawton, Maysville, Merrick, Muskogee, Norman, Oklahoma City, Pawhuska, Quapaw, Schulter, Spivey, Stilwell, Walters, and Watonga. Other photographs depict settlers, cowboys, range cattle, buffalo, businesses, schools, mining, military scenes, the Miller Brothers 101 Ranch, Fort Sill and Fort Davis, Spiro Mounds, Indian agencies, and the University of Oklahoma campus. Notable individuals included in the collection are William F. Cody, Frank Eaton, Geronimo, Robert S. Kerr, Josh Lee, Gordon W. Lillie, William Barclay Masterson, Bennie Owen, Quanah Parker, David L. Payne, Peter P. Pitchlynn, Roan Chief, Alice M. Robertson, Carl Sweezy, Ross Rizley, and Elmer Thomas.

Unpublished finding aid available.

DIVISION OF MANUSCRIPTS–SOUTHWEST 203
OKLAHOMA COLLECTION
Photographs ca. 1900–1965

1,268 items

Black-and-white original and copy prints of Apache, Kiowa, Comanche, Kiowa-Apache, and Sioux Indians. Some prominent individuals pictured are Quanah Parker, Geronimo, Hunting Horse, Lone Wolf, White Buffalo, White Bull, and Spencer Asah. Also included are images of churches, dancers, Deyo Mission, Craterville Park, Fort Sill Indian School, and Post Oak Mission in Indiahoma, Oklahoma.

Unpublished finding aid available.

DOBSON, GLADYS 204
Photographs 1893–1918
216 items
Black-and-white copy prints of the Haskins family. The collection includes homesteading and farming scenes in the Cherokee Outlet, and photographs of airplanes and automobiles.
Unpublished finding aid available.

DONNELLEY, HERNDON FORD (1900–2000) 205
Photographs 1905–1977
15 items
Black-and-white copy prints of Enid and Helena, Oklahoma, and of the H. F. Donnelley family. Some photographs include scenes of businesses, airplanes, and U.S. Army infantry.
Unpublished finding aid available.

DORRANCE, LEMUEL (1876–1921) 206
Photographs 1896–1915
5 items
Black-and-white original prints of Lemuel Dorrance, the first graduate of the University of Oklahoma School of Pharmacy.
Unpublished finding aid available.

DRAKE, NOAH FIELDS (1864–1945) 207
Photographs ca. 1935
12 items
Black-and-white original prints of landscape scenes near Carlsbad, New Mexico, and in China and of rural Chinese, taken while Dr. Drake taught in China.
Unpublished finding aid available.

DRUMRIGHT, EVERETT F. (1907–1993) 208
Photographs ca. 1910–1994
190 items
Black-and-white and color original and copy prints of Everett F. Drumright, U.S. Ambassador to Taiwan, his wife Florence Teets Drumright, and their families and scenes from his career in the Foreign Service. This collection includes images of military and commercial airplanes, airports, the Aviation Writers Association, the Drumright wedding ceremony, and the China Foundation. Locations include New York City, South Korea, Japan, China, Taiwan, Germany, India, Hawaii, and California. Noted personalities are Dwight D. Eisenhower, Chiang Kai-Shek,

Madame Kai-Shek, George Yeh, Margaret Bourke-White, and John Dulles; plus images of members of the United States armed forces and foreign service. *Unpublished finding aid available.*

DUFF, H. R. 209
Photograph 1921
1 item
A black-and-white original print of a parade float representing the Gilkey-Jarboe Hardware Company, Lawton, Oklahoma.

DUKE, DORIS (1912–1993) 210
Photographs 1967
6 items
Color original prints of Choctaw Indians who participated in the Doris Duke Oral History Project in Oklahoma. The informants include Georgia Carnes, Peter W. Hudson, Ed O. Oakes, Bob Philip, Nancy and Elizabeth Thompson, and Emma Wesley.
Unpublished finding aid available.

DUNCAN, HANK 211
Photographs ca. 1930
2 items
Black-and-white original prints of miners at the lead and zinc mines near Picher, Oklahoma.
Unpublished finding aid available.

DUNN, JOHN 212
Photographs 1890–1910
46 items
Black-and-white copy prints of Norman, Oklahoma Territory and state, including street scenes, businesses, parades, and schools.
Unpublished finding aid available.

DURHAM, (Mrs.) W. F. 213
Photographs n.d.
3 items
Black-and-white original prints of Mrs. W. F. Durham, Pottawatomie County Historical Society president, along with an interior scene of the society headquarters, formerly a Quaker Mission, at Shawnee, Oklahoma.
Unpublished finding aid available.

DWIGHT MISSION COLLECTION 214
Photograph ca. 1863
1 item
A hand-colored original print of Charles Cutter Torrey, a missionary at Dwight Mission, Indian Territory, during the Civil War years.

EASLEY, JOHN F. 215
Photographs 1896–1936
19 items
Black-and-white original prints of businesses, law enforcement, and a music band in Ardmore, Indian Territory and Oklahoma, along with photographs of Lake Murray, the Arbuckle Mountains, Devil's Den, and Platt National Park. The collection also includes scenes of damage from a gasoline explosion at Ardmore, Oklahoma, in 1915.
Unpublished finding aid available.

EASTMAN, FRANCIS B. 216
Photographs 1917
4 items
Black-and-white original prints of the U.S. Army at Camp William H. Taft, Toledo, Ohio.
Unpublished finding aid available.

EDWARDS, THOMAS ALLISON (1874–1955) 217
Photographs 1898
2 items
Black-and-white original and copy prints of a sod house and of the courthouse for Washita County, then located at Cloud Chief, Oklahoma Territory.

EDWARDS, W. T. 218
Photograph ca. 1910
7 items
Black-and-white copy prints of the Pocahontas Producing coal mine near Dow, Oklahoma, including buildings, miners, and coal mining operations.
Unpublished finding aid available.

ELKINS, HARRISON M. 219
Photograph n.d.
1 item
A black-and-white original print of the Harrison M. Elkins family.

ELLINGER, RALPH F. 220
Photograph 1910
1 item
A black-and-white original panorama of Main Street in Purcell, Oklahoma.

ELLIOTT, JAMES FORD 221
Photographs 1894–1911
5 items
Black-and-white copy prints of Oklahoma mines and miners, and a photograph of Fort Sill troops sent to a miners' strike in 1894 in Krebs, Indian Territory.
Unpublished finding aid available.

ENIX, RALPH 222
Photographs 1902–1926
37 items
Black-and-white copy prints of drugstore interiors, and the towns of Carnegie and Walters, Oklahoma Territory, and Ponca City and Yale, Oklahoma.
Unpublished finding aid available.

ERDMANN, E. M. 223
Photographs ca. 1880
2 items
Black-and-white original prints of a group of soldiers encamped at Sweet Springs, Missouri.
Unpublished finding aid available.

EVANS, ARTHUR W. 224
Photographs 1890–1916
21 items
Black-and-white original prints of former University of Oklahoma president Arthur Grant Evans, the Evans family, and Monnet Hall at the University of Oklahoma. Also included in the collection are photographs of El Montecito Presbyterian Church in Montecito, California, where Rev. A. Grant Evans served as pastor during its early years.
Unpublished finding aid available.

EVANS, SAM 225
Photographs 1897–1917
4 items
Black-and-white copy prints of Sam Evans's drugstores in Waukomis and Enid, Oklahoma Territory and state.
Unpublished finding aid available.

Photographs 1895–1964

405 items

Black-and-white original prints, negatives, and postcards of film, television, music, and rodeo performers, and American historical figures. Those pictured include Jimmy Adams, Gracie Allen, Louis Armstrong, Gene Autry, Lucille Ball, Mexican Joe Barrera, Judge Roy Bean, Warren Beatty, Dan Blocker, Doug Blubaugh, Ward Bond, Richard Boone, Matthew Brady, Charles Bronson, Buster Brown, Edgar Burgan, George Burns, Bruce Cabot, James Cagney, Rory Calhoun, Greer Garson, Jack Carson, Jeff Chandler, William F. Cody, Tex Cooper, Wendell Corey, Ken Curtis, Jane Darvell, Joan Davis, Dolores del Rio, Jack Dempsey, Andy Devine, Vince Dillon, Fats Domino, Clint Eastwood, Albert Einstein, Dwight D. Eisenhower, Wild Bill Elliot, Alice Faye, Wallace Ford, Henry Ford, Kay Francis, Sidney Franklin, Judy Garland, James Garner, John Nance Garner, Barry Goldwater, Henry Grammer, Ulysses S. Grant, Katherine Grayson, Monte Hale, Gabby Hayes, Fox Hastings, Hugh Herbert, John Hodiak, Bob Hope, Hubert H. Humphrey, Ben Johnson, Jr., Lyndon B. Johnson, Claudia "Lady Bird" Johnson, Buck Jones, Danny Kaye, John F. Kennedy, Guy Kibbee, Wayne King, Jackie Laird, Lash La Rue Stan Laurel, Buck LeGrand, Little Richard, Joe Louis, Judy Lynn, Dorothy Malone, Jayne Mansfield, Victor Mature, Richard Gordon Matzene, Tim McCoy, Jeanette MacDonald, Victor McLaughlin, Ezra Meeker, Una Merkel, Robert Mitchum, Tom Mix, Paul Mix, Chester Morris, Wayne Morris, Lucille Mulhall, Zach Mulhall, Audie Murphy, Willie Nelson, Admiral Chester Nimitz, Annie Oakley, George O'Brien, Pat O'Brien, W. Lee O'Daniel, General John J. Pershing, Frank Phillips, Slim Pickens, Bill Pickett, Pistol Pete, Tyrone Power, Robert Preston, Ray Price, Jack Quait, Claude Rains, Sam Rayburn, Ruth Roach, Pernell Roberts, Dale Robertson, Bill Robinson, Will Rogers, Gilbert Roland, Sigmund Romberg, Mickey Rooney, Paddy Ryan, Robert Ryan, Zachary Scott, Tom Selleck, Allen Shepard, Charley Shultz, Floyd Shultz, Guy Shultz, Frank Sinatra, Robert Slick, John Philip Sousa, Adlai Stevenson, Jimmy Stewart, Gail Storm, Pancho Villa, John Wayne, Jim White, Bob Wills, Chill Wills, Keenan Wynn, and Dick Yeager. *Unpublished finding aid available.*

FALCONER R SERIES COLLECTION 227

Photographs 1918–1959

85 items

Black-and-white original prints of the Ponca City Round Up, rodeo events, cowboys and the range cattle industry, the Miller Brothers 101 Ranch, and the Townsend and Pickett's Ranch. This collection contains images of many rodeo personalities, such as Jim Shoulders, Pancho Villa, Ben Johnson, Zack Miller, Shorty Shultz, and Buck LeGrand. *Unpublished finding aid available.*

FALCONER, RAY 228
Photographs 1889–1938
426 items
Black-and-white original glass plate negative and copy prints by William Pretty-man of settlers during the 1889 and 1893 Oklahoma land runs, including Guthrie and Oklahoma City, Oklahoma Territory. Also included are Prettyman plates of Caddo, Comanche, Kaw, Osage, Otoe, Pawnee, and Ponca Indians, as well as original Edward S. Curtis glass plate negatives of Hopi, Salish, and Tahiltan Indians. Other photographs include scenes related to the Miller Brothers 101 Ranch, such as the wild west show and performers, the ranch complex, the filming of a movie on the ranch, and photographs of Joe Miller, G. W. Lillie, and Lew Wentz. Studio portraits of African American settlers supplement the collection.
Unpublished finding aid available.

FALCONER, VELMA 229
Photographs 1939–1954
64 items
Black-and-white original and copy prints of military, commercial, and private airplanes flying in formation, dropping bombs, wrecked, on aircraft carriers, and on the ground. This collection also includes images of passengers deplaning from Braniff Airways flights, the Ponca City Dodgers baseball team, and the airport, aircraft supply store, and statues in Ponca City, Oklahoma.
Unpublished finding aid available.

FARLEY, ALAN W. 230
Photographs 1870–1903
51 items
Black-and-white original prints of the 1903 flood at Kansas City, Kansas, and a photograph of abolitionist John Brown. The collection also has a number of photographs taken by Andrew J. Russell along the route of the Union Pacific and Central Pacific railroads. The Russell photographs include scenes of the Rocky Mountains; Wyoming Territory; the Mormon Tabernacle in Salt Lake City, Utah Territory; hydraulic gold mining operations in California; railroad construction; railroad rolling-stock; locomotives; bridges; and steamboats.
Unpublished finding aid available.

FARM SECURITY ADMINISTRATION COLLECTION 231
Photographs 1935–1940
44 items
Black-and-white copy prints illustrating the effects of the economic depression in rural Oklahoma. Included are photographs of businesses, educators, farming, labor unions, civic organizations, migrants, dust storms, and foreclosed farms. Places depicted include the towns of Eufaula, McAlester, Muskogee, Sallisaw, Tabor, and Tahlequah; and Cimarron, Cleveland, McIntosh, Muskogee, and Sequoyah counties.
Unpublished finding aid available.

FAUX, KATHLEEN 232
Photographs 1889–1894
126 items
Black-and-white copy prints of Cherokee families, houses, schools, and social gatherings in Indian Territory. Included are photographs of Fort Gibson, the Cherokee Female Seminary, the Cherokee Male Seminary, children and picnics at the Park Hill Mission, Indian Territory, as well as views of stagecoaches and ferries operating in the Cherokee Nation. Additional images show scenes from Portland, Oregon, including battleships and Asian immigrants; and images from New Metlakahtla, Alaska, including wildlife, schools, bands, and the Reverend William Duncan.
Unpublished finding aid available.

FAY, ROBERT O., and HELEN S. FAY 233
Stereograph cards 1904
294 items
Black-and-white original stereograph cards of buildings, exhibits, and scenes from the 1904 World's Fair in St. Louis, Missouri, which celebrated the centennial of the Louisiana Purchase.
Unpublished finding aid available.

FELLOWS, J. E. 234
Photographs n.d.
12 items
Black-and-white and color original prints of the Fellows and Gundrum families in Iowa and Oklahoma.
Unpublished finding aid available.

FERGUSON, WALTER SCOTT (1886–1936) 235
Photographs 1870–1920
861 items
Black-and-white original and copy prints of Oklahoma outlaws, lawmen, agricul-
ture, wild west shows, land openings, businesses, saloons, towns and cities, schools,
settlers, the Miller Brothers 101 Ranch, and members of the state and federal gov-
ernment and the U.S. Army. Some of the Oklahoma Territory locations depicted
are Alva, Edmond, Lawton, Orlando, Pawhuska, Perry, Taloga, Watonga, and
Woodward. The tribes represented are the Apache, Arapaho, Cherokee, Cheyenne,
Comanche, Creek, Delaware, Osage, and Seminole. Personalities in this collection
are Bacon Rind, Black Beaver, Black Dog, Jesse Chisholm, Edward Everett Dale,
Angie Debo, Geronimo, William Goldsby, Isparhecher, Isaac Journeycake, William
H. Murray, Quanah Parker, and Will Rogers.
Unpublished finding aid available.

FIELDS, H. W. 236
Photographs 1931
6 items
Black-and-white original prints of lead and zinc mines and mining activity at
Picher, Oklahoma.
Unpublished finding aid available.

FINK, JOHN BERLIN (1886–1960) 237
Photographs 1911–1957
9,051 items
Black-and-white original prints of railroads in Alabama, Arkansas, Florida, Geor-
gia, Illinois, Indiana, Kansas, Kentucky, Louisiana, Mississippi, Missouri, New
York, Ohio, Oklahoma, Pennsylvania, Tennessee, Texas, Washington, D.C., and
Mexico, including scenes of depots, locomotives, rolling stock, bridges, and track.
The collection also contains photographs of numerous cities and towns, industries,
agriculture, businesses, parades, churches, schools, universities, and mining activ-
ities in the same states.
Unpublished finding aid available.

FINK, JOHN BERLIN, POSTCARD COLLECTION (1886–1960) **238**
Postcards n.d.
634 items
Black-and-white and color original postcards of towns, cities, post offices, courthouses, government buildings, parades, mines and mining, state parks, universities, the oil industry, schools, forts, churches, and businesses in Oklahoma, Pennsylvania, South Carolina, South Dakota, Tennessee, and Texas. Also included are postcards of Apache, Cherokee, Comanche, Kiowa, Pawnee, and Sioux Indians.
Unpublished finding aid available.

FINLEY, (Mrs.) C. D. **239**
Photograph 1937
1 item
A black-and-white original print of Owen McHugh of the Hartshorne Coal Company.

FINNEY, THOMAS M., and FRANK F. FINNEY **240**
Photographs 1873–1957
424 items
Black-and-white original and copy prints of Osage tribal leaders, buildings at the Osage agency, and unidentified Indians living in and around Pawhuska and Gray Horse, Oklahoma. The collection also contains photographs of traditional Osage lodges, round houses, and burial sites. Some noteworthy individuals pictured are Ulysses S. Grant, Theodore Roosevelt, Bill Pickett, Ouray, and Will Rogers.
Unpublished finding aid available.

FISHER, ADA LOIS SIPUEL (1924–1995) **241**
Photographs ca. 1945–1960
5 items
Black-and-white copy prints of Ada Lois Sipuel Fisher with N.A.A.C.P. leaders and with University of Oklahoma president George Lynn Cross; and a photograph of George W. McLaurin
Unpublished finding aid available.

FISHER, CLYDE (1878–1941), and TE ATA FISHER (1895–1995) **242**
Photographs 1934
11 items
Black-and-white original prints of the San Ildefonso Pueblo in New Mexico, including scenes of American Indians baking bread and performing an eagle dance.
Unpublished finding aid available.

FISHER, DANIEL G. 243
Photographs 1900–1929
36 items
Black-and-white original and copy prints of turn-of-the-century figures such as
Woodrow Wilson, John D. Rockefeller, and O. Henry. The collection also includes
photographs of the 1914 memorial service in Samoa for Robert Louis Stevenson.
Unpublished finding aid available.

FISHER, TE ATA (1895–1995) 244
Photographs ca. 1900–1980
96 items
Black-and-white and color original and copy prints of Chickasaw actress and
storyteller Te Ata Fisher in traditional American Indian dress in both indoor and
outdoor settings.
Unpublished finding aid available.

FITCH COLLECTION 245
Engravings 1778–1891
205 items
Black-and-white and color engravings of Indians of the Southwest, namely
Pueblo, Hopi, and Navajo. Included are scenes of village life, native dwellings,
individual Indians, and dances. Though less numerous, depictions of hunting and
ceremonies of the Lakota, Blackfeet, Chippewa, and Mandan Indians are also
included in the collection.
Unpublished finding aid available.

FITE, F. B. 246
Photograph 1893
1 item
A black-and-white original print of the first hospital in Muskogee, Indian Territory.

FITE, GILBERT C. (1918–2010) 247
Photographs ca. 1920–1945
72 items
Black-and-white original and copy prints of Mount Rushmore before, during,
and after construction. Included are close photographs of the presidents' faces,
workers drilling and blasting to shape the likenesses, and the working models
sculptor Gutzen Borglum used to create Mount Rushmore.
Unpublished finding aid available.

FLETCHER, DAN　　　　　　　　　　　　　　　　　　　　**248**
Photographs 1900–1939
5 items
Black-and-white copy prints of Kiowa Dutch and his son, Pat Mallory.
Unpublished finding aid available.

FLIPPIN, MABELLE　　　　　　　　　　　　　　　　　　**249**
Photograph 1897
1 item
A black-and-white original print of Theodore B. Brewer on the day of his graduation from Vanderbilt University.

FLORA, SNOWDEN DWIGHT (1879–1957)　　　　　　　　**250**
Photographs 1890–1955
829 items
Black-and-white original and copy prints collected by meteorologist Snowden Dwight Flora. The scenes include tornadoes and tornado damage from across the United States, along with photographs of lightning, hailstones, dust storms, waterspouts, snow, and clouds.
Unpublished finding aid available.

FOLSOM TRAINING SCHOOL COLLECTION　　　　　　　**251**
Photographs 1922–1927
199 items
Black-and-white original prints of students and faculty at Folsom Indian Training School in Smithville, Oklahoma. Folsom Training School was established by the Methodist Church, South, for Indian and non-Indian students. The collection includes views of buildings on campus, scenes of students performing chores, and student clubs and athletic teams.
Unpublished finding aid available.

FORBES, ANDREW ALEXANDER (1862–1921)　　　　　　**252**
Photographs 1880–1900
129 items
Black-and-white original prints and glass plate negatives, taken by Andrew Alexander Forbes, of cowboys and the range cattle industry in western Oklahoma and the Texas panhandle. Also included are scenes of Oklahoma City, Oklahoma Territory; sod houses; railroad construction; the U.S. Army; buffalo; and Cheyenne and Sac and Fox Indians.
Unpublished finding aid available.

45th INFANTRY DIVISION COLLECTION 253
Photographs ca. 1897–1978
124 items

Black-and-white copy prints of soldiers of the Oklahoma National Guard in training and in combat, both in Oklahoma and overseas. Included are photographs of artillery, tanks, trenches, fighter planes, and camps.
Unpublished finding aid available.

FOSTER, HENRY VERNON (1875–1939) 254
Photographs ca. 1870–1990
49 items

Black-and-white original and copy prints of Henry Vernon Foster, first president of the Indian Territory Illuminating Oil Company, with his family and business associates. Photographs of oil fields in Seminole, Oklahoma, and on the Osage reservation are also included in the collection.
Unpublished finding aid available.

FRAME, PAUL 255
Photographs 1890–1934
34 items

Black-and-white copy prints of Ardmore, Indian Territory and Oklahoma. Included are scenes of Main Street, businesses, firefighters, a cotton market, parades, and photographs showing the aftermath of a fire that destroyed a large section of Main Street in 1895.
Unpublished finding aid available.

FRANK, IRVIN 256
Photographs 1890–1965
55 items

Black-and-white copy prints of Leo Meyer, an early twentieth-century Oklahoma politician, and of members of the Frank and Meyer families on vacation and at family gatherings. Also included are photographs of Elk City, Erick, and Tulsa, Oklahoma, and of the Tulsa Jewish Community Council.
Unpublished finding aid available.

FRANKLIN, W. A. 257
Photograph 1861
1 item

An original daguerreotype, in an ornate case, of three Confederate soldiers.

FRENCH, (Mrs.) L. A. 258
Photograph 1894
1 item
A black-and-white copy print of the last legal execution in the Choctaw Nation, which occurred at Red Oak, Indian Territory.

FREUDENTHAL, ELSBETH ESTELLE (1902–1953) 259
Photographs ca. 1911–1941
23 items
Black-and-white original and copy prints of early 1900s aircraft and pilots.
Unpublished finding aid available.

FRITZ, JOE 260
Photograph 1950
1 item
A black-and-white original print of two Indian dancers at the annual Quapaw Powwow held at Devil's Promenade, Oklahoma.

FULTON, ELMER LINCOLN 261
Photograph 1950
1 item
A black-and-white original print of Elmer Lincoln Fulton.

GARRETTSON, EARL A. 262
Photographs 1886–1889
17 items
Black-and-white copy prints of the Oklahoma land run of 1889, and scenes of Kingfisher, Oklahoma Territory.
Unpublished finding aid available.

GARRITY, RICHARD T. 263
Photographs 1907–1987
123 items
Black-and-white and color original and copy prints of powwows near Little Axe and Carnegie, Oklahoma, in the late 1970s and early 1980s. Included are photographs of dancers, drummers, and craft booths. The collection also features images of Oklahoma train stations and locomotives used on various railways in the state, and train wrecks near Kellyville (ca. 1920) and Davis (1910).
Unpublished finding aid available.

GARY, RAYMOND DANCEL (1908–1993) **264**
Photographs ca. 1955
2 items
Black-and-white original prints of Raymond Gary, governor of Oklahoma from
1955 to 1959.
Unpublished finding aid available.

GENERAL PERSONALITIES COLLECTION **265**
Photographs 1840–1980
235 items
Black-and-white original and copy prints of individuals, many of whom have his-
torical ties to Indian Territory, Oklahoma Territory, and Oklahoma state, and to
the University of Oklahoma. Included are Walter T. Adair, French Stanton Amos,
John Calhoun Anderson, Charles Apekaum, Kate Barnard, Asa P. Blunt, Elias C.
Boudinot, Billy Bowlegs, David Ross Boyd, Mary A. Boyd, Thomas M. Buffington,
Burning Face, Rube Burrow, Dennis Bushyhead, Mrs. Dennis Bushyhead, Cyrus
Byington, Mrs. Cyrus Byington, Palmer Byrd, Lewis Cass, Samuel Checote, Dave
Clark, Lawrence Wooster Cole, Douglas Hancock Cooper, A. L. Crable, John C.
Cremony, Lorena Cruce, Pauline Cushman, Edwin DeBarr, H. T. Dickerson, Lewis
Downing, John Ellinger, Joel H. Elliot, Tsianina Grayson Fuller, Jim Gaskey, Geron-
imo, W. I. Gilbert, Henry Gooding, Thomas P. Gore, Washington Grayson, Anna
Grayson, Walter C. Grayson, William Nelson Greene, David Hall, C. Johnson Har-
ris, J. R. Hogue, Sam Houston, Patrick J. Hurley, Washington Irving, Isparhecher,
Andrew Jackson, Thomas James, Buffalo Jones, Charles Journeycake, Jack Kendall,
Gee Farrar Kingfisher, Charles Joseph Latrobe, Josh Lee, Emil W. Lenders, C. W.
McCune, Tom Maher, J. H. Mashburn, Samuel Houston Mayes, Joel B. Mayes,
Roley McIntosh, Aimee Semple McPherson, George Miller, E. L. Mitchell, Julien C.
Monnet, Bernard Murphy, Mushulatubbee, George Nigh, Grace Dewey Norman,
Opothleyaholo, William H. Osburn, Henry Overholser, Mrs. Henry Overholser,
Robert L. Owen, Pahuska, Francis Parkman, Vernon L. Parrington, Smith Paul,
Sam Paul, Joseph Pawneenopahshe, L. C. Perryman, Bill Pickett, Pleasant Porter,
Push Ma Ta Ha, Bass Reeves, A. H. Reeder, Alexander Reid, Milton W. Reynolds,
William N. Rice, Major Ridge, John Ridge, William Charles Rogers, William P. Ross,
Charley Ross, John Ross, Mary Russel, George Herman "Babe" Ruth, Abraham J.
Seay, Sequoyah, B. A. Shelton, Red Bird Smith, Spring Frog, Elmer Thomas, Charles
Thompson, T. Wyman Thompson, Tooan Tuh, John Tyner, Abel Warren, Mary A.
Warren, Joel Wells, Dell Wells, Charles "Bud" Wilkinson, George T. Wilson, Samuel
A. Worcester, Muriel H. Wright, and Yellow Wolf.
Unpublished finding aid available.

GENERAL REDCORN 266
Photographs 1880–1910
64 items
Black-and-white copy prints and original glass plate negatives of Caddo and Osage Indians, of outlaws, and of Hominy, Oklahoma.
Unpublished finding aid available.

GENSMAN, L. M. 267
Photographs ca. 1901–1940
3 items
Black-and-white original prints of a group of Kiowa, Apache, and Comanche Indians standing outside a building in Lawton, Oklahoma. Some of the more prominent individuals pictured are Chief Lonewolf (Kiowa), Herman Asenap (Comanche), Lewis Ware (Kiowa), and Apache Ben (Apache).
Unpublished finding aid available.

GENTRY, ENYARD W. 268
Photographs 1890–1945
161 items
Black-and-white copy prints of Porum, Indian Territory and Oklahoma, including photographs of businesses, railroads, schoolchildren, farming, ranching, mining, and family portraits.
Unpublished finding aid available.

GERNAND, BRAD 269
Photographs 1911–1952
16 items
Black-and-white original and copy prints of the Gernand family, who settled in Pushmataha County in present-day Oklahoma in the early 1900s.
Unpublished finding aid available.

GIBSON, ARMAND E. 270
Photographs 1890–1920
27 items
Black-and-white copy prints of Dustin, Indian Territory and Oklahoma, including scenes of businesses, railroads, farming, and cotton gins. The collection also contains a scene of Cromwell, Oklahoma, and a photograph of Creek Indians.
Unpublished finding aid available.

GIBSON, ARRELL M. (1921–1987) 271
Photographs 1897–1957
42 items
Black-and-white original and copy prints of Kickapoo Indians from Kansas, Oklahoma, and Mexico, as well as Kickapoo bark lodges.
Unpublished finding aid available.

GIBSON, J. W. 272
Photograph 1900
1 item
A black-and-white original print of the National Hotel at Pauls Valley, Indian Territory.

GIBSON, (Mrs.) W. D. 273
Photographs 1900–1908
2 items
Black-and-white original prints of Pauls Valley, Indian Territory and Oklahoma, and members of the Knights of Pythias organization.

GIEZENTANNER, MARGUERITE (1901–1994) 274
Photographs 1920–1925
382 items
Black-and-white original prints of University of Oklahoma alumna Marguerite Giezentanner, members of her family, and friends. The collection centers on scenes of 1920s-era student life and buildings at the University of Oklahoma in Norman, Oklahoma; and views of buildings at the University of Chicago and tourist destinations in Chicago, Illinois. Individuals pictured include Marguerite's brothers Archie, Dudgeon "Dud," Irvin, and Maurice Giezentanner; and Dorothy Biglow, Edna Blanchard, Rachel Brooks, Audry May Floyd, John Hervey, Virginia Schmuels, Vern Thornton, Eloise Wilson, and others.
Unpublished finding aid available.

GILBERT, H. F. 275
Photographs 1898–1942
40 items
Black-and-white original prints of Comanche and Kiowa Indians, along with photographs of their churches, missions, and baptismal scenes in western Oklahoma.
Unpublished finding aid available.

GILMER, DIXIE 276
Photograph n.d.
1 item
A black-and-white original print of Dixie Gilmer.

GITTINGER, ROY (1878–1957) 277
Photograph ca. 1950
1 item
A black-and-white copy print of the ceremony to announce the release of Roy Gittinger's book, *The University of Oklahoma: A History of Fifty Years, 1892–1942.*

GIVEN FAMILY COLLECTION 278
Photographs 1909–1913
156 items
Black-and-white original prints of Comanche Indians, Red Stone Baptist Mission, Fort Sill Indian School, and members of the Given family.
Unpublished finding aid available.

GLASBY, STEPHEN KIRK 279
Photographs 1901–1930
29 items
Black-and-white copy prints of the Glasby family. Included in the collection are scenes of Lawton, Oklahoma Territory and state; Fort Sill, Oklahoma; businesses; and an oil well.
Unpublished finding aid available.

GOINS, CHARLES R., and JOHN W. MORRIS 280
Photographs 1970–1980
3,099 items
Black-and-white original 35mm negatives of homes in Oklahoma, photographed by Goins and Morris for selected use in their book entitled *Oklahoma Homes: Past and Present.* Included are photographs of homes in Oklahoma towns and cities.
Unpublished finding aid available.

GOOD, NANCYE 281
Photograph n.d.
1 item
A black-and-white original print of Oklahoma Governor John C. (Jack) Walton.

GOODLAND INDIAN SCHOOL COLLECTION 282
Photographs 1850–1984
78 items
Black-and-white copy prints of the students, faculty, and campus of the Goodland Indian School near Hugo, Oklahoma.
Unpublished finding aid available.

GORE, THOMAS P. (1870–1949) 283
Photographs 1910–1949
15 items
Black-and-white original and copy prints of U.S. Senator Thomas P. Gore (Democrat, Oklahoma).
Unpublished finding aid available.

GOULD, CHARLES NEWTON (1868–1949) 284
Photographs 1900–1940
1,399 items
Black-and-white original prints of University of Oklahoma geology professor Charles N. Gould; the first university-sponsored geological field trip in Oklahoma; and the first geology classes and library at the University of Oklahoma. The collection includes photographs of geology conferences held in Colorado, Oklahoma, New Mexico, and Texas. Numerous photographs of the Gould family are also in the collection.
Unpublished finding aid available.

GOULD, (Mrs.) M. J. 285
Photographs 1900–1903
5 items
Black-and-white original prints of Hollis, Oklahoma Territory. The collection includes street scenes and businesses.
Unpublished finding aid available.

GOVERNMENT DEPARTMENT COLLECTION 286
Photograph ca. 1940
1 item
A black-and-white original print of French Stanton Evans Amos, one of the University of Oklahoma's first faculty members.

GRASS, PATTY, and FRANK GRASS 287
Photographs 1890–1930
66 items
Black-and-white original prints of L. E. Patterson's feather business in Texas, and of his streetcar line in Norman, Oklahoma City, and Sulphur, Oklahoma. The collection also contains photographs of Oklahoma City, Oklahoma, and Austin and Pecos, Texas, including business scenes in those cities.
Unpublished finding aid available.

GRAY, H. O. 288
Photographs ca. 1937–1941
76 items
Black-and-white original prints of mining equipment, smelting plants, and workers at zinc and lead mines in Oklahoma.
Unpublished finding aid available.

GRAY, MELVIN 289
Photograph ca. 1900
1 item
A black-and-white original print of Dr. Melvin Gray.

GREASEWOOD INDIAN DAY SCHOOL COLLECTION 290
Photographs 1936
29 items
Black-and-white original prints of the Greasewood Indian Day School, Navajo Reservation, Arizona. Includes photographs of students, school activities, weaving classes, playground games, and Navajo hogans. Among the individuals pictured are Mr. and Mrs. Ralph Chee, Francis and Johnson Yazzie, Hosteen Begay and family, and Mrs. San Joe.
Unpublished finding aid available.

GREENSHIELDS, TEA, and ALTHA GREENSHIELDS 291
Photograph ca. 1930
1 item
A black-and-white copy print of the Greenshields Typewriter Company building in Norman, Oklahoma.

GRIFFIS, MOLLY LEVITE 292
Photographs 1900–1964
25 items
Black-and-white copy prints of the Levite family and of Apache, Oklahoma. The collection includes photographs of schoolchildren, street scenes, and Levite's store at Apache.
Unpublished finding aid available.

GRIFFITTS, (Mrs.) JAMES ADDISON 293
Photographs 1880–1920
8 items
Black-and-white original prints of the Griffitts family and the Society of Friends (Quaker) school at Hillside Mission, Indian Territory.
Unpublished finding aid available.

GRISSO, WALKER D. (1905–1965) 294
Photographs 1872–1900
6 items
Black-and-white copy prints of the Cherokee Nation Senate and the Cherokee Nation Council. Personalities included in the collection are Jackson Christie, T. B. Downing, William Mayes, George McDaniel, William Rogers, Henry Ross, William P. Ross, Frog Sixkiller, Red Bird Smith, James Starr, Washington Swimmer, D. W. Vann, and Stand Watie.
Unpublished finding aid available.

GROVES, ELVA 295
Photographs 1886–1919
20 items
Black-and-white original prints, mostly of cowboys and cattle, farms and farmers, railroad depots, and rolling stock, in and around Wray, Colorado. The collection also includes photographs of Geronimo; of a bridge across the Brazos River that had been damaged by stampeding cattle; and of the interior of a mine near Cripple Creek, Colorado.
Unpublished finding aid available.

GUTHRIE PUBLIC LIBRARY COLLECTION 296
Photographs 1900–1919
20 items
Black-and-white copy prints of African Americans in Guthrie, Oklahoma, including studio portraits and businesses.
Unpublished finding aid available.

HADSELL, SARDIS ROY (1876–1942) 297
Photographs 1895–1918
42 items
Black-and-white original prints of Norman, Oklahoma Territory, and the University of Oklahoma, including photographs of campus buildings, students, faculty, university regents and presidents, and athletic events.
Unpublished finding aid available.

HAINER, BAYARD TAYLOR (1866–1933) 298
Photographs 1880–1933
6 items
Black-and-white original prints of Bayard T. Hainer, Sr., and Bayard T. Hainer, Jr.; and of the Hainer home at Perry, Oklahoma Territory. The collection also includes photographs of presidents Franklin D. Roosevelt, Warren G. Harding, Woodrow Wilson, and Herbert Hoover.
Unpublished finding aid available.

HALL, ALBERT 299
Photographs 1902–1938
179 items
Black-and-white original prints of American Indians, including Caddo, Cheyenne, Hopi, Kiowa, Menominee, Navajo, Pueblo, and Sioux; airplanes; baseball players; Belle Starr; businesses; cowboys; the land run of 1889; mining operations in Nome, Alaska; mining; schools; soldiers; street scenes; tornado damage in Duke, Oklahoma; the Anadarko Indian Fair in Anadarko, Oklahoma; Baxter, Hawarden, and Smithland, Iowa; Fort Riley, Kansas; Ellsworth, Minnesota; Cameron, Missouri; and Fort Gibson, Fort Sill, and Oklahoma City, Oklahoma.
Unpublished finding aid available.

HALL, HORACE MARK (1854–1945) 300
Photograph n.d.
1 item
A black-and-white copy print of Horace M. Hall at age seventeen.

HALL, JIM, III 301
Photograph ca. 1850
1 item
A black-and-white original print of a cotton gin in Texas.

HALLINEN, JOSEPH EDWARD (1859–1932) 302
Photograph n.d.
1 item
A black-and-white original print of Joseph Edward Hallinen.

HALSELL, HAROLD HALLETT (b. 1892) 303
Photograph 1918
1 item
A black-and-white original print of a Presbyterian church at Beaver, Oklahoma.

HAMILTON, (Mrs.) C. P. 304
Photographs 1910
6 items
Black-and-white original prints of the J. A. Powers and C. P. Hamilton families of
Mangum, Oklahoma, along with photographs of the Hamilton Hardware Store and
a parade of Confederate veterans at Mangum.
Unpublished finding aid available.

HAMILTON, CHARLES W. 305
Photographs 1918–1939
1,176 items
Black-and-white original prints of petroleum industry operations in Mexico and
Venezuela, including photographs of oil wells, storage tanks, pipelines, production
camps, oil-field workers, oil terminals, tankers, and oil company offices. There are
also many photographs of landscapes, transportation, and villages and cities in the
above countries.
Unpublished finding aid available.

HAMILTON, E. B. 306
Photographs 1898–1908
3 items
Black-and-white copy prints of E. B. Hamilton in his drugstore at Wilburton, Okla-
homa, along with a photograph of the McClellan Wilson family.
Unpublished finding aid available.

HANSKA, (Mrs.) LOUIS 307
Photographs 1900–1930
24 items
Black-and-white copy prints of Czech Americans in Oklahoma. The collection
includes images of the Hanska family, wedding portraits, and farming scenes.
Unpublished finding aid available.

HARDIN STUDIO COLLECTION 308

Photographs ca. 1899–1950

170 items

Black-and-white original and copy prints of street scenes, businesses, and workers in Henryetta, Oklahoma. The collection includes photographs of Oklahoma National Guardsmen called to Henryetta to quell the Crazy Snake Rebellion in 1909 and the coal miners' strike in 1925. Other scenes depict coal mining sites and workers.

Unpublished finding aid available.

HARGETT, JAY L. 309

Photographs 1890–1940

24 items

Black-and-white original and copy prints of Cheyenne, Chickasaw, Choctaw, Comanche, Kiowa, and Wichita Indians. The collection also includes scenes of the Choctaw Tribal Council; Muskogee, Indian Territory; and the Goodland Indian School. C. W. Choate, M. H. LeFlore, Green McCurtain, and Quanah Parker are among the personalities represented.

Unpublished finding aid available.

HARRAH HERITAGE AND HISTORICAL SOCIETY COLLECTION 310

Photographs 1895–1940

55 items

Black-and-white original prints of Harrah, Oklahoma Territory and state, and of Polish American families in the Harrah area. Included are street scenes, weddings, businesses, and the Oklahoma Gas and Electric plant at Harrah.

Unpublished finding aid available.

HARRISON, WALTER M. (1888–1961) 311

Photographs 1900–1961

138 items

Black-and-white original and copy prints of Walter Harrison and of his family and friends, including photographs of Robert S. Kerr, Ernest W. Marland, Johnston Murray, William (Alfalfa Bill) Murray, and Will Rogers. The collection also contains scenes of Oklahoma City, Oklahoma.

Unpublished finding aid available.

HART, J. P. 312
Photographs 1929–1931
9 items
Black-and-white copy prints of the buildings at Cantonment, Oklahoma. The collection also contains a photograph of a Cheyenne Indian Sun Dance.
Unpublished finding aid available.

HARVEY, NORA LEE BURGES, and 313
CLARENCE "BADGER" REED HARVEY
Photographs ca. 1910–1914
153 items
Black-and-white original prints of the range cattle industry at Bell Ranch in New Mexico, including images of cowboys, cowgirls, flood damage, and landscapes.
Unpublished finding aid available.

HASKELL, CHARLES NATHANIEL (1860–1933) 314
Photographs 1903–1907
33 items
Black-and-white copy prints of the inauguration of Oklahoma governor Charles N. Haskell and the barbecue celebration that followed the inaugural ceremonies. The collection also includes a photograph of the Sequoyah Convention.
Unpublished finding aid available.

HATFIELD, EDNA GREER PORTER 315
Photographs 1897–1898
2 items
Black-and-white copy prints of Dayton School in Grant County, Oklahoma Territory, and Prairie Center School in Garfield County, Oklahoma Territory.

HAVERSTOCK COLLECTION 316
Photographs 1896–1955
368 items
Black-and-white copy prints of traveling vaudeville shows operated by the Haverstock family. Photographs of the Haverstock family and their performers and workers are included, as well as images of the show tents, trucks, trains, and advertising billboards.
Unpublished finding aid available.

HAWKINS, BRAD 317
Photographs 1932-1951
10 items
Black-and-white original and copy prints of construction on various buildings on the University of Oklahoma campus around 1950, including the student union. Also included is a photo of Will Rogers with a group of unidentified individuals. *Unpublished finding aid available.*

HEALY, FRANK DALE, JR. (1896-1963) 318
Photographs 1886
9 items
Black-and-white copy prints of the Healy Brothers' ranching activities in the Oklahoma panhandle. The collection also includes scenes of Beaver and Woodward, Oklahoma Territory. *Unpublished finding aid available.*

HECK, JESSE W. 319
Photographs 1905-1921
9 items
Black-and-white original prints of the Jess W. Heck family, and the towns of Oklahoma City, Oklahoma Territory; Cushing and Bixby, Oklahoma; and Sapulpa, Indian Territory. *Unpublished finding aid available.*

HEDGES, HOMER 320
Photograph n.d.
1 item
A black-and-white original print of a Catholic church at Eufaula, Oklahoma.

HEFFNER, ROY E. (1895-1949) 321
Photographs 1923-1948
16,743 items
Black-and-white original prints of the University of Oklahoma, and of Oklahoma cities and towns, including Norman, Oklahoma. The university photographs include scenes of the campus; buildings and building construction; university presidents and senior administrators; faculty and staff; students; athletes and athletic events; and public events and programs. Arthur B. Adams, Carl Albert, William Bennett Bizzell, David Ross Boyd, Joseph A. Brandt, William H. Carson, James H. Felgar, Roy Gittinger, Charles N. Gould, Roy Heffner, Savoie Lottinville, William H. Murray, Benjamin Gilbert Owen, Will Rogers, and Guy Y. Williams are among the

individuals represented in this collection. The collection also contains photographs of buildings, businesses, and street scenes from Arapaho, Bessie, Canute, Cleveland, Clinton, Cordell, Corn, Elk City, Guthrie, Norman, Oklahoma City, Tulsa, and Snyder, Oklahoma. Researchers should consult the inventory of this collection for a complete list of the places, events, and personalities in it.
Unpublished finding aid available.

HENDERSON, ARN 322
Photographs ca. 1960
9 items
Black-and-white copy prints of the Bavinger House in Norman, Oklahoma, designed by Bruce Goff for Nancy and Eugene Bavinger.
Unpublished finding aid available.

HENDERSON, HURLEY L. 323
Photographs 1910
25 items
Black-and-white copy prints of Sentinel, Oklahoma, including photographs of street scenes, businesses, farming, cotton gins, and baptisms.
Unpublished finding aid available.

HENNIGH, EARL L. 324
Photograph 1908
1 item
A black-and-white original print of Thomas P. Gore, U.S. senator from Oklahoma.

HENSLEY, CLAUDE 325
Photographs 1875–1891
3 items
Black-and-white copy prints of an architectural drawing of Fort Reno, Oklahoma Territory; a buffalo hunter's camp; and of Sioux Indians skinning a buffalo.
Unpublished finding aid available.

HERBERT, HAROLD HARVEY (1888–1980) 326
Photographs 1916–1964
38 items
Black-and-white original and copy prints of Oklahoma high school track teams, tennis players, and winners of music and voice contests. The collection also includes images of classes, organizations, and the campus of the University of Oklahoma.
Unpublished finding aid available.

HERRING, ALVIN J. (1899–1954) 327
Photographs 1907–1938
74 items
Black-and-white original and copy prints of farming and coal mining near Chelsea, Oklahoma. The collection also includes street scenes in Chelsea.
Unpublished finding aid available.

HEYDRICK, L. C. 328
Photograph 1900
1 item
A black-and-white copy print of Creek Nation council members.

HICKS, LEON M. 329
Photograph 1902
1 item
A black-and-white copy print of Hollis, Oklahoma Territory.

HICKS, TIM 330
Photographs 1895–1929
7 items
Black-and-white copy prints of Ardmore, Oklahoma, and Marietta, Indian Territory. The collection includes photographs of the postal service, businesses, school-children, and members of Woodsmen of the World.
Unpublished finding aid available.

HIGHAM, ANNIE STEWART 331
Photographs 1896
11 items
Black-and-white original prints of Cheyenne, Comanche, Otoe, Ponca, and Sac and Fox Indians. Individual portraits include Comanche Jack and Peter Mitchell.
Unpublished finding aid available.

HILL, (Mrs.) EVANS MONTGOMERY 332
Photographs 1892–1899
7 items
Black-and-white original prints of the University of Oklahoma campus and students.
Unpublished finding aid available.

HILL, (Mrs.) WAYNE 333
Photographs 1880–1900
6 items
Black-and-white original and copy prints of students, faculty, and the campus of Bloomfield Academy, a Chickasaw Indian school for girls in Bryan County, Chickasaw Nation.
Unpublished finding aid available.

HINE, L. T. 334
Photograph n.d.
1 item
A black-and-white original print of Mr. and Mrs. L. T. Hine of Purcell, Indian Territory.

HOBSON, MABEL THACKER (1888–1975) 335
Photographs 1912
5 items
Black-and-white original and copy prints of a class play, and Evans Hall at the University of Oklahoma.
Unpublished finding aid available.

HOFSOMMER, DON L. 336
Photographs 1903–1916
39 items
Black-and-white copy prints of the railroad depots at Byars and Pauls Valley, Indian Territory; Avery, Chuckaho, Cushing, Fairfax, Kaw, Kendrick, Maramec, Meeker, Newkirk, Payson, Quay, Ralston, Remington, Shawnee, Skedee, Sparks, Tecumseh, Uncas, Wanette, and Yale, Oklahoma Territory; and Macomb, Oklahoma. Also included are photographs of locomotives, railroad bridges, and railroad yards.
Unpublished finding aid available.

HOLDEN, LASALLE (ca. 1867–1954) 337
Photographs 1890–1902
5 items
Black-and-white original prints of Bluejacket, Indian Territory. Included in the collection are scenes of farming, schools, businesses, and railroads.
Unpublished finding aid available.

HOLLEM, ANNA IVERSON 338
Photographs 1896–1901
2 items
Black-and-white original prints of a sod schoolhouse in Woods County, Oklahoma, and of the Trekell and Rounds Lumberyard in Lawton, Oklahoma.
Unpublished finding aid available.

HOLLIS PUBLIC LIBRARY COLLECTION 339
Photographs 1878–1966
98 items
Black-and-white copy prints of the towns of Bethel, Dryden, Hollis, Looney, and Metcalf, Oklahoma, including businesses, postal service, farms and farming activities, parades, schools, schoolchildren, and studio portraits of the Hollis family, the Cunningham family, and the Denton family.
Unpublished finding aid available.

HOLLIS, WILLIAM 340
Photographs 1901–1919
17 items
Black-and-white original prints of the Hollis family, and Hollis, Oklahoma Territory and state, including photographs of street scenes, businesses, cotton gins, camp meetings, and statehood day celebrations.
Unpublished finding aid available.

HOLMBERG, GUSTAF FREDRIK (1872–1936) 341
Photograph n.d.
1 item
A black-and-white original print of Carl Bush.

HOLMBOE, JAMES A. 342
Photographs ca. 1912–1919
4 items
Black-and-white original prints of Monnet Hall and Science Hall on the University of Oklahoma campus in Norman, Oklahoma.
Unpublished finding aid available.

HOLMES, HELEN (1915–1997) 343
Photographs ca. 1889–1988
1,790 items
Black-and-white original and copy prints of early Guthrie, Oklahoma, businesses, schools, parks, municipal buildings, and police and fire departments. The collection includes scenes of students at Langston University and photographs taken before the 1889 and 1893 Oklahoma land runs. Street scenes from Coyle, Crescent, Marshall, and Mulhall, Oklahoma are also included.
Unpublished finding aid available.

HOLT COLLECTION 344
Photographs 1910–1945
39 items
Black-and-white copy prints of farm scenes near Guthrie and Davidson, Oklahoma. Members of the Holt family are pictured, as well as various threshing crew members.
Unpublished finding aid available.

HOSS, HENRY SESSLER (1882–1921) 345
Photographs ca. 1895–1930
16 items
Black-and-white original prints of Dr. H. S. Hoss as a young man and at middle age, and photographs of a high school boys' football team and track squad.
Unpublished finding aid available.

HOWARD STUDIO COLLECTION 346
Photographs ca. 1891–1920
11 items
Black-and-white original and copy prints of street scenes in downtown Tulsa, Oklahoma.
Unpublished finding aid available.

HOWSTINE, CY 347
Photograph 1896
1 item
A black-and-white copy print of a loaded freight wagon on the route from El Reno to Cheyenne, Oklahoma Territory.

HUDSON, RALPH 348
Photograph 1915
1 item
A black-and-white original print of the Ardmore, Oklahoma, railroad depot following an explosion and fire.

HUDSON, WADDIE (1865–1954) 349
Photographs 1880–1900
54 items
Black-and-white original and copy prints of Cherokee Indians, the Cherokee Female Seminary, and Tahlequah, Indian Territory. Also included are portraits of U.S. marshals and outlaws. Among the personalities in the collection are William P. Adair, T. M. Buffington, Rabbit Bunch, Dennis Wolf Bushyhead, Ned Christie, William Goldsby, S. H. Mayes, John Ross, William P. Ross, Belle Starr, and Henry Starr. *Unpublished finding aid available.*

HUME, CARLETON ROSS (1878–1960) 350
Photographs 1890–1948
211 items
Black-and-white original and copy prints of Oklahoma attorney for the Caddo Indians, C. Ross Hume, and family and friends. Family members pictured include his brother, Minco physician Raymond R. Hume; his mother, Anadarko photographer Annette Ross Hume; and his father, physician at the Kiowa, Comanche, and Wichita Agency, Dr. Charles R. Hume. The collection features views of early Anadarko, Oklahoma Territory, and the University of Oklahoma, as well as images of Apache, Caddo, Comanche, Kiowa, Mohave, Sioux, and Wichita Indians. Personalities represented are Big Tree, Buffalo Goad, Quanah Parker, Enoch Smokey, Tabawanica, and Towaconie Jim. *Unpublished finding aid available.*

HUME-HAMMOND COLLECTION 351
Negatives ca. 1905–1920s
185 items
Black-and-white glass plate negatives of the Hume family in Anadarko, Oklahoma Territory and state, including photographer Annette Ross Hume, her husband and physician of the Kiowa, Comanche, and Wichita Agency, Dr. Charles R. Hume, and their sons, C. Ross Hume, and Raymond R. Hume. *Unpublished finding aid available.*

HURLEY, PATRICK JAY (1883–1956) 352

Photographs 1900–1956

1,100 items

Black-and-white original and copy prints of Patrick Jay Hurley as assistant U.S. secretary of war and secretary of war, special presidential representative to the Soviet Union, Great Britain, Afghanistan, and the Middle East, and U.S. ambassador to China during World War II. The collection contains scenes of Hurley with Joseph W. Stilwell, Chou En Lai, Mao Tse Tung, Chiang Kai Shek, Douglas MacArthur, Claire Lee Chennault, and Herbert Hoover. Also included are photographs of Secretary of War Hurley's inspection tours of U.S. military installations; suppression of the Bonus Army riots in 1932; Hurley with Japanese military officers; Bacone College in Muskogee, Oklahoma; the towns of McAlester, Oklahoma, and Phillips, Indian Territory; and of personalities including Franklin D. Roosevelt, Charles A. Lindbergh, Amon Carter, Will Rogers, Chester Nimitz, Jonathan Wainwright, Henry Stimson, and William Halsey.

Unpublished finding aid available.

HURST, (Mrs.) MAX M. 353

Photograph ca. 1920

1 item

A black-and-white copy print of an unidentified family standing beside a car.

HUSTON, FRED 354

Photographs 1891–1975

63 items

Black-and-white copy prints of railroad depots in Oklahoma and Kansas, along with scenes of mining settlements and mining in Colorado.

Unpublished finding aid available.

HUTCHINS, ROLLIN 355

Photographs 1890–1907

17 items

Black-and-white copy prints of Anadarko, Oklahoma Territory and state, including photographs of businesses, the railroad depot, parades, street scenes, and Geronimo.

Unpublished finding aid available.

HUTCHISON, L. L. 356
Photographs ca. 1900–1910
50 items
Black-and-white original prints of buildings, students, and professors at the
University of Oklahoma. The collection also includes a photo of the 1909 OU
men's tennis team that Hutchison coached, as well as photographs taken by the
Oklahoma Geological Survey, of which Hutchison was a member.
Unpublished finding aid available.

HUTTO, ROBERT W. (b. 1885) 357
Photograph n.d.
1 item
A black-and-white original print of Robert W. Hutto.

INDIAN SCHOOLS COLLECTION 358
Photographs n.d.
15 items
Black-and-white original and copy prints of the Cherokee Male Seminary and
Cherokee Female Seminary, the Chilocco Indian School, the Chickasaw Orphan-
age, the Rock Academy, the Collins Institute, and the Harley Institute.
Unpublished finding aid available.

INDIAN WAR VETERANS COLLECTION 359
Photographs 1862–1947
82 items
Black-and-white original and copy prints of Indians at the Fort Apache Indian
Reservation in Arizona, and of historic and natural landmarks of Arizona.
Unpublished finding aid available.

INDIANS OF NEVADA COLLECTION 360
Photographs 1870–1940
40 items
A photographic history entitled "Indians of Nevada," composed of forty unbound
photographs from various sources. The collection includes images of Paiute, Sho-
shoni, and Washo Indians.
Unpublished finding aid available.

Photographs 1880–1930
229 items
Black-and-white original prints of Apache, Comanche, Hopi, Kiowa, and Papago
Indians, along with photographs of the Irwin family; Chickasha and Duncan,
Indian Territory; and foothills along the Gila Mountains in Arizona. Also included
are hunting, farming, and business scenes, as well as scenes of ranching and home-
steading in western Texas. Ahpeatone, Geronimo, D. K. Lonewolf, Mabel Mahseet,
Martha Napawat, White Buffalo, and White Wolf are among the individuals repre-
sented in this collection.
Unpublished finding aid available.

IRWIN, THOMAS J. 362
Photographs 1905–1920
12 items
Black-and-white original and copy prints of the Presbyterian church and clergy
in Lawton, Oklahoma. Also included are scenes of Geronimo and other Apache
Indians.
Unpublished finding aid available.

I SEE O (d. 1927) 363
Photographs 1922
5 items
Black-and-white copy prints of the Kiowa scout I See O, including a photograph of
I See O with General John Pershing.
Unpublished finding aid available.

JACK, JESS 364
Photograph n.d.
1 item
A black-and-white copy print of the Johnson house on Elm Street, Norman,
Oklahoma.

JACKSON, SUSU 365
Photographs 1900–1915
9 items
Black-and-white copy prints of schoolchildren at Rocky and Cordell, Oklahoma.
Also included is a photograph of the Rock Mill Custom Grinding Company of
Rocky, Oklahoma.
Unpublished finding aid available.

JACOBSON, OSCAR BROUSSE (1882–1966) 366
Photographs ca. 1925–1950
27 items
Black-and-white original and copy prints of Oscar B. Jacobson, interior and exterior views of his Norman home, and a group photo of four members of the Kiowa Five: Spencer Asah, Jack Hokeah, Stephen Mopope, and Monroe Tsatoke. Also included are photographs of Oklahoma pilot Wiley Post; murals in post offices by Acee Blue Eagle, Randall Davey, and Olive Rush; and a mural by Woody Crumbo at the Department of the Interior Building in Washington, D.C.
Unpublished finding aid available.

JAFFE, ELI (1913–2001) 367
Photographs ca. 1938–1961
21 items
Black-and-white original prints of a community camp in Oklahoma City (1930s), a demonstration by unemployed persons outside the Oklahoma state capitol in 1940, and the Guymon Pioneer Day celebration. Also included is a photo of Eli Jaffe at a White House ceremony for the unveiling of the Eleanor Roosevelt five-cent stamp, at which John F. Kennedy is speaking.
Unpublished finding aid available.

JAMES, LOUISE 368
Photographs 1902–1920
8 items
Black-and-white copy prints of Knowles, Oklahoma, and Taloga, Oklahoma Territory.
Unpublished finding aid available.

JENKS, OZETTA 369
Photographs 1885–1900
2 items
Black-and-white copy prints of a Kickapoo Indian village and the Friends Mission Home at Shawneetown, Indian Territory.

JOHNSON, DOROTHY 370
Photographs ca. 1900
2 items
Black-and-white original prints of lawman Heck Thomas with Captain Frank Daugherty and an unidentified man; and the pall bearers at Thomas's funeral.

JOHNSON, E. B. (Edward Bryant) (1865–1935) 371
Photographs n.d.
35 items
Black-and-white original prints of California towns, missions, and landscapes; federal government buildings in Washington, D.C.; Comanche, Kiowa, and Apache Indians; and President William McKinley.
Unpublished finding aid available.

JOHNSON, E. B., POSTCARD COLLECTION 372
Postcards ca. 1886–1912
486 items
Black-and-white and color postcards of Oklahoma schools, colleges, hotels and resorts, churches, libraries, and municipal buildings. The collection also includes views of parks, schools, hotels, and buildings in California, Illinois, Maryland, Minnesota, Missouri, and Texas.
Unpublished finding aid available.

JOHNSON, EDITH CHERRY (1879–1961) 373
Photographs 1910–1951
18 items
Black-and-white original and copy prints of Edith Cherry Johnson.
Unpublished finding aid available.

JOHNSON, FORREST L. 374
Photographs ca. 1860–1912
2 items
Black-and-white copy prints of the T. J. Johnson family and of two unidentified Civil War soldiers.

JOHNSON, (Mrs.) L. A. 375
Photograph 1910
1 item
A black-and-white original panorama of Mangum, Oklahoma.

JOHNSTON, HENRY SIMPSON (1870–1965) 376
Photographs 1893–1935
88 items
Black-and-white original and copy prints of Henry S. Johnston; of the 1903 Cherokee Strip Celebration at Perry, Oklahoma Territory; and of the towns of Crescent, Durant, El Reno, Henryetta, McLoud, Norman, Oklahoma City, Pawhuska, Seminole, and Shawnee, Oklahoma. The collection also includes photographs of the Miller Brothers 101 Ranch.
Unpublished finding aid available.

JONES, A. D. 377
Photographs 1898–1909
15 items
Black-and-white original prints of Sayre and Weatherford, Oklahoma Territory and state. Included are scenes of schools, businesses, and the football team of Southwestern Normal School at Weatherford, Oklahoma. A photograph of the school at Mountain View, Oklahoma Territory, is also in the collection.
Unpublished finding aid available.

JONES, DOVIE 378
Photographs 1880
2 items
Black-and-white original prints of the Armstrong Academy for Choctaw Indians in Indian Territory, and of Johnson Jacob.

JONES, RICHARD 379
Photographs ca. 1910
3 items
Black-and-white copy prints of the Central Grocery Store in Dillard, Oklahoma.
Unpublished finding aid available.

JORDAN, DICK, STUDIO COLLECTION 380
Photographs 1896–1910
164 items
Black-and-white original prints of Kingfisher, Oklahoma Territory and state, including scenes of businesses, farming, railroads, cotton marketing, firefighters, and schools. The collection also contains a photograph of Omega, Oklahoma.
Unpublished finding aid available.

JORDAN, JOHN D. 381
Photograph n.d.
1 item
A black-and-white copy print of Colonel James M. Bell, First Cherokee Regiment, Confederate States Army.

KAGEY, JOSEPH NEWTON (1890–1959) 382
Photographs 1902–1951
4 items
Black-and-white copy prints of the Seneca Indian School in Indian Territory, and a scene of a flood in Miami, Oklahoma.
Unpublished finding aid available.

KALI-INLA COAL COMPANY COLLECTION 383
Photographs n.d.
24 items
Black-and-white original prints of the mining activities of the Kali-Inla Coal Company.
Unpublished finding aid available.

KANSAS BUSINESS AND PROFESSIONAL 384
WOMEN'S CLUB COLLECTION
Photographs and postcards 1923
310 items
Black-and-white and color original prints and postcards of the Kansas Business and Professional Women's Club during a trip to the Pacific Northwest. Locations and points of interest include Juneau, Ketchikan, Sitka, Skagway, Tenakee Springs, and Wrangell, Alaska; Banff, Alberta; Sicamous and Vancouver, British Columbia; Portland, Oregon; Seattle and Spokane, Washington; the Columbia River Highway; Mount Rainier National Park; coastal scenes; boats; glaciers; mountains; and waterfalls.
Unpublished finding aid available.

KARNS-WOOLLEY COLLECTION 385
Photographs 1893
11 items
Black-and-white copy prints of street scenes in Caldwell, Kansas, before the opening of the Cherokee Outlet in 1893. Other scenes depict trains loaded with people, some of whom are standing on top of the railcars, bound for the Cherokee Outlet.
Unpublished finding aid available.

KAUFMAN, KENNETH CARLYLE (1887–1945) **386**
Photographs n.d.
35 items
Black-and-white original prints of Kenneth Kaufman and several other University of Oklahoma personalities, including William B. Bizzell, Katherine Salter, and Alfred Barnaby Thomas. In addition, the collection contains a photograph of Hydro, Oklahoma.
Unpublished finding aid available.

KEEF, TENIA BETH **387**
Photographs 1895–1938
9 items
Black-and-white copy prints of Krebs, Indian Territory and Oklahoma, including scenes of businesses, athletic events, and mining.
Unpublished finding aid available.

KEITH, HAROLD (1903–1998) **388**
Photographs 1870–1937
45 items
Black-and-white original and copy prints of Will Rogers as a student, as a performer of rope tricks, as a film actor, and with Wiley Post in Alaska. Also included are images of Harold Keith, Vicente Oropezo, and Franklin Delano Roosevelt.
Unpublished finding aid available.

KELLER SEED STORE COLLECTION **389**
Photographs 1925
56 items
Black-and-white original prints of agricultural activities; the Clark & Keller seed store in Shawnee, Oklahoma; and gatherings of the Western Seedmen Association and the Southern Seedmen.
Unpublished finding aid available.

KELLER, CHARLES D. **390**
Photographs 1906–1983
6 items
Black-and-white original prints of the U.S. Army at Fort Riley, Kansas.
Unpublished finding aid available.

KELLY, MARY 391
Photographs 1925
7 items
Black-and-white copy prints of Jesse Kelly, the Kelly Cotton Gin at Canute, Oklahoma, and railroad cars designed for hauling poultry.
Unpublished finding aid available.

KELTNER, PAULA SCHONWALD 392
Photograph 1953
1 item
A black-and-white copy print of Allie Reynolds inspecting an American Indian artifact held by Fred P. Schonwald.

KENNEDY, FRANCES 393
Photographs n.d.
57 items
Black-and-white original prints of contractors and construction scenes in Custer City and Mountain View, Oklahoma. Included are photographs of equipment, construction sites, and workmen building what appear to be commercial buildings and a cistern.
Unpublished finding aid available.

KENNEDY, JOHN 394
Photographs 1915
3 items
Black-and-white copy prints of Purcell, Oklahoma.
Unpublished finding aid available.

KENNEDY, JOHN C. (1910–1993) 395
Photographs 1901–1990
273 items
Black-and-white original prints of businesses, courthouses, parades, schools, banks, street scenes, interurban rail stations, building and road construction, and post offices in Fort Sill, Lawton, and Medicine Park, Oklahoma Territory and state. Also included are images of John C. Kennedy participating in Jimmy Carter's presidential campaign, and later with President Carter on *Air Force One*; serving as a representative at the United Nations; and at events for Goodwill Industries of Southwest Oklahoma and North Texas, Inc., which Kennedy founded in Lawton, Oklahoma. Among the individuals pictured in the collection are Carl Albert, David L. Boren, Fred and LaDonna Harris, Jed Johnson, Ned Shepler, Ray Trent, Andrew Young, and Stanton Young, as well as members of John C. Kennedy's family.
Unpublished finding aid available.

KERLIN, JANICE, and AMY KERLIN **396**
Photographs 1917–1918
2 items
Black-and-white original prints of Helen and Marian Brooks, volunteers with the Norman, Oklahoma, Red Cross chapter.
Unpublished finding aid available.

KERR, BETTY **397**
Photograph n.d.
1 item
A black-and-white original studio portrait of Betty Kerr.

KERR, HARRISON (1897–1978) **398**
Photographs 1947–1948
269 items
Black-and-white original prints of American composer Harrison Kerr and tourist views of many travel destinations he visited during his career. Locales in the United States include Washington, D.C.; Boston, Massachusetts; and New York City, New York. Scenes abroad feature Salzburg, Austria; London and Oxford, England; Paris, France; Kobe, Nara, and Tokyo, Japan; and Seoul, South Korea.
Unpublished finding aid available.

KERR, ROBERT S., JR. (1926–2004) **399**
Photographs 1971–1974
36 items
Black-and-white and color copy prints of the Kiamachi Fish Farm in Talihina, Oklahoma; a meeting of Oklahoma Water, Inc., in Tulsa, Oklahoma; and images of Oklahoma civic leaders Robert S. Kerr, Jr., and Ray Ackerman.
Unpublished finding aid available.

KERR, ROBERT S., SR. (1896–1963) **400**
Photographs n.d.
4 items
Black-and-white original prints of cattle.
Unpublished finding aid available.

KERR-McGEE CORPORATION COLLECTION 401
Photographs 1922–1978
149 items
Black-and-white copy prints of the Kerr-McGee Corporation, including scenes
of mining, oil and gas exploration and production in Alaska, Alabama, Arizona,
California, Florida, Idaho, Louisiana, Mississippi, Missouri, Nevada, New Mexico,
Oklahoma, Texas, Wyoming, Japan, Iran, and the Gulf of Mexico. Also includes
photographs of Dean McGee and Robert Samuel Kerr.
Unpublished finding aid available.

KESSLER, EDWIN, III 402
Photographs 2011
4 items
Color original prints of Dicaperl Minerals Corporation in Noble, Oklahoma,
including buildings and containers of perlite.
Unpublished finding aid available.

KILLINGSWORTH, GEORGE F. 403
Photographs 1903–1934
36 items
Black-and-white copy prints of Seminole, Indian Territory and Oklahoma, and
Davenport, Indian Territory. Included are photographs of businesses, a temperance
meeting, parades, and the oil industry.
Unpublished finding aid available.

KING, (Mrs.) A. J. 404
Photograph 1862
1 item
A black-and-white copy print of Abraham J. Seay, second governor of Oklahoma
Territory.

KING, MICHELLE S. 405
Photograph 1906
1 item
A black-and-white original print of Quanah Parker in a group portrait taken at the
Oklahoma Constitutional Convention in Guthrie, Oklahoma Territory. The others
in the group are unidentified.

KINGFISHER COLLEGE COLLECTION　　　　　　　　　　**406**
Photograph n.d.
1 item
A black-and-white original print of Julius Temple House, president of Kingfisher College from 1895 to 1908.

KIOWA COUNTY (Oklahoma) HISTORICAL　　　　　**407**
SOCIETY COLLECTION
Photographs 1890–1948
347 items
Black-and-white copy prints of the towns of Chickasha, Indian Territory; Hobart, Lone Wolf, Mountain Park, and Sedan, Oklahoma Territory; and Cold Springs, Cooperton, Enid, Hobart, Lone Wolf, Newkirk, and Roosevelt, Oklahoma. Included are photographs of businesses and buildings, farming and farm equipment, railroads and railroad depots, grain storage facilities and cotton gins, funerals, oil fields, and petroleum industry operations. The collection also contains images of Apache, Comanche, and Kiowa Indians, including individual photographs of Delos Lone Wolf, Geronimo, and Quanah Parker.
Unpublished finding aid available.

KIRBY STUDIO COLLECTION　　　　　　　　　　　**408**
Photograph 1906
1 item
A black-and-white copy print of Pauls Valley, Indian Territory.

KOBEL, RALEIGH (1877–1951)　　　　　　　　　　**409**
Photographs 1887–1951
10 items
Black-and-white original prints of the Kobel family and family businesses, and the town of Cookson, Oklahoma.
Unpublished finding aid available.

KRAETTLI, EMIL RUDOLPH (1890–1979)　　　　　　**410**
Photographs 1903–1947
196 items
Black-and-white original prints of the University of Oklahoma, including images of the campus, students, faculty, presidents, board of regents, and university events. The collection also contains scenes of Norman and Oklahoma City, Oklahoma.
Unpublished finding aid available.

KUNZ, GRACE M. 411
Photograph 1894
1 item
A black-and-white original print of a Dewey County, Oklahoma, school and its students.

LAFFERTY, CHARLES 412
Photograph 1893
1 item
A black-and-white copy print of the opening of the land run into the Cherokee Outlet on September 16, 1893.

LAIN, EVERETT S. (1876–1970) 413
Photographs 1893–1918
11 items
Black-and-white original prints of physician and University of Oklahoma School of Medicine professor Dr. Everett S. Lain, including scenes of his medical office. *Unpublished finding aid available.*

LAMERTON, MARGARET R. 414
Photographs 1900–1909
7 items
Black-and-white original prints of John A. Reck's medical office and X-ray machine, and the towns of Enid and Oklahoma City, Oklahoma Territory. *Unpublished finding aid available.*

LAMM, MARY 415
Photographs 1907–1920
7 items
Black-and-white copy prints of German Americans in Elk City and Canute, Oklahoma. Scenes of schools and businesses are included in the collection. *Unpublished finding aid available.*

LATHAM, (Mrs.) EVERETT N. 416
Photographs 1904–1938
28 items
Black-and-white original prints of Denoya, Ponca City, and Purcell, Oklahoma, including photographs of railroads, churches, and parades. The collection also contains images of the Seminole oil field and a flood of the South Canadian River in 1904. *Unpublished finding aid available.*

LAWRENCE, ARTHUR R. 417
Photographs 1905
2 items
Black-and-white copy prints of the Red Store near Lawton, Oklahoma Territory.
Unpublished finding aid available.

LAWTON CHAMBER OF COMMERCE COLLECTION 418
Photographs 1890–1891
25 items
Black-and-white copy prints of railroads and Lawton, Oklahoma Territory, businesses.
Unpublished finding aid available.

LDSH COLLECTION 419
Photographs n.d.
116 items
Black-and-white original and copy prints of unidentified studio portraits, camping scenes, and landscapes.
Unpublished finding aid available.

LEE, (Mrs.) OTTIE 420
Photographs 1890–1947
13 items
Black-and-white original prints of Deputy U.S. Marshal R. Crockett Lee and of other lawmen from the area around McAlester, Indian Territory and Oklahoma, along with scenes of confiscated stills.
Unpublished finding aid available.

LEFLER STUDIO COLLECTION 421
Photographs 1889–1896
6 items
Black-and-white copy prints of Cheyenne Indians, and scenes of settlers near Tipton, Oklahoma Territory, waiting for a land run to begin.
Unpublished finding aid available.

LEGGETT, G. C. (Bishop) 422
Photographs 1922–1941
10 items
Black-and-white negatives of refineries and gasoline plants in Okmulgee, Graham, and Madill, Oklahoma, and Wilson, California; images of Bishop G. C. Leggett, and of wheat harvesting near Avard, Oklahoma.
Unpublished finding aid available.

LENNY AND SAWYERS COLLECTION 423
Photographs 1890–1900
20 items
Black-and-white original prints of Apache, Caddo, Comanche, Kiowa, Otoe, and Wichita Indians, taken at the Lenny and Sawyers Studio in Purcell, Indian Territory. Individual portraits include Big Tree, Faw Faw, White Man, and Wild Horse.
Unpublished finding aid available.

LENSKI, LOIS, POSTCARD COLLECTION 424
Postcards n.d.
1,170 items
Black-and-white and color postcards of scenes throughout the United States and abroad. Many of the postcards are from Arizona, New Mexico, and Oklahoma, showing Cherokee, Hopi, Navajo, Pawnee, and Pueblo Indians. Other states represented in the collection are Alabama, Alaska, California, Connecticut, Florida, Georgia, Illinois, Kentucky, Louisiana, Maine, Maryland, Massachusetts, Michigan, New Hampshire, New York, North Carolina, Ohio, Oregon, Pennsylvania, Rhode Island, South Carolina, South Dakota, Tennessee, Texas, Utah, Vermont, Virginia, Washington, and West Virginia. Areas outside the United States include St. Lawrence, Quebec, and Nova Scotia, Canada; Rotterdam, Holland; Stockholm, Sweden; Tiberias, Israel; and Luxembourg. Subjects include national parks, ghost towns, schools, agricultural activities, churches, the petroleum industry, and Amish children and adults.
Unpublished finding aid available.

LENTZ, DANIEL MORGAN 425
Photographs n.d.
3 items
Black-and-white copy prints of Daniel Morgan Lentz and his wife, Amanda E. Kennedy.
Unpublished finding aid available.

LEVITE, GEORGE WASHINGTON (1893–1975) 426
Photographs 1906–1923
13 items
Black-and-white copy prints of Apache, Oklahoma Territory and state. Included are images of the Levite family; businesses; and football, baseball, and basketball teams.
Unpublished finding aid available.

LEWIS, KATE 427
Photographs 1908–1930
16 items
Black-and-white copy prints of the Broadway Hotel in Okemah, Oklahoma; the Stuart, Oklahoma, school faculty; the basketball teams from Non and Castle, Oklahoma; and the Kelly cotton gin at Canute, Oklahoma.
Unpublished finding aid available.

LIGON, MARY LOUISE 428
Photographs 1880–1920
63 items
Black-and-white original prints of Isaac C. Renfro's vineyard and grape crop; of the mineral water health resorts and fountains at Sulphur, Oklahoma; of Sulphur, Indian Territory; and of Clinton, Oklahoma City, and Weatherford, Oklahoma, including street scenes, businesses, and parades.
Unpublished finding aid available.

LILJEDAHL, R. 429
Photographs ca. 1894–1920
22 items
Black-and-white original prints of Apache Indians at the San Carlos Agency in Arizona. The collection includes photographs of the agency school, of Indians receiving rations, and of the Seventh Cavalry at the agency, under the command of Captain W. Nicholson.
Unpublished finding aid available.

LILLIE, FORESS B. (1885–1926) 430
Photographs 1889–1920
354 items
Black-and-white original and copy prints of the Foress B. Lillie family, and of Guthrie, Oklahoma Territory and state. The collection includes photographs of Guthrie streets and businesses; outlaws; modes of transportation; oil wells; and scenes of places, cities, and towns in California, New York, Massachusetts, and New Jersey.
Unpublished finding aid available.

LILLIE, GORDON WILLIAM (1860–1942) 431
Photographs 1870–1935
417 items
Black-and-white original and copy prints of Gordon W. (Pawnee Bill) Lillie, his
family, friends, and performers in his wild west show. Among the personalities are
May Lillie, Big Strike Ax, William F. Cody, William S. Hart, Lone Bear, Tom Mix,
Will Rogers, and Sun Chief. Also included is a panorama of Gordon W. Lillie and
Pawnee Indians traveling to Herbert Hoover's inauguration, along with scenes of
Osage and Sioux Indian performers.
Unpublished finding aid available.

LINCOLN, MYRTLE (Howling Buffalo) (b. 1888) 432
Photographs 1935–1967
13 items
Black-and-white copy prints of Arapaho Myrtle (Howling Buffalo) Lincoln and
family on their farm near Cantonment, Oklahoma.
Unpublished finding aid available.

LININGER, HERBERT K. (1889–1953) 433
Photographs 1893–1935
25 items
Black-and-white original prints of Duncan, El Reno, Fort Reno, Oklahoma City,
and Perry, Oklahoma Territory; and of Marlow and Ardmore, Indian Territory. The
photographs include street scenes and businesses, and a dust storm at Boise City,
Oklahoma.
Unpublished finding aid available.

LITTLEMAN, ALICE (1910–2000) 434
Photographs ca. 1900–1992
17 items
Black-and-white original and copy prints of Kiowa beading artist Alice Littleman
and other Indian artists. A photo of Spencer Asah and Charles Tsoodle is also
included in the collection.
Unpublished finding aid available.

LITTON, GASTON (1913–1995) 435
Photographs 1890–1930
46 items
Black-and-white original and copy prints of Cherokee, Chickasaw, and Choctaw Indians. Included are scenes of the Bloomfield Academy; the Chickasaw Nation capitol building; officials of the Chickasaw tribal government; and Chickasaw Governor Douglas H. Johnson. The collection also contains photographs of Tams Bixby, Mary Alice Herrell Murray, William Henry (Alfalfa Bill) Murray, Elmer Thomas, and Saladin Watie.
Unpublished finding aid available.

LOCKART, BILL 436
Photographs 1893–1967
38 items
Black-and-white original and copy prints of railroads, depots, street scenes, and businesses in Bartlesville, Cherokee, Depew, Kingston, Oklahoma City, Olustee, Sulphur, and Tuttle, Oklahoma; and Ardmore, Indian Territory. The collection also includes railway images from Leadville and Silverton, Colorado.
Unpublished finding aid available.

LOGAN, OSCAR 437
Photographs n.d.
5 items
Black-and-white copy prints of Osage Indian Councilman Oscar Logan, his wife Mary Logan, and John Stink, Bacon Rind, and Frank Corndropper.
Unpublished finding aid available.

LONG STUDIO COLLECTION 438
Photographs 1914–1940
392 items
Black-and-white original and copy prints of a cotton gin and workers, swimmers at Medicine Park, Oklahoma, and farm scenes near Roosevelt and Lone Wolf, Oklahoma. The collection also includes photographs of gas stations and churches in Wellington, Texas.
Unpublished finding aid available.

LONG, GEORGE 439
Photographs 1885–1956
16 items
Black-and-white original prints of the Seneca Indian schools at Wyandotte, Indian Territory; Spring River, Indian Territory; and Medicine Park, Oklahoma. *Unpublished finding aid available.*

LOVETT, HOUSTON 440
Photograph 1918
1 item
A black-and-white copy print of James M. Littlefield's cotton gin at Peno, Oklahoma.

LOVETT, JOHN R. (1918–1980) 441
Photographs 1938–1974
105 items
Black-and-white and color original and copy prints of the U.S. Navy in the Pacific, 1938–1974. Includes photographs of naval warships and aircraft of World War II, and minesweeping operations in Hiaphong Harbor, North Vietnam, in 1973. The collection also contains photographs of the German pocket battleship *Graf Spee*, and the recovery of the crews (1973–1974) from Skylabs II and IV.

LUSTER, DEWEY "SNORTER" (1899–1980) 442
Photographs 1920–1953
11 items
Black-and-white original prints of University of Oklahoma football teams, head OU football coach Dewey "Snorter" Luster, the wives of the 1920 OU lettermen, soldiers, and the University of Oklahoma Law School Class of 1922. *Unpublished finding aid available.*

LYNN, ARTHUR L. 443
Photograph 1921
1 item
A black-and-white original print of the University of Oklahoma Band in 1921. Arthur L. Lynn is pictured in the group.

MACKEY, CLIFTON M. (1894–1958) 444
Photographs 1913–1918
134 items
Black-and-white original prints of students, athletic events, athletes, commencement, and buildings on the University of Oklahoma campus, and general scenes of Norman, Oklahoma.
Unpublished finding aid available.

MACKEY, (Mrs.) CLIFTON M. (1893–1979) 445
Photographs 1872–1952
129 items
Black-and-white original prints of Patrick J. Hurley and members of the Hurley and Mackey families. The collection also contains photographs of Walter Stanley Campbell, Bacone College, and several Catholic convents and schools associated with the Hurley and Mackey families.
Unpublished finding aid available.

MADDOX, KATHERINE T. 446
Photographs 1910
11 items
Black-and-white original prints of tornado damage in Snyder, Oklahoma.
Unpublished finding aid available.

MAGNOLIA PETROLEUM COMPANY COLLECTION 447
Photographs 1914–1924
8 items
Black-and-white copy prints of oil-field activities near Wirt and Healdton, Oklahoma.
Unpublished finding aid available.

MAGUIRE, GRACE ADELINE KING (1880–1951) 448
Photograph 1910
1 item
A black-and-white original print of the James D. Maguire hardware store in Norman, Oklahoma.

MANGUM DAILY STAR COLLECTION 449
Photographs n.d.
2 items
Black-and-white original prints of *Mangum Daily Star* editors G. H. Eubanks and C. W. Edwards.

MANKILLER, WILMA PEARL (1945–2010) 450
Photographs 1995
4 items
Color original prints of Wilma Mankiller's state of the Cherokee Nation address.
Unpublished finding aid available.

MARABLE, MARY H. 451
Photographs 1948
84 items
Black-and-white original prints of many noted authors, including Robert Frost,
Aldous Huxley, James Joyce, Franz Kafka, Thomas Mann, A. A. Milne, Gertrude
Stein, Alice B. Toklas, Gloria Vanderbilt, and Virginia Woolf.
Unpublished finding aid available.

MARRIOTT, ALICE (1910–1992) 452
Photographs 1890–1960
774 items
Black-and-white original and copy prints of Apache, Cherokee, Kiowa, Navajo,
Pueblo, and Seminole Indians. Also included are photographs of baskets from
the Aleuts, Apache, Cahuilla, Cheyenne, Chippewa, Clallam, Delaware, Eskimos,
Haida, Havasupai, Hopi, Hupa, Karok, Kickapoo, Klamath, Klikitat, Lillooet,
Maidu, Makah, Modoc, Mono, Navajo, Nez Percé, Nootka, Paiute, Papago,
Penobscot, Pima, Pomo, Pueblo, Quinault, Seneca, Shoshoni, Tlingit, Umatilla,
Wailaki, Wasco, Washo, Winnebago, and Yokuts tribes. The collection also
contains views of archaeological work sites in the southwestern United States,
including those near Oklahoma City, Fort Sill, Okeene, Anadarko, Idabel, and
Ardmore, Oklahoma; San Ildefonso, Santa Fe, and Chimayo, New Mexico; and
San Antonio, Texas.
Unpublished finding aid available.

MARRIOTT, SYDNEY C. 453
Photographs 1915–1930
11 items
Black-and-white original prints of asphalt being applied to Ardmore, Oklahoma,
streets.
Unpublished finding aid available.

MARRS, (Mrs.) MAURICE A. 454
Photographs n.d.
2 items
Black-and-white original prints of U.S. Army officers in Oklahoma Territory.
Unpublished finding aid available.

MARTIN, (Mrs.) T. P. 455
Photographs 1901–1930
37 items
Black-and-white original and copy prints of the towns of Oklahoma City and
Darlington, Oklahoma, as well as Marlow, Indian Territory and Oklahoma. Also
included in the collection are scenes of early airmail service to Oklahoma City,
Oklahoma.
Unpublished finding aid available.

MASON, IDA 456
Photographs 1889
3 items
Black-and-white original prints of the students and teachers of the first school in
Guthrie, Oklahoma Territory.
Unpublished finding aid available.

MASON, VIOLA 457
Photographs 1908
3 items
Black-and-white original prints of the Lincolnville, Oklahoma, school, and teachers
at a training course in Wyandotte, Oklahoma.
Unpublished finding aid available.

MASSAD, ERNEST L. (1908–1993) 458
Photographs 1918–1972
220 items
Black-and-white original and copy prints of Ernest L. Massad's career in the U.S.
Army. He is pictured posing with various servicemen, receiving awards, and
attending receptions. The collection also includes photographs of Carl Albert
visiting Army Reserves troops, Will Rogers at the University of Oklahoma, the
University of Oklahoma football team from 1928 to 1931 (when Massad was an
All-American team member), and homecoming floats from these years.
Unpublished finding aid available.

MASSEY, FRED 459
Photograph ca. 1906
1 item
A black-and-white original print of an interior view of Massey's store at Chelsea,
Indian Territory.

MATTHEWS, SAM P. 460
Photograph 1901
1 item
A black-and-white copy print of the members of the Ardmore, Indian Territory,
townsite survey team.

MAUPIN, MARY B. 461
Photographs 1860–1945
50 items
Black-and-white copy prints of the Allen, Baggett, Barefoot, Bursell, Curren,
Loving, Weatherford, Welch, and Wilkerson families. The collection also includes
scenes of farming and of a dust storm approaching Guymon, Oklahoma.
Unpublished finding aid available.

McALESTER CHAMBER OF COMMERCE COLLECTION 462
Photographs 1905–1950
2 items
Black-and-white copy prints of McAlester, Indian Territory, following a town fire,
and a view of the Rock Island Improvement Company Mine No. 12 near Harts-
horne, Oklahoma.

McALESTER PUBLIC LIBRARY COLLECTION 463
Photographs 1895–1935
68 items
Black-and-white copy prints of Italian Americans in Pittsburg County, Indian Ter-
ritory and Oklahoma. Included are photographs of their organizations, businesses,
coal mining, athletic events, and cemeteries. The collection also contains photo-
graphs of McAlester, Indian Territory and Oklahoma; Krebs, Indian Territory; and
Hartshorne and Crowder, Oklahoma.
Unpublished finding aid available.

McALLISTER, J. D. 464
Photograph n.d.
1 item
A black-and-white copy print of Pat Garrett with a group of men.

McCALL, BOB 465

Photographs 1901–1905

6 items

Black-and-white original prints of Cache and Lawton, Oklahoma Territory. *Unpublished finding aid available.*

McCLAIN COUNTY HISTORICAL SOCIETY COLLECTION 466

Postcards n.d.

6 items

Color postcards of churches, businesses, and schools in Purcell, Oklahoma. *Unpublished finding aid available.*

McCLAIN, R. S. 467

Photographs ca. 1930

18 items

Black-and-white original prints of businesses and street scenes of Oklahoma City, Oklahoma, and theaters in Oklahoma and Texas. *Unpublished finding aid available.*

McCLERG, VICTORY 468

Photographs 1917–1922

4 items

Black-and-white original prints of the Confederate Veterans Home and Hardy Sanitorium at Ardmore, Oklahoma, and the railroad depot at Ringling, Oklahoma. *Unpublished finding aid available.*

McCOY, JAMES STACY (1834–1862) 469

Photograph n.d.

1 item

A hand-colored tintype of James Stacy McCoy.

McCURTAIN COUNTY HISTORICAL SOCIETY COLLECTION 470

Photographs 1904–1940

46 items

Black-and-white copy prints of scenes in McCurtain County, Oklahoma, including logging, railroad construction, businesses, and farming. The collection also contains prints of the towns of Broken Bow, Eagletown, Garvin, Haworth, Idabel, Smithville, and Wright City, Oklahoma. *Unpublished finding aid available.*

McCURTAIN, GREEN (1848–1910) 471
Photographs 1880–1950
285 items
Black-and-white original and copy prints of the McCurtain and Scott families. Also included are scenes of ranching, schools, and the towns of Atoka, Kinta, McAlester, Muskogee, Stigler, and Tuskahoma, Indian Territory. Personalities depicted in the collection are J. V. Adair, Marilda Folsom, Cora McCurtain, David Cornelius McCurtain, Green McCurtain, Scott McCurtain, John McIntosh, Alice McCurtain Scott, Folsom Scott, and George Scott.
Unpublished finding aid available.

McELHANY, S. H. 472
Photographs 1907–1977
29 items
Black-and-white copy prints of the McElhany family and the University of Oklahoma administration building burning in 1907.
Unpublished finding aid available.

McINTIRE, JOHN STALLINGS (1890–1954) 473
Photographs 1898–1900
509 items
Black-and-white original prints of horseback camping trips in Montana and Wyoming in 1898 and 1900. Included are photographs of Columbus, Montana; Fort Yellowstone, Wyoming; Yellowstone National Park; campsites; sport hunting and fishing; and landscape scenes in the Rocky Mountains.

McKENZIE, (Mr. and Mrs.) W. H. 474
Photographs 1896–1937
146 items
Black-and-white original prints of tornado damage in Snyder, Oklahoma; members of the Welch family; and businesses, banks, and street scenes in Haileyville and Cement, Oklahoma; Shreveport, Louisiana; Rouse, Colorado; and Groesbeck and Ralls, Texas.
Unpublished finding aid available.

McKINNEY, ROBERT MOODY (1910–2001) 475
Photographs 1913–1987
103 items
Black-and-white copy prints from the life and career of Robert Moody McKinney, the longtime editor and publisher of *The Santa Fe New Mexican*, and U.S. ambassador to Switzerland during the Kennedy administration. Notable photographs in the collection are of the USS *Tarawa*, and McKinney with General Lucius D. Clay, and Swiss President Friedrich Traugott Wahlen.
Unpublished finding aid available.

McMURDO, GEORGE 476
Photographs ca. 1935
6 items
Black-and-white original prints of Pittsburg County Railway Company streetcars, and of McAlester, Oklahoma.
Unpublished finding aid available.

McMURRAY, DANIEL 477
Photographs 1898
15 items
Black-and-white copy prints of military units and barracks in the Philippines during the Spanish-American War.
Unpublished finding aid available.

MEDFORD PROGRESS CLUB COLLECTION 478
Photographs 1920
5 items
Black-and-white original prints of the interior of the public library at Medford, Oklahoma.
Unpublished finding aid available.

MEHLER, MARY 479
Postcard 1936
1 item
A black-and-white postcard of a Price Falls roadside stop in Oklahoma.
Unpublished finding aid available.

MEKUSUKEY INDIAN SCHOOL COLLECTION **480**
Photographs ca. 1925
56 items
Black-and-white original prints of Seminole Indian children, teachers, and buildings at the Mekusukey Indian School.
Unpublished finding aid available.

MEMMINGER, CHARLES B. (1892–1970) **481**
Photographs ca. 1912
4 items
Black-and-white original prints of the University of Oklahoma campus, including the construction of Monnet Hall.
Unpublished finding aid available.

MERCER, ROBERT **482**
Photographs 1965–1995
201,323 items
Black-and-white and color negatives and color slides made by freelance photographer Robert Mercer. The collection includes scenes of naval operations off the coast of Vietnam, American Indian powwows in Oklahoma, wildlife, and work on the Arkansas River navigation project. Other photographs depict the oil industry in Oklahoma; scenes from the Oklahoma City and Tulsa areas; Oral Roberts University; the 1979 Professional Golf Association U.S. Open Championship; the gubernatorial races of George Nigh and David L. Boren; and images of Wilma Mankiller, former chief of the Cherokee Nation. Various festivals in the Tulsa area, Oklahoma farming and cattle raising scenes, and views of Hurricane Anita are in the collection.

MERRELL, GARLAND, JR. **483**
Photographs 1927–1929
108 items
Black-and-white copy prints of oil fields in the Seminole, Oklahoma, area. Included are photographs of oil wells, oil fields, oil-field camps, oil-field workers, and vehicles used for transportation to the fields. Also in the collection are photographs of oil-field fires; the town of Seminole, Oklahoma; and Seminole Indians.
Unpublished finding aid available.

MERRILL, MAURICE H. 484
Photographs 1870–1880
11 items
Black-and-white copy prints of William Addison Phillips and his family. Also included are photographs of the John Wardell Stapler family at their home in Tahlequah, Indian Territory.
Unpublished finding aid available.

MEYER PHOTOGRAPHIC SHOP COLLECTION 485
Photographs 1889–1930
27 items
Black-and-white copy prints of Guthrie and Oklahoma City, Oklahoma Territory, and Oklahoma City, Oklahoma. Other photographs in the collection include businesses; street scenes; the streetcar system; the land run of 1893 near Orlando, Oklahoma Territory; and images of Wichita and Comanche Indians.
Unpublished finding aid available.

MEYER, CLIFFORD 486
Photograph 1957
1 item
A black-and-white original print of attendees at the Fellowship of Christian Athletes Second Annual Conference, held in Estes Park, Colorado. The group includes University of Oklahoma student athletes.

MIDKIFF, CHARLES F. 487
Photographs 1897–1906
6 items
Black-and-white original prints of Pauls Valley, Indian Territory and Oklahoma. The collection features scenes of businesses and schools.
Unpublished finding aid available.

MILBURN, GEORGE (1906–1966) 488
Photographs 1907–1965
6 items
Black-and-white and color original prints of George Milburn as an infant, and later in life with granddaughter Phyllis Porter.
Unpublished finding aid available.

MILES, RAY 489
Photographs n.d.
3 items
Black-and-white copy prints of Isaac Gibson and Father Paul Mary Ponziglione.
Unpublished finding aid available.

MILLER BROTHERS 101 RANCH AND 490
WILD WEST SHOW COLLECTION
Photographs 1900–1935
74 items
Black-and-white original prints of the Miller Brothers 101 Wild West Show
and the 101 Ranch. Included in the collection are photographs of cowboy and
cowgirl performers, the Miller brothers, and a production scene for a western
movie.
Unpublished finding aid available.

MILLER, D. H. 491
Photograph 1958
1 item
A black-and-white copy print of the first eight managers of the Veterans Adminis-
tration Hospital, Muskogee, Oklahoma.

MILLER, WILLIAM 492
Photographs 1900–1925
21 items
Black-and-white original prints of Gotebo, Oklahoma Territory and state, includ-
ing photographs of William Miller, his home, his medical office, street scenes,
businesses, firefighters, and the cotton trade in Gotebo.
Unpublished finding aid available.

MILLION, ELMER 493
Photographs 1935
2 items
Black-and-white original print and a negative of members of the University of
Oklahoma Law School's Class of 1935.

MILLS, (Mrs.) JACK R. 494
Photographs ca. 1920
24 items
Black-and-white copy prints of the towns of Enid, Jet, and Marshall, Oklahoma; and of Camp Doniphan and Fort Sill, Oklahoma.
Unpublished finding aid available.

MITCHELL, (Mrs.) ALFRED 495
Photographs 1899–1915
14 items
Black-and-white original prints, copy prints, and tintypes of the family of the Creek Indian poet Alexander Posey, and of the Creek Indian school at Wetumka Mission, Indian Territory.
Unpublished finding aid available.

MITCHELL, IRENE ELDRIDGE 496
Photographs 1896–1912
20 items
Black-and-white original and copy prints of Red Rock and Guthrie, Oklahoma, with scenes of cattle ranching near Red Rock. Also included are hunting scenes and studio portraits of Ella M. Reed, Walter M. Snyder, Ed Snyder, and members of the Eldridge family.
Unpublished finding aid available.

MITCHELL, SAM W. 497
Photograph 1913
1 item
A black-and-white copy print of Heber Denman inside the Mammoth Vein Mine No. 1, a coal mine in western Arkansas.

MITCHELL, VERNON 498
Photographs 1901–1930
58 items
Black-and-white copy prints of Byars and Johnson, Indian Territory and Oklahoma; and Arapaho, Oklahoma Territory. The photographs include scenes of schools, railroads, parades, and businesses.
Unpublished finding aid available.

MITCHELL-BENHAM COLLECTION 499
Photographs ca. 1890–1927
21 items
Black-and-white original prints of the Elk City, Oklahoma, reservoir dam; the Benham, Mitchell, and Pyle families; and schools in Dewey and Kiefer, Oklahoma. The collection also contains photographs of homesteads, a wagon yard in Weatherford, Oklahoma, and a Sinclair Oil and Gas plant.
Unpublished finding aid available.

MIX, TOM (1880–1940) 500
Photographs ca. 1930
8 items
Black-and-white original prints of Tom Mix in the movies *Last of the Duanes, No Man's Gold,* and *Long Runs Wild.* Also included are photographs of Mix with his dog, horse, and saddle.
Unpublished finding aid available.

MOLEN, GERTHA 501
Photographs 1910–1940
50 items
Black-and-white copy prints of Cordell, Oklahoma, including street scenes, businesses, railroads, cotton harvesting, and a photograph of Quanah Parker's house at Cache, Oklahoma.
Unpublished finding aid available.

MONNET, (Mrs.) BUFORD 502
Photographs 1895–1920
26 items
Black-and-white copy prints of Tulsa, Indian Territory and Oklahoma; and of Bartlesville and Morris, Oklahoma. Included are scenes of bands, businesses, schools, a bridge, and a cotton market.
Unpublished finding aid available.

MONNET, JULIEN CHARLES (1868–1951) 503
Photographs 1910–1918
18 items
Black-and-white original prints of the first dean of the University of Oklahoma School of Law, Julien Charles Monnet, and various early scenes of the University of Oklahoma.
Unpublished finding aid available.

MOORE FAMILY COLLECTION

504

Photograph n.d.

1 item

A black-and-white copy print of Joseph G. Moore's ferry boat on the Washita River below Fort Washita, Indian Territory.

MOORE PUBLIC LIBRARY COLLECTION

505

Photographs 1900–1925

41 items

Black-and-white copy prints of the towns of Moore and Snyder, Oklahoma Territory; Cement, Damon, Davidson, Elmore City, Frederick, Ioland, Norman, Peek, Stroud, Tipton, Vinita, and Welch, Oklahoma; and Coweta, Indian Territory. Included are scenes of businesses, the oil industry, railroads, parades, the University of Oklahoma, football games, cotton marketing, and firefighters.

Unpublished finding aid available.

MOORE, LOUISE BEARD (1905–1992)

506

Photographs ca. 1923–1990

333 items

Black-and-white and color original prints from the life and career of Louise Beard Moore, professor of journalism and longtime faculty adviser to the University of Oklahoma student newspaper, the *Oklahoma Daily*. The collection contains photographs of Louise Beard Moore, Morris Price Moore, and the Beard family, as well as *Oklahoma Daily* editors and staff, buildings and student organizations at the University of Oklahoma, and a photo album from Phillips High School in Enid, Oklahoma.

Unpublished finding aid available.

MOORE, TOM

507

Photographs 1902–1919

5 items

Black-and-white original prints of Olustee, Oklahoma Territory, including scenes of shipping wheat from the Olustee railroad depot, the Mock and Moore Grain Company, and wheat harvesting.

Unpublished finding aid available.

MOORE, (Mrs.) WADE 508
Photographs 1896–1901
4 items
Black-and-white original prints of the University of Kansas baseball team, the Kansas State Agricultural College football team, and two unidentified athletic teams.
Unpublished finding aid available.

MOORELAND (Oklahoma) SECURITY STATE BANK COLLECTION 509
Photograph n.d.
1 item
A black-and-white copy print of the interior of the Security State Bank in Mooreland, Oklahoma.

MOORMAN, LEWIS 510
Photograph n.d.
1 item
A black-and-white copy print of Dr. Lewis Moorman with his horse, "Old Billy."

MORGAN, DICK T. 511
Photographs n.d.
11 items
Black-and-white original portraits of unidentified children and women.
Unpublished finding aid available.

MORMON COLLECTION 512
Photographs 1840–1920
178 items
Black-and-white copy prints of photographs, paintings, and lithographs of Mormons in Utah, including images of Brigham Young, Joseph Smith, and other Mormon leaders. Also in the collection are scenes of Arizona, Colorado, Idaho, Illinois, New York, Ohio, and Texas; photographs of the Mormon Temple; the residence of Brigham Young; and Salt Lake City, Utah.
Unpublished finding aid available.

MORRIS, JOHN WESLEY (1907–1982) **513**
Photographs 1880–1975
449 items
Black-and-white original and copy prints of Centralia, Eagletown, Tidmore, Tishomingo, Wewoka, and Whitebead, Indian Territory, along with numerous Oklahoma towns, including scenes of businesses, health resorts, stone quarries, railroads, and dust storms. The collection also contains prints of Cherokee, Chickasaw, Choctaw, Creek, Sac and Fox, and Seminole Indians.
Unpublished finding aid available.

MORRIS, JOHN WESLEY–OKLAHOMA CITY COLLECTION **514**
Photographs 1889–1934
89 items
Black-and-white copy prints of street scenes, businesses, parades, government buildings, churches, athletic events, parks, depots, and interurban trains in Oklahoma City, Oklahoma Territory and state.
Unpublished finding aid available.

MORRIS, TOBY **515**
Photographs 1949–1958
10 items
Black-and-white original prints of scenes in the Anadarko, Oklahoma, area, including the Washita River, flood damage, the Anadarko Power Plant, and Randlett Park. The collection also contains an image of Mrs. John B. Abbott at the 1958 League of Women Voters convention in Atlantic City, New Jersey.
Unpublished finding aid available.

MOSLEY, ZACK **516**
Photographs 1945–1952
9 items
Black-and-white original prints of Zack Mosley, the Mosley family, and Roy Crane.
Unpublished finding aid available.

MULLEN, J. W. **517**
Photographs 1895–1924
64 items
Black-and-white original prints of camping trips in Arkansas, Kansas, Oklahoma, Oregon, and Utah. Photographs of sport fishing, hunting, and trapping are also in the collection.
Unpublished finding aid available.

MUNGER, WILLIAM HOUSTON (1852–1926) 518
Photographs 1890–1947
62 items

Black-and-white original and copy prints of Watonga, Oklahoma, along with images of Arapaho, Caddo, Cheyenne, and Creek Indians, including photographs of Cut Nose, Little Bird, Mad Bull, Guy Red Cloud, Red Leggins, Amanda Roman Nose, Lizzie Turkey Legs, and Wolf Mule.
Unpublished finding aid available.

MUNN, IRVIN 519
Photographs 1890–1940
367 items

Black-and-white original and copy prints of the towns of Chickasha and Minco, Indian Territory and Oklahoma; and Tuttle, Oklahoma. The collection includes photographs of street scenes, businesses, farms and farming activities, schools, ferries, firefighters, airplanes, and steam and electric railroads.
Unpublished finding aid available.

MURPHY, JOSEPH 520
Photograph n.d.
1 item

A black-and-white copy print of Olympic medal winner Jim Thorpe.

MURPHY, WILLIAM ALBERT PATRICK (1872–1952) 521
Photographs 1907–1952
16 items

Black-and-white original prints of the towns of Carmen, Guthrie, and Lawton, Oklahoma, including scenes of railroads, hunting, a sod house, and an Osage Indian village.
Unpublished finding aid available.

MURRAY, BURBANK (1911–1984) 522
Photographs 1880–1970
208 items

Black-and-white original prints of William H. (Alfalfa Bill) Murray and of his family. Included are scenes of William Murray with Oklahoma National Guardsmen guarding the Red River bridges during Oklahoma's dispute with Texas over toll bridges; the inauguration of William H. Murray as governor of Oklahoma; the Oklahoma National Guard at Fort Sill, Oklahoma; U.S. Army aircraft; William H. Murray's colony in Bolivia; and William H. Murray's family in Bolivia.
Unpublished finding aid available.

MURRAY, FRANKIE COLBERT (1907–1994) 523
Photographs 1880–1967
242 items
Black-and-white original prints of William H. (Alfalfa Bill) Murray and of his family. The collection contains images of William Murray as governor of Oklahoma; the 1907 Oklahoma constitutional convention; the inauguration of Johnston Murray as governor of Oklahoma; the Cherokee Nation senate; the Murray farm near Tishomingo, Oklahoma; and Murray State College in Tishomingo, Oklahoma. Also included are photographs of the Oklahoma National Guard; petroleum industry operations in Oklahoma; Cherokee, Chickasaw, Choctaw, Creek, and Seminole Indians; the Murray family in Bolivia; and the Murray colony and colonists in Bolivia.
Unpublished finding aid available.

MURRAY, JOHNSTON (1902–1974) 524
Photographs 1951–1954
351 items
Black-and-white original prints of Oklahoma governor Johnston Murray; the Murray family; his 1950 gubernatorial campaign; state activities and events; the Oklahoma state capitol; and Murray's goodwill tour of Mexico. Also included are photographs of Harry S. Truman, Dwight D. Eisenhower, and the construction of the Turner Turnpike.
Unpublished finding aid available.

MURRAY, WILLIAM HENRY (1869–1956) 525
Photographs 1870–1951
280 items
Black-and-white original prints of Oklahoma's ninth governor, William H. "Alfalfa Bill" Murray; the Murray family; the Murray colony in Bolivia; the inauguration of Johnston Murray as governor of Oklahoma; members of the Sequoyah convention; a train wreck at Caston, Oklahoma; a school for African Americans in Rentiesville, Oklahoma; and siege artillery at Tampa, Florida, during the Spanish-American War.
Unpublished finding aid available.

MYERS, (Mrs.) TOMMY MOORE 526
Photographs 1900
17 items
Black-and-white copy prints of Olustee, Oklahoma Territory, including a photograph of construction of a railroad bridge across the Red River.
Unpublished finding aid available.

NEAL, HENRY 527
Photograph 1959
1 item
A black-and-white original print of the post office in Wanette, Oklahoma.

NELSON, GEORGE (1870–1944) 528
Photographs n.d.
2 items
Black-and-white original prints of George Nelson, a Choctaw Indian who served as an interpreter for the U.S. Indian Service at McAlester, Oklahoma.
Unpublished finding aid available.

NESBITT, CHARLES (1921–2007) 529
Photographs ca. 1955
46 items
Black-and-white original prints of American Indians wearing traditional clothing.
Unpublished finding aid available.

NESBITT, CHARLES, MARGÔT NESBITT, and E. A. BURBANK 530
Photographs ca. 1900
33 items
Black-and-white original and copy prints of prominent Sioux Indians such as Red Cloud, Yellow Shirt, Kicking Bear, American Horse, and Spotted Elk. Also included are photographs of White Swan (Crow) and Naiche (Apache).

NESBITT, CHARLES, MARGÔT NESBITT, and EMIL W. LENDERS 531
Photographs 1900–1925
3,268 items
Black-and-white original prints of the employees and performances of the Miller Brothers 101 and Pawnee Bill's wild west shows. The collection includes individual images and group scenes of cowboy and cowgirl performers, as well as those of Indian performers from the Arapaho, Blackfoot, Cheyenne, Comanche, Crow, Kickapoo, Osage, Pawnee, Ponca, Potawatomi, Sac and Fox, and Sioux tribes.
Unpublished finding aid available.

NESBITT, CHARLES, MARGÔT NESBITT, and FRANK A. RINEHART 532
Photographs 1898–1899
124 items
Black-and-white and hand-tinted original prints of Apache, Arapaho, Assiniboine, Blackfoot, Cheyenne, Cocopa, Crow, Kiowa, Maricopa, Omaha, Ponca, Potawatomi, Pueblo, Sac and Fox, Sioux, Tonkawa, Wichita, and Winnebago Indians.
Unpublished finding aid available.

NESBITT, CHARLES, MARGÔT NESBITT, and RINEHART 533
LITHOGRAPHS COLLECTION
Lithographs ca. 1898
42 items

Color lithographs of prominent Indians from various tribes, including White Man (Kiowa), Grant Richards (Tonkawa), Sitting Bull (Sioux), Wolf Robe (Cheyenne), Red Cloud (Sioux), Josh (Apache), White Swan (Crow), Hollow Horn Bear (Sioux), Red Shirt (Sioux), White Buffalo (Arapaho), and Diego Naranjo (Pueblo).

NEWBY, ERRETT RAINS (1885–1977) 534
Photographs 1907–1920
60 items

Black-and-white original and copy prints of University of Oklahoma students, faculty, athletic teams, buildings and campus; street scenes in Norman, Oklahoma; and the fire that destroyed University Hall, the second administration building at the University of Oklahoma, in 1907.

Unpublished finding aid available.

NEWKIRK HISTORICAL SOCIETY COLLECTION 535
Photographs 1916–1917
9 items

Black-and-white copy prints of street scenes, parades, businesses, an oil refinery fire, and oil wells in and near Dilworth, Oklahoma.

Unpublished finding aid available.

NEWLAND, (Mrs.) JOHN L. 536
Photograph n.d.
1 item

A black-and-white original print of John Lynn Newland, publisher of the *Frederick Leader* from 1910 to 1941.

NEWMAN, OSCAR CLARENCE (1876–1953) 537
Photograph 1901
1 item

A black-and-white original print of Grand, Oklahoma Territory.

NEWSON, D. EARL 538
Photographs 1904–1918
10 items
Black-and-white original and copy prints of the Drumright and Burbank oil fields in and around the Oklahoma towns of Fulkerson (later Drumright) and Oilton. The collection also contains views of Stillwater, Oklahoma, including street scenes and the local chapter of the International Order of Odd Fellows; a cotton gin in Morrison, Oklahoma; and the Hotel Charles in Cushing, Oklahoma.
Unpublished finding aid available.

NICE, MARGARET MORSE (1883–1974) 539
Photographs 1922–1944
10 items
Black-and-white original prints of ornithologists Margaret Morse Nice and George M. Sutton, and aerial views of Oklahoma City University, and Lake Overholser in central Oklahoma.
Unpublished finding aid available.

NICHOLS, LEA MURRAY (b. 1878) 540
Photographs 1903–1954
34 items
Black-and-white original prints of newspaperman Lea Murray Nichols. The collection also contains a scene of an oil well near Tulsa, Indian Territory.
Unpublished finding aid available.

NICHOLSON, JAMES O. 541
Photograph n.d.
1 item
A black-and-white copy print of a bullet extraction kit.

NIKSCH, W. H. 542
Photograph 1929
1 item
A black-and-white original print of the railroad depot at Bluejacket, Oklahoma.

NOLAN, BILL 543
Photographs 1889
2 items
Black-and-white original prints of early street scenes in Norman, Oklahoma Territory.
Unpublished finding aid available.

NORMAN PUBLIC LIBRARY COLLECTION 544
Photographs 1893–1919
41 items
Black-and-white copy prints of Norman and Cheyenne, Oklahoma Territory and state. Also in the collection are photographs of Drumright and Broken Bow, Oklahoma; the University of Oklahoma; cowboys; businesses; and Cheyenne and Arapaho Indians.
Unpublished finding aid available.

NORMAN, OKLAHOMA, COLLECTION 545
Photographs ca. 1905
42 items
Black-and-white digital copies of the University of Oklahoma campus, schools, churches, street scenes, cotton gins, the Cleveland County courthouse, the state sanitarium, businesses, banks, houses, and agricultural activities in and around Norman, Oklahoma Territory and state.
Unpublished finding aid available.

NORRIS, THOMAS T. 546
Photographs 1890–1941
10 items
Black-and-white original and copy prints of the towns of Crowder City, Indian Territory, and McAlester, Oklahoma; a surgical operation being performed at the Oklahoma State Penitentiary; and a group photograph of members of a fraternal order in McAlester, Oklahoma.
Unpublished finding aid available.

NOTHSTEIN, (Mrs.) CHARLES ANDERSON 547
Photographs 1889–1907
46 items
Black-and-white original prints of Hennessey and Kingfisher, Oklahoma Territory and state, along with scenes of the Miller Brothers 101 Ranch.
Unpublished finding aid available.

NOVY, HENRIETTA 548
Photographs 1894–1935
15 items
Black-and-white copy prints of Czech Americans from the towns of Banner, Bison, Goltry, and Prague, Oklahoma. The collection includes scenes of weddings, schools, churches, and farming.
Unpublished finding aid available.

O'DELL, SAM HOYT (1925–2010) 549
Photographs 1944–1945
29 items
Black-and-white copy prints of scenes at the U.S. Navy Air Base on Tinian Island during World War II. The images show Samuel O'Dell and other U.S. Navy personnel; military barracks; and aircraft bearing nose art. The collection also includes a photograph of the *Enola Gay*.
Unpublished finding aid available.

OKFUSKEE COUNTY HISTORICAL SOCIETY COLLECTION 550
Photographs ca. 1903–1937
104 items
Black-and-white copy prints of street scenes, businesses, and municipal buildings in Okemah and Welty, Oklahoma. Included in this collection are photographs of Okemah baseball teams from the 1920s and 1930s.
Unpublished finding aid available.

OKLAHOMA COLLECTION 551
Photographs 1880–1951
617 items
Black-and-white original and copy prints of Apache, Caddo, Cherokee, Cheyenne, Comanche, Creek, Iowa, Kickapoo, Kiowa, Osage, Otoe, Pawnee, Ponca, Quapaw, and Seminole Indians. Images of the range cattle industry, road construction in the Arbuckle Mountains, farms and farming activities, schools, transportation, settlers, military, and prisons are also included. Other photographs include scenes from the Oklahoma towns of Anadarko, Cantonment, Clinton, Devol, Dewey, Drumright, Edmond, El Reno, Elm Springs, Fort Towson, Guthrie, Hammon, Hartshorne, Headrick, Hugo, Kingfisher, Lawton, Miami, Mulhall, Muskogee, Norman, Oklahoma City, Okemah, Pawnee, Perry, Phillips, Ponca City, Sapulpa, Thackerville, Verden, and Watonga. Individuals pictured include Bad Man, Frank Eaton, Maria Martinez, Zack Miller, Tom Mix, Stephen Mopope, Quanah Parker, Bill Pickett, and Stand Watie.
Unpublished finding aid available.

OKLAHOMA CITY LIBERTY NATIONAL BANK COLLECTION 552
Photographs 1889–1926
6 items
Black-and-white copy prints of Oklahoma City, Oklahoma Territory and state; statehood day activities in Guthrie, Oklahoma; and the opening of the Cherokee Outlet to settlement.
Unpublished finding aid available.

OKLAHOMA DENTAL ASSOCIATION COLLECTION 553
Photographs 1902
54 items
Black-and-white copy prints of dentists and the interiors of their offices in Musk-
ogee, Indian Territory, and Stillwater, Oklahoma Territory. Also included are
scenes from dental offices in Antlers, Durant, Grove, Holdenville, Hugo, Marlow,
Sapulpa, Seminole, Tulsa, and Wagoner, Indian Territory; as well as Clinton, Elk
City, Guymon, Lawton, Mooreland, Norman, Oklahoma City, Stillwater, and
Woodward, Oklahoma Territory.
Unpublished finding aid available.

OKLAHOMA FARM BUREAU COLLECTION 554
Photograph 1942
1 item
A black-and-white original print of the board of directors of the Oklahoma Farm
Bureau.

OKLAHOMA GEOLOGICAL SURVEY COLLECTION 555
Photographs 1900–1940
6,625 items
Black-and-white original prints, negatives, and panoramas of numerous Oklahoma
towns, mines, oil wells, oil fields, industries, rivers, health resorts, farms, sod houses,
railroads, and the University of Oklahoma. The collection also includes scenes of
Oklahoma mountains, rock formations, soils, and meteorite craters, along with
Indian schools.
Unpublished finding aid available.

OKLAHOMA LABOR STUDIES COLLECTION 556
Photographs 1908–1983
156 items
Black-and-white original and copy prints of Oklahoma labor unions and work-
ers in trades such as bricklaying, carpentry, and transportation. The collection
also includes photographs of union parade floats, labor strikes, and union social
functions. Also notable are photographs of the Socialist Party encampment in
Oklahoma around 1910.
Unpublished finding aid available.

OKLAHOMA MUSIC EDUCATORS ASSOCIATION COLLECTION 557
Photographs 1927–1934
18 items
Black-and-white original and copy prints of high school and collegiate marching and concert bands, music competitions and clinics, and conductors.
Unpublished finding aid available.

OKLAHOMA OUTDOOR COUNCIL COLLECTION 558
Photographs 1952
2 items
Black-and-white original prints of Governor Johnston Murray signing the proclamation establishing National Wildlife Week in Oklahoma.
Unpublished finding aid available.

OKLAHOMA POSTCARD COLLECTION 559
Postcards n.d.
2,318 items
Black-and-white and color postcards of schools, businesses, the Arbuckle Mountains, Turner Falls, lakes, churches, depots, street scenes, banks, colleges, government buildings, hospitals, memorials, rodeos, libraries, oil wells, parks, the Miller Brothers 101 Ranch, Chilocco Indian Agricultural School, the Oklahoma State Fair, the American Indian Exposition, Frontier City, Alabaster Caverns, and Will Rogers. This collection also includes postcards of Apache, Cherokee, Choctaw, Comanche, Kiowa, Osage, Pawnee, Ponca, and Sioux Indians. Towns include Ada, Afton, Altus, Alva, Anadarko, Antlers, Ardmore, Bartlesville, Beaver, Bernice, Blackwell, Bliss, Boise City, Braman, Bristow, Broken Arrow, Buffalo, Camp Gruber, Carmen, Chandler, Checotah, Cherokee, Chickasha, Claremore, Cleo Springs, Clinton, Collinsville, Comanche, Cushing, Darlington, Davenport, Davis, Dewey, Drumright, Duncan, Durant, Edmond, El Reno, Elk City, Enid, Eufaula, Fort Gibson, Fort Sill, Fort Supply, Frederick, Grove, Guthrie, Guymon, Haskell, Hennessey, Henryetta, Hinton, Hobart, Holdenville, Hollis, Hugo, Kiefer, Kingfisher, Lawton, Madill, Mangum, Marietta, McAlester, Medford, Medicine Park, Miami, Mountain Park, Muskogee, Newkirk, Norman, Nowata, Okeene, Okemah, Oklahoma City, Okmulgee, Pawhuska, Pawnee, Perry, Ponca City, Poteau, Pryor, Purcell, Sallisaw, Sand Springs, Sapulpa, Sayre, Seminole, Shattuck, Shawnee, Stillwater, Stilwell, Sulphur, Tahlequah, Talihina, Tishomingo, Tonkawa, Tulsa, Vinita, Wagoner, Walters, Watonga, Waynoka, Weatherford, Weleetka, Wewoka, Wilburton, and Woodward.
Unpublished finding aid available.

OKLAHOMA SCHOOL OF RELIGION COLLECTION 560
Photographs n.d.
90 items
Black-and-white original prints of the faculty and staff of the Oklahoma School of Religion in Norman, Oklahoma, and images of E. Nicholas Comfort and family. The collection also includes a photograph of McFarlin Memorial Auditorium at Southern Methodist University.

OKLAHOMA SEMI-CENTENNIAL EXPOSITION COLLECTION 561
Photographs 1957–1958
838 items
Black-and-white copy prints of the Oklahoma Semi-Centennial Exposition, documenting the year-long celebration to commemorate the first fifty years of Oklahoma statehood. The collection includes scenes of the exposition grounds, exhibitions, and performances.
Unpublished finding aid available.

OKLAHOMANS FOR INDIAN OPPORTUNITY COLLECTION 562
Photographs n.d.
17 items
Black-and-white and color original prints of LaDonna Harris, Fred Harris, Iola Hayden, Mike Monroney, Sargent Shriver, Oklahomans for Indian Opportunity scholarship winners, and the Oklahomans for Indian Opportunity board.
Unpublished finding aid available.

OKMULGEE COUNTY BOOSTERS COLLECTION 563
Photographs 1916
5 items
Black-and-white original and copy prints of members of the Okmulgee County Boosters and the Okmulgee Concert Band in Pittsburgh, Pennsylvania. Individuals include L. G. Jones, J. A. Tillotson, Henry W. Strong, and Bert H. Martin.
Unpublished finding aid available.

OLINGER, PAUL T. 564
Photographs 1878–1888
5 items
Black-and-white copy prints of Choctaw Nation government officials.
Unpublished finding aid available.

OMER, W. J. 565
Photograph n.d.
1 item
A black-and-white original print of W. J. Omer.

O'RILEY, (Mrs.) LESTER 566
Photographs 1903
2 items
Black-and-white copy prints of Fort Washita, Indian Territory.
Unpublished finding aid available.

ORR FAMILY COLLECTION 567
Photographs and postcards n.d.
20 items
Black-and-white original prints and postcards of depots, businesses, street scenes,
and tornado damage in Leedey, Oklahoma.
Unpublished finding aid available.

OSKISON, JOHN MILTON (1874–1947) 568
Photographs 1931
9 items
Black-and-white original prints of the cast of a play entitled *Black Jack Davy*, per-
formed at the University of Oklahoma.
Unpublished finding aid available.

O'SULLIVAN, TIMOTHY H. (ca. 1840–1882) 569
Photographs 1871–1874
25 items
Black-and-white original prints of images taken by photographer Timothy H.
O'Sullivan and included in the published volume entitled *Photographs Showing
Landscapes, Geological and Other Features of Portions of the Western Territory of the
United States, Obtained in Connection with Geographical and Geological Explora-
tions and Surveys West of the 100th Meridian, Seasons of 1871, 1872, 1873 and 1874.
1st Lt. George M. Wheeler, Corps of Engineers, U.S. Army in Charge.* Included are
scenes of the Grand Canyon, the Colorado River, the San Juan River, Casa Blanca,
Shoshone Falls, and Canyon de Chelly, along with prints of Apache, Navajo, and
Zuni Indians.
Unpublished finding aid available.

OWEN, NARCISSA 570
Photographs 1860-1900
6 items
Black-and-white copy prints of Robert L. Owen, Robert Latham, and Narcissa Owen.
Unpublished finding aid available.

PAINE, (Mrs.) G. C. 571
Photographs 1885-1950
147 items
Black-and-white original and copy prints of Pauls Valley, Indian Territory and Oklahoma, including scenes of businesses, schoolchildren, cotton marketing, and churches. The collection also contains photographs of the towns of Wynnewood, Indian Territory, and Sulphur, Oklahoma.
Unpublished finding aid available.

PARKER, EVERETT C. (b. ca. 1893) 572
Photographs 1913-1917
36 items
Black-and-white original prints of Everett C. Parker; the University of Oklahoma campus; Oklahoma City, Oklahoma; and the Oklahoma National Guard training at Camp Roy V. Hoffman near Chandler, Oklahoma.
Unpublished finding aid available.

PARKER, FRANKLIN (b. 1921) 573
Photographs 1967
3 items
Color original prints of a University of Oklahoma classroom in 1967.
Unpublished finding aid available.

PARKER, GUY 574
Photographs 1904-1909
6 items
Black-and-white copy prints of Roosevelt, Oklahoma Territory and state. Included are street scenes and businesses.
Unpublished finding aid available.

PARMAN, FRANK 575

Photographs 1894–1965

65 items

Black-and-white copy prints of Cloud Chief, Oklahoma Territory, and of Ardmore, Cordell, Foss, and Gotebo, Oklahoma. The collection also contains photographs of businesses, railroads, farming, picnicking, schools, a Ku Klux Klan parade, and tornado damage.

Unpublished finding aid available.

PATE, J. D. 576

Photographs ca. 1900

5 items

Black-and-white original prints of Dr. J. D. Pate and his office in Francis, Oklahoma Territory.

Unpublished finding aid available.

PATRICK, (Mr. and Mrs.) HAROLD A. 577

Photographs 1908–1910

13 items

Black-and-white original prints of McAlester, Oklahoma, including photographs of theaters, bands, and damage scenes of a 1908 explosion at the Union railroad depot.

Unpublished finding aid available.

PATTERSON, OKLAHOMA, COLLECTION 578

Photographs ca. 1890–1900

507 items

Glass plate negatives of the Patterson Lumber Mill, railroad bridges and stations, construction workers, and schoolchildren at play. The collection also includes photographs of unidentified families and individuals outside buildings and houses and in outdoor settings.

Unpublished finding aid available.

PAUL, R. M. 579

Photographs 1915

9 items

Black-and-white original prints of the University of Oklahoma campus, including Boyd House, the Carnegie building, Evans Hall, the engineering building, King Hall, Monnet Hall, and the power plant. The collection also contains a photograph of the railroad depot at Norman, Oklahoma.

Unpublished finding aid available.

PAULS VALLEY CHAMBER OF COMMERCE COLLECTION　　　　580
Photographs 1908–1941
3 items
Black-and-white original prints of the 1908 and 1941 floods in Pauls Valley, Oklahoma.
Unpublished finding aid available.

PAULS VALLEY STATE TRAINING SCHOOL　　　　581
FOR BOYS COLLECTION
Photographs 1919–1936
3 items
Black-and-white original prints of Clarence Rhodes and Leoa Miller (later Leoa Dixon).
Unpublished finding aid available.

PAXTON, JOSEPH FRANCIS　　　　582
Photograph 1901
1 item
A black-and-white original print of the cast of a play, dressed in colonial costumes.

PAYNE, W. L.　　　　583
Photographs 1874–1925
19 items
Black-and-white copy prints of Okfuskee, Indian Territory, and Okemah, Indian Territory and Oklahoma, including street scenes, views of businesses, cotton marketing, and outlaws.
Unpublished finding aid available.

PEACH, GUINE　　　　584
Photographs 1900–1940
155 items
Black-and-white original photographs of Guine Peach, and the towns of Broken Bow, Chandler, McAlester, Norman, and Weatherford, Oklahoma. Also included are scenes of Peach as a student at the University of Oklahoma.
Unpublished finding aid available.

PEARSON, LEB E.　　　　585
Photograph n.d.
1 item
A black-and-white copy print of a man standing beside a car.

PEARSON, LOLA CLARK (1871–1951) 586
Photographs ca. 1920–1947
78 items

Black-and-white original and copy prints of Lola Clark Pearson, president of the Oklahoma State Federation of Women's Clubs, with club members and officials from across the United States. Also included in the collection are photographs of a Wichita Indian grass lodge.
Unpublished finding aid available.

PEREZ, MANUEL, JR. 587
Photographs 1943–1944
19 items

Black-and-white negatives and copy prints of Manuel Perez, Jr., taken primarily at Camp Mackall, North Carolina, during training for his service in the 511th Parachute Infantry Regiment of the U.S. Army in World War II.
Unpublished finding aid available.

PERKINS, AMY, and J. T. PERKINS 588
Photographs 1888–1904
26 items

Black-and-white original and copy prints of Osage and Kaw Indians, oil wells, farming scenes, schools, and scenes of Guymon and Tonkawa, Oklahoma Territory.
Unpublished finding aid available.

PETERS, KAY (b. 1885) 589
Photographs 1893–1920
34 items

Black-and-white original prints of Garber, Oklahoma Territory, including scenes of farming, businesses, oil wells, bands, and schools.
Unpublished finding aid available.

PETERSON, JESSIE PEARL 590
Photographs ca. 1905
11 items

Black-and-white copy prints of the Jack Abernathy family and Theodore Roosevelt.
Unpublished finding aid available.

PETERSON, ROBERT O. H. 591
Photographs 1960
14 items
Black-and-white original prints of the University of Oklahoma campus in Nor-
man, Oklahoma, and an outdoor performance by unidentified American Indian
dancers. Campus buildings include the Oklahoma Memorial Union, Bizzell
Memorial Library, Woodrow Wilson Center, and the university's natural history
museum, then known as the Stovall Museum.
Unpublished finding aid available.

PHILLIPS, FRANK (1873–1950) 592
Photographs 1870–1930
2,758 items
Black-and-white original prints, copy prints and glass plate negatives of Apache,
Arapaho, Blackfoot, Caddo, Cherokee, Cheyenne, Chickasaw, Chippewa, Choctaw,
Comanche, Creek, Crow, Delaware, Kalispel, Kickapoo, Kiowa, Kiowa-Apache,
Kutenai, Modoc, Mohave, Navajo, Nez Percé, Osage, Otoe, Paiute, Pawnee, Ponca,
Pueblo, Sac and Fox, Seminole, Shastan, Shawnee, Shoshoni, Sioux, Skitswish, Spo-
kan, Taos, Tonkawa, Umatilla, Wasco, Wichita, Yakima and Yuma Indians. More
than 750 of the glass plate negatives in this collection were created by Anadarko
photographer Annette Ross Hume. Her photographs focus on life on and around
the Kiowa, Comanche, and Wichita Indian Agency in Anadarko, circa 1890. The
collection also contains images of mining; the oil industry; the military; farms and
farming activities; the range cattle industry; education; and transportation in Okla-
homa Territory, Indian Territory, and Oklahoma. Scenes of the Oklahoma towns
of Alva, Atoka, Beaver, Claremore, Duncan, Edmond, Eufaula, Guthrie, Henryetta,
Laverne, Lexington, McAlester, Muskogee, Noble, Pawhuska, Plainview, Ponca
City, Purcell, Shawnee, Tahlequah, Tishomingo, and Weatherford are included. In
addition, the first year of settlement of Anadarko, Oklahoma, is well documented
by photographs in this collection. Among the many personalities represented in
this collection are Frank Apache, Elizabeth Apheatone, Bacon Rind, Big Tree,
Black Beaver, Minnie Black Star, Duke Buffalo, Dennis Wolf Bushyhead, Chief
Joseph, Crazy Snake, Cut Nose, Eagle Staff, Gall, Geronimo, Gotebo, John Grass,
James Butler Hickok, Keokuk, Kicking Bird, Left Hand Bear, Delos Lone Wolf, S.
H. Mayes, Green McCurtain, Etta Mopope, George Mopope, Paiute Jim, Cynthia
Ann Parker, Quanah Parker, David L. Payne, Alexander Posey, Prairie Flower, Red
Cloud, Roman Nose, William P. Ross, Satank, Satanta, Sitting Bull, Spotted Tail,
Standing Bear, Standing Bull, Touch the Clouds, Two Moons, Sarah C. Watie, Stand
Watie, Don Whistler, White Antelope, White Horse, and Wolf Robe.
Unpublished finding aid available.

PHILLIPS, LEON CHASE (1890–1958) 593
Photographs 1934–1942
306 items

Black-and-white original prints of Leon C. Phillips, including photographs of Phillips as speaker of the Oklahoma House of Representatives, as a candidate for governor, and as governor of Oklahoma. The collection also contains photographs of the Kiowa Tribe at Anadarko, Oklahoma, taking part in a ceremony making Phillips an honorary Kiowa chief; the Phillips family; the Oklahoma National Guard; the 1938 Democratic Convention in Tulsa; campaign parades; state functions and ceremonies; and the Oklahoma State Penitentiary band. Photographs of Franklin Delano Roosevelt, Will Rogers, Jr., Lyle Boren, Frank Phillips, William Grove Skelly, and William B. Bizzell are among the personalities in the collection.
Unpublished finding aid available.

PHILLIPS, TOM 594
Photographs ca. 1900–1910
11 items

Black-and-white original prints of businesses in Holdenville, Indian Territory and Oklahoma, and the Emahaka Mission, Indian Territory.
Unpublished finding aid available.

PIBURN, ANNE ROSS (1892–1960) 595
Photographs 1860–1910
34 items

Black-and-white copy prints of the Ross and Murrell families; the Cherokee Male Seminary; and students and campus of the Cherokee Female Seminary. Also included in the collection is a portrait of Mock, a Sac and Fox Indian, along with photographs of Cherry Adair, Lucile Archer, Alice French, Grace Phillips, Anne Ross, Carrie Ross, Fanny Ross, John Ross, Mary Ross, Fanny Sixkiller, Eldee Starr, and Robert Sparks Walker.
Unpublished finding aid available.

PICKARD, CLYDE C. 596
Photographs 1909
3 items

Black-and-white original prints of Northern Arapaho chief Black Coal, a pony, and an oil derrick in Oklahoma.
Unpublished finding aid available.

PICKLUM, ANNA 597
Photographs 1925
3 items
Black-and-white original prints of nurses and staff of the El Reno, Oklahoma, sanitarium.
Unpublished finding aid available.

PINE, W. B. (1877–1942) 598
Photographs ca. 1930
7 items
Black-and-white original prints of U.S. Senator W. B. Pine meeting with various groups of delegates and delivering a speech in Chandler, Oklahoma.
Unpublished finding aid available.

PITCHLYNN, PETER PERKINS (1806–1881) 599
Photographs 1870–1900
10 items
Black-and-white original prints of Choctaw Indian Chief Peter P. Pitchlynn and family. Also included are photographs of Allen Wright, Basil LeFlore, Joseph P. Folsom, and Israel Folsom, all officials of the Choctaw Nation tribal government.
Unpublished finding aid available.

PLATTER, CLARA 600
Photographs 1910–1934
7 items
Black-and-white original prints of Peoria, Oklahoma, and photographs of automobile dealerships and repair facilities.
Unpublished finding aid available.

PORTER (Oklahoma) FIRST NATIONAL BANK COLLECTION 601
Photographs 1907–1942
5 items
Black-and-white original prints of Porter, Oklahoma, including photographs showing damage from a tornado in 1919.
Unpublished finding aid available.

POSTCARD COLLECTION

Picture postcards 1900–1915

3,231 items

Black-and-white and color postcards, with some offering holiday greetings, and others featuring views of cities, national parks, rivers, mountains, and scenic places in the United States. Many cards include scenes of Apache, Hopi, Kiowa, Navajo, Pueblo, and Ute Indians.

Unpublished finding aid available.

PRAIRIE OIL and GAS COMPANY COLLECTION

Photographs ca. 1930

89 items

Black-and-white original prints of oil wells, machinery, and employees of Prairie Oil and Gas Company, including images of the president of the company and workers in the oil fields.

Unpublished finding aid available.

PRICKETT, THEODOCIA CRALLE

Photographs 1887–1946

55 items

Black-and-white original prints of University of Oklahoma President Stratton D. Brooks and his family. The collection also includes images of the University of Oklahoma campus and a later university president, William Bennett Bizzell.

Unpublished finding aid available.

PRIMEAUX, FLOYD

Photographs ca. 1900

4 items

Black-and-white copy prints of Crazy Bear, Fireshaker, Roughface, Yellow Bull, Hairy Bear, Oscar Makes Cry, Zole Makes Cry, Thomas Makes Cry, and William Iron Thunder, all of whom are Ponca Indians.

Unpublished finding aid available.

PRITCHETT, ROGER

Photographs 1902–1970

9 items

Black-and-white copy prints of the Czech American community at Prague, Oklahoma Territory and state. Included are scenes of businesses, members of the local Sokol Society, and a Fort Smith and Western Railroad locomotive.

Unpublished finding aid available.

PUCKETT, E. N. 607

Photographs 1920–1950

6 items

Black-and-white original and copy prints of a Union Equity Cooperative Exchange stockholders' meeting, and the construction of grain elevators at Enid, Oklahoma, and at Perryton, Texas.

Unpublished finding aid available.

PUSHMATAHA COUNTY HISTORICAL SOCIETY COLLECTION 608

Photographs 1910–1960

56 items

Black-and-white copy prints of Antlers, Oklahoma, including scenes of streets, schools, businesses, railroads, and the town band.

Unpublished finding aid available.

QUAPAW (Oklahoma) SAINT MARY'S SCHOOL COLLECTION 609

Photographs 1907–1923

2 items

Black-and-white original prints of Saint Mary's Catholic School at Quapaw, Oklahoma.

Unpublished finding aid available.

RACKLEY, B. H. 610

Photographs 1889–1915

5 items

Black-and-white original and copy prints of settlers in the land run of 1889 crossing the Canadian River at Purcell, Indian Territory. Also included in the collection are photographs of a women's temperance society at Lexington, Oklahoma; a parade at Blanchard, Oklahoma; and the lynching of four men in Ada, Oklahoma, for the killing of Deputy U.S. Marshal Gus Bobbitt.

Unpublished finding aid available.

RADER, JESSE LEE (1883–1973) 611

Photographs 1889–1951

66 items

Black-and-white original prints of Norman, Oklahoma Territory, and Guthrie, Oklahoma. Also in the collection are scenes of the University of Oklahoma that include photographs of students, faculty, and the campus.

Unpublished finding aid available.

RADER, KATHERINE (1915–2005) 612
Photographs ca. 1902–1908
23 items
Black-and-white original prints of the University of Oklahoma class of 1908; University of Oklahoma prep school class photographs; and a photograph of Sigma Nu fraternity members on the University of Oklahoma football team.
Unpublished finding aid available.

RADFORD, ERNEST E. (1870–1948) 613
Photographs 1916
18 items
Black-and-white copy prints of businesses, banks, and street scenes in Oklahoma City and Shawnee, Oklahoma.
Unpublished finding aid available.

RAINES, (Mrs.) GEORGE 614
Photographs 1914–1915
2 items
Black-and-white original prints of the Ramona, Oklahoma, High School basketball and football teams.

RAINES, J. A. 615
Photographs 1950–1951
4 items
Black-and-white original prints of bridges near Bartlesville, Ponca City, and Wagoner, Oklahoma.
Unpublished finding aid available.

RAINEY, GEORGE (1866–1940) 616
Photographs 1848–1927
125 items
Black-and-white original and copy prints of Apache, Arapaho, Arikara, Assiniboine, Blackfoot, Caddo, Cayuga, Cayuse, Cherokee, Cheyenne, Chinook, Chippewa, Choctaw, Comanche, Crow, Delaware, Hidatsa, Hopi, Iowa, Kaw, Kickapoo, Kiowa, Klamath, Laguna, Makah, Mandan, Miami, Missouri, Modoc, Nez Percé, Omaha, Onondaga, Osage, Otoe, Paiute, Papago, Pawnee, Peoria, Ponca, Potawatomi, Pueblo, Puyallup, Quapaw, Quinault, Sac and Fox, Salish, Seminole, Seneca, Shawnee, Shoshoni, Sioux, Tuscarora, Umatilla, Ute, Walla Walla, Winnebago, Wyandotte, Yakima, Yuchi, Yuma, and Zuni Indians. The collection contains village scenes, along with group photographs and studio portraits of persons

including Bacon Rind, Big Jim, Bird Chief, Bird Rattle, Billy Bowlegs, Chief Joseph, Curley, Cut Finger, Cut Nose, Eagle Chief, Gall, Geronimo, Gotebo, Iron Tail, Keokuk, Little Soldier, Low Dog, Pacer, Quanah Parker, Plenty Coups, Rain in the Face, Red Jacket, Satanta, Spotted Tail, John Stink, Three Bears, John Tiger, White Eagle, and Yellow Hammer.

Unpublished finding aid available.

RANDALL, WILLIAM B. (1882–1968) 617
Photographs 1900–1930
147 items

Black-and-white original prints of oil drilling activities in Osage County, Oklahoma Territory; and scenes of the towns of Ramona, Indian Territory and Oklahoma; and Avant, Bartlesville, Claremore, Dewey, Garvin, Miami, Skiatook, Tulsa, and Webbers Falls, Oklahoma. The collection also contains photographs of the U.S. Army, railroads, businesses, and schools.

Unpublished finding aid available.

RATON, NEW MEXICO, COLLECTION 618
Photographs ca. 1910
12 items

Black-and-white original prints of Raton, New Mexico. Included are photographs of a parade, street scenes, and a mill.

Unpublished finding aid available.

RAY, GRACE ERNESTINE (1900–1984) 619
Photographs 1906–1949
386 items

Black-and-white original prints of the University of Oklahoma; the U.S. Naval Air Station at Norman, Oklahoma; defense work at Tinker Field, near Midwest City, Oklahoma, including women employees; the British Air School at Miami, Oklahoma, during World War II; dust storms; Ponca and Cherokee Indians; and scenes of the Miller Brothers 101 Ranch.

Unpublished finding aid available.

RAYMOND, FRANK A. 620
Photograph 1896
1 item

A black-and-white copy print of Red Oak, Indian Territory.

RECORDS, RALPH HAYDEN (1889–1957) 621
Photographs 1884–1937
24 items
Black-and-white copy prints of the Ralph Records family, and Osage Indians Hard Rope, Black Dog, Ogese Captain, and others.
Unpublished finding aid available.

REDWINE FAMILY COLLECTION 622
Photographs 1910–1942
20 items
Black-and-white copy prints of Spiro, Oklahoma. Included are photographs of the Redwine Brothers Store, street scenes, and cotton market day at Spiro. There are also images of the salvaged battleship, USS *Oklahoma*, and of the USS *Oklahoma* baseball team.
Unpublished finding aid available.

REESE, JIM EANES, and SARAH BURTON REESE 623
Photographs 1896–ca. 1955
11 items
Black-and-white original prints of University of Oklahoma economics professor Dr. Jim Eanes Reese, members of his family, and early views of buildings and businesses in downtown Comanche, Texas.
Unpublished finding aid available.

RENNIE, ALBERT (1863–1948) 624
Photographs 1892, 1932–1933
40 items
Black-and-white original and copy prints of the Rennie family, and a jury, judge, and marshal in Ardmore, Indian Territory.
Unpublished finding aid available.

RESENDES, MARY W. 625
Photograph ca. 1900
1 item
A black-and-white original print of University of Oklahoma students Maude A. Ambrister, Stella Medlock, and Lula Hooper, on the steps of the university's first administration building.

RHOADS, EARL ROAINE 626
Photographs 1940–1943
15 items

Black-and-white original prints of U.S. Marine Earl Roaine Rhoads during his service in World War II; Also depicted are members of his family, including William Henning, Guy Kariker, Della Mae Rhoads, Gaytha Rhoads, Lettie Henning Rhoads, Sherman Rhoads, Shirley Rhoads, and Shirley Ruth Rhoads.
Unpublished finding aid available.

RHODES, CHARLES B. (1862–1949) 627
Photographs 1880–1930
9 items

Black-and-white original and copy prints of Judge Isaac Parker and federal marshals who operated from Fort Smith, Arkansas. Also included are photographs of some of the outlaws captured or killed by the marshals.
Unpublished finding aid available.

RHODES, W. H. 628
Photographs n.d.
2 items

Black-and-white original prints of buildings and automobiles in Gray, Oklahoma.
Unpublished finding aid available.

RICE, DON 629
Photographs ca. 1889–1939
107 items

Black-and-white copy prints of Oklahoma City shortly after the 1889 land run, the Oklahoma state capitol building, and Franklin D. Roosevelt delivering a speech in Oklahoma. The collection also contains images of businesses and street scenes in many cities and towns in Indian and Oklahoma territories and the state, including Chickasha, Durant, Kingfisher, Lawton, Norman, Ravia, and Tulsa. Miscellaneous additional photographs show an oil well fire; Will Rogers; and the lynching of four men in Ada, Oklahoma, for the killing of Deputy U.S. Marshal Gus Bobbitt.
Unpublished finding aid available.

RIEDT, G. A. 630
Photograph 1902
1 item
A black-and-white copy print of coal miners at the Milby and Dow Coal and Mining Company, Dow, Indian Territory.

RITCHIE, W. H. 631
Photograph 1910
1 item
A black-and-white original panorama of Main Street, Durant, Oklahoma.

ROGERS-NEILL COLLECTION 632
Photographs 1870–1949
6 items
Black-and-white original and copy prints, and a tintype of the Elkhouse Hotel and Boarding House, at McAlester, Indian Territory. The collection also includes photographs of the Sittel family.
Unpublished finding aid available.

ROSE, NOAH HAMILTON (1874–1952) 633
Photographs 1870–1940
2,229 items
Black-and-white copy prints of early Texas history, Texas Rangers, lawmen, outlaws, gunfighters, and wild west shows. The collection also includes scenes of ranching, cattlemen, and cowboys of the Southwest; the U.S. Army during the Apache campaigns; the Little Big Horn battlefield; the Indian Wars of 1876 and 1890–1891; and prints of churches, cathedrals, and missions in Texas, California, and Arizona. Images of Apache, Arapaho, Cheyenne, Chippewa, Comanche, Creek, Crow, Kickapoo, Kiowa, Maricopa, Modoc, Navajo, Nez Percé, Otoe, Papago, Pawnee, Ponca, Pueblo, Shoshoni, Sioux, and Yuma Indians may be found in the collection. Prominent western personalities include Wild Bill Hickok, Buffalo Bill Cody, Gall, Geronimo, Quanah Parker, Low Dog, Sitting Bull, Frank and Jesse James, Heck Thomas, Bill Tilghman, Chris Madsen, Pat Garrett, Billy the Kid, the Daltons and Youngers, Roy Bean, George A. Custer, California Joe, the Sundance Kid, Butch Cassidy, and the Earp brothers.
Unpublished finding aid available.

ROSENTHAL, ELIZABETH (Betty) CLARK (1921–2008) 634
Photographs ca. 1890–1981
1,078 items
Black-and-white and color original prints from the life and career of anthropologist and Indian advocate Betty Rosenthal and her parents, Episcopal missionaries the Reverend David W. Clark and Elizabeth Mann Clark. The collection contains photographs of Navajo, Sioux, and other American Indians and Episcopal Church activities at Gallup and Santa Clara Pueblo, New Mexico; Rosebud Reservation, Fort Thompson, Rapid City, and Crow Creek Agency, South Dakota; and Good Shepherd Mission at Fort Defiance, Arizona. Episcopal churches in Batavia and Geneseo, New York, are also pictured. Members of the Clark family, their friends, American Indian community leaders, and church associates appear in many of the photographs. Individual names include Robert L. Bennett, Philip Deloria, the Right Reverend George H. Kinsolving, the Reverend Baptiste Lambert, James A. McGrath, and David Warren.
Unpublished finding aid available.

ROUNDTREE, WALTER 635
Photograph 1905
1 item
A black-and-white copy print of a barber shop in Pauls Valley, Indian Territory.

RUGELEY, THERESA MATOCHA (1921–) 636
Photographs n.d.
91 items
Black-and-white original prints of the Rugeley family from Cameron, Texas.
Unpublished finding aid available.

RUSH, FRANK 637
Photographs ca. 1925
59 items
Black-and-white copy prints of the All-Indian Fair held at Craterville Park, Oklahoma, in the Wichita Mountains. The prints include images of Apache, Comanche, and Kiowa Indians in native clothing.
Unpublished finding aid available.

RUSSELL, NANCY, TRUST COLLECTION 638
Photographs 1938–1970
46 items
Color original prints of artwork by western American artists Charles M. Russell and Frederic Remington. This collection also includes images of Russell's gravesite, Douglas "Wrong Way" Corrigan, Spotted Elk, and Great Falls, Montana.
Unpublished finding aid available.

RUTH, KENT (1916–1990) 639
Photographs 1892–1980
362 items
Black-and-white copy prints of Fort Reno, Oklahoma Territory; El Reno, Oklahoma City, and Tuttle, Oklahoma; Albuquerque, Fort Union, and Las Vegas, New Mexico; Branson, Missouri; Lebanon, Ohio; New York, New York; Montreal and Quebec, Quebec; Ottawa and Toronto, Ontario; and Vancouver, British Columbia. The collection also includes prints of the Pioneer Woman Monument at Ponca City, Oklahoma, and the Cheyenne and Arapaho Indian Fair at Watonga, Oklahoma.
Unpublished finding aid available.

SAINT GREGORY'S ABBEY COLLECTION 640
Photographs 1892–1974
141 items
Black-and-white copy prints of Sacred Heart Mission, Abbey, and College, along with scenes of Saint Gregory's College and Abbey, Saint Benedict's Mission, and Saint Patrick's Mission, all in Oklahoma. The collection also includes photographs of students, members of monastic orders, and construction of the schools and abbeys.
Unpublished finding aid available.

SALTER, HENRY HYDE (1823–1871) 641
Photograph 1858
1 item
A black-and-white copy print of Henry Hyde Salter.

SALTER, LEWIS SPENCER (1926–1989) 642
Photographs 1892–1915
10 items
Black-and-white original prints and glass plate negatives of cowboys and ranching scenes. The collection also includes a photograph of members of the Oklahoma Territorial Volunteer Infantry Regiment, and photographs of a football team and a track meet at the University of Oklahoma.
Unpublished finding aid available.

SCHERMAN, (Mrs.) WILLIAM 643
Photographs 1892–1914
11 items
Black-and-white original and copy prints of coal mining activities at Krebs and Dow, Oklahoma.
Unpublished finding aid available.

SCHMITT, KARL, and IVA SCHMITT 644
Photographs 1900–1948
28 items
Black-and-white copy prints of Caddo, Cheyenne, and Kiowa Indians, accumulated in the course of the Schmitts' anthropological research.
Unpublished finding aid available.

SCHWAB, BEN 645
Photographs 1943–1945
16 items
Black-and-white and color copy prints of William M., J. W., Harry C., and Henry F. Schwab during their military service in World War II. Main service areas include Clinton, Oklahoma; New York City, New York; and England.
Unpublished finding aid available.

SCHWABE, GEORGE B. (1886–1952) 646
Photographs 1946–1947
14 items
Black-and-white copy prints of U.S. Congressman George B. Schwabe and his home in Tulsa, Oklahoma.
Unpublished finding aid available.

SEARCY, E. C. and KATE W. SEARCY 647
Photographs n.d.
3 items
Black-and-white original prints of children from the Red Moon Indian School in Elk City, Oklahoma.
Unpublished finding aid available.

SEARS, (Mr. and Mrs.) WALTER 648
Photographs 1890–1929
13 items
Black-and-white original prints of Ramona, Indian Territory and Oklahoma. Also included are photographs of Walter Sears at his automobile dealership in Ramona.
Unpublished finding aid available.

SELLS, IRENE BOWERS 649
Photographs n.d.
2 items
Black-and-white original prints of Lemuel Dorrance, one of the first graduates of
the University of Oklahoma.
Unpublished finding aid available.

SEMINOLE NATION MUSEUM COLLECTION 650
Photographs 1880–1930
202 items
Black-and-white copy prints of Seminole Indians, railroads, oil fields, schools, and
cotton gins, along with scenes of Maud, Seminole, Weber City, and Wewoka, Indian
Territory and Oklahoma. Individuals include Caesar Bowlegs, John Chupco, Alice
B. Davis, Chili Fish, Floyd Harjo, Mary Harjo, George Scott, John Stink, and Lena
Turman.
Unpublished finding aid available.

SEMINOLE PRODUCER COLLECTION 651
Photographs 1920–1936
53 items
Black-and-white original prints of the towns of Seminole and Bowlegs, Oklahoma,
during the oil boom of the 1920s. The collection also includes photographs of oil
production activities in the Seminole area.
Unpublished finding aid available.

SEMINOLE PUBLIC LIBRARY COLLECTION 652
Photographs 1910–1947
11 items
Black-and-white copy prints of World War II war dead being returned to Seminole,
Oklahoma, for burial. The collection also includes a photograph of a baptism, and
farming and business scenes in the Seminole area.
Unpublished finding aid available.

SERAN, A. M. 653
Photographs 1875–1920
44 items
Black-and-white original and copy prints of Wewoka, Indian Territory and Okla-
homa; cotton gins; businesses; and a Democratic Party celebration. Also included
are scenes of Seminole Indian cemeteries and tribal voting.
Unpublished finding aid available.

SEWELL, EMMA **654**
Photographs 1910–1919
8 items
Black-and-white original prints and panoramas of Pauls Valley, Oklahoma. The collection includes scenes of Main Street, businesses, the railroad depot, and a parade for the returning World War I servicemen of Garvin County, Oklahoma.
Unpublished finding aid available.

SHAWNEE NEWS STAR COLLECTION **655**
Photographs 1902
11 items
Black-and-white copy prints of Shawnee, Indian Territory, including photographs of a trade union parade, businesses, cotton gin, and railroad construction.
Unpublished finding aid available.

SHAWNEE PUBLIC LIBRARY COLLECTION **656**
Photographs 1896–1928
86 items
Black-and-white copy prints of the towns of Hazel, Newalla, Romulus, Sayre, and Shawnee, Oklahoma, including scenes of schools, businesses, farming, railroads, sawmills, and mining.
Unpublished finding aid available.

SHELTON, STAN **657**
Photographs ca. 1880–1960
100 items
Black-and-white original and copy prints of Quanah Parker, his wives, descendents, and houses. Other photographs depict the reburial of Parker at Fort Sill in 1955; Geronimo; studio views of unidentified Indians; and the Ku Klux Klan. The collection also includes photographs of John F. Kennedy and Lyndon B. Johnson at an unidentified campaign stop.
Unpublished finding aid available.

SHERWIN, KATE COLLAR **658**
Photographs 1889
2 items
Black-and-white original prints of Guthrie, Oklahoma Territory, shortly after its settlement.
Unpublished finding aid available.

SHIRLEY, L. L. 659
Photographs 1885–1900
23 items
Black-and-white original prints of Turner Falls, Indian Territory; Chickasaw Indians; a balloon ascension at Sulphur, Indian Territory; and of the towns of Wynnewood and Cherokee Town, Indian Territory.
Unpublished finding aid available.

SHOOK, WILLIAM VANCE (1871–1960) 660
Photographs 1910–1929
29 items
Black-and-white original prints of Methodist churches in the towns of Fort Cobb, Gracemont, and Putnam City, Oklahoma. Also included in the collection are scenes of William Vance Shook and his family; tornado damage at Union City, Oklahoma; and the Men's Bible Class of Crescent, Oklahoma.
Unpublished finding aid available.

SHOWEN, W. E. 661
Photographs 1908–1920
25 items
Black-and-white original prints of the towns of Minco, Mountain View, Okemah, and Wynnewood, Oklahoma. The collection includes scenes of businesses, schools, newspaper publishing, and a corn carnival at Minco, Oklahoma.
Unpublished finding aid available.

SHUCK, J. A. 662
Photographs 1880–1920
172 items
Black-and-white copy prints and original glass plate negatives of Arapaho, Cheyenne, Cheyenne-Arapaho, Kiowa, Pawnee, Sioux, and Wichita Indians. The collection also includes scenes of the U.S. Army, the Darlington Indian Agency, the Concho Indian School, and Fort Reno, Oklahoma Territory. Among the personalities in the collection are Bobtail Wolf, Bull Bear, George Eaglenest, Little Owl, Magpie, John Red Turtle, Henry Roman Nose, Three Fingers, Whirlwind, Yellow Bear, and Young Bear.
Unpublished finding aid available.

SHULL, RUSSELL JOHNSON (1878–1954) 663
Photograph 1918
1 item
A black-and-white original print of Russell J. Shull.

SHUMARD, EVELYN HUGHES (1886–1942) 664
Photographs 1895–1940
101 items
Black-and-white original prints of Sapulpa, Indian Territory and Oklahoma; Fort Reno, Oklahoma City, and Tulsa, Oklahoma; Fort Smith, Arkansas; and photographs of businesses, schools, oil wells, railroads, and cotton ginning. The collection also includes scenes of Apache, Comanche, Creek, and Yuchi Indians, and the Euchee Mission near Sapulpa, Indian Territory.
Unpublished finding aid available.

SIEG, WILL R. 665
Photograph 1905
1 item
A black-and-white copy print of Noble Academy, Noble, Oklahoma Territory.

SIGMA ALPHA EPSILON FRATERNITY COLLECTION 666
Photographs 1910–1916
11 items
Black-and-white original prints of Sigma Alpha Epsilon fraternity members and events. The collection also includes photographs of the University of Oklahoma campus and the football team.
Unpublished finding aid available.

SIMPSON, J. D. 667
Photographs 1895–1900
2 items
Black-and-white original prints of the interior of J. D. Simpson's hardware store in Arapaho, Oklahoma Territory, along with a scene of Simpson's farming activities.

SIMPSON, (Mrs.) MORRIS S. 668
Photographs 1909–1925
21 items
Black-and-white original prints of Lawton, Oklahoma, including scenes of Morris Simpson's store, ranch, and cotton gin.
Unpublished finding aid available.

SIPE, JOHN 669
Photographs 1896–1940
38 items
Black-and-white copy prints of Cheyenne, Kiowa, and Shoshoni Indians. Included are photographs of Mary Coyote, Red Bird, Inez Roman Nose, Wolf Chief, and the Whiteskunk family.
Unpublished finding aid available.

SLACK, ERLE B. 670
Photograph n.d.
1 item
A black-and-white original print of Erle B. Slack, editorial cartoonist for the *Tulsa Daily World.*

SLICK, THOMAS BAKER (1883–1929) 671
Photographs 1904–1950
42 items
Black-and-white copy prints of independent oil producer Tom Slick and of the Cushing, Oklahoma City, and Tonkawa, Oklahoma, oil fields. The collection also includes photographs of the Slick and Urschel families.
Unpublished finding aid available.

SMITH, HOPE 672
Photographs 1905
2 items
Black-and-white copy prints of the last Cherokee senate. Also includes a photograph of David Towe, assistant principal chief of the Cherokee Nation.

SMITH, J. G. 673
Photographs 1903–1940
10 items
Black-and-white original prints of Joseph G. Smith and his medical offices in Bartlesville, Cropper, and Ochelata, Oklahoma. Also included is a photograph of Olive Stokes (Mrs. Tom Mix) roping a steer.
Unpublished finding aid available.

SMITH, WOODROW W. 674
Photographs 1936–1939
320 items
Black-and-white original prints of Smith during his tour of duty on the battleship USS *Oklahoma*. Included are photographs of the USS *Oklahoma*, USS *Chicago*, USS *Lexington*, USS *Saratoga*, and other U.S. naval warships and aircraft. The photographs are of a 1936 cruise of the USS *Oklahoma*, with scenes of the Panama Canal, San Diego and San Francisco, California, England, France, and Gibraltar. Also in the collection are photographs of United States citizens boarding the USS *Oklahoma* at Bilboa, Spain, during the Spanish Civil War. *Unpublished finding aid available.*

SNOW, JERRY WHISTLER 675
Photographs 1880–1970
1,550 items
Black-and-white original prints of the Whistler, Carson, and Alexander families; Sac and Fox Indians; and the Sac and Fox Agency, Indian Territory. Also included are scenes of the University of Oklahoma campus and athletic events; landscapes and camping; ranching; cotton gins; Sacred Heart Mission; schools; and Shawneetown, Indian Territory; along with images of Iowa, Pawnee, Potawatomi, and Shawnee Indians. The collection contains individual photographs of Esther Big Walker, Mabel Conteau, Charlie Keokuk, Isaac McCoy, Alice Whistler, Don Whistler, Jerry Whistler, Rex Whistler, and Sarah Whistler. *Unpublished finding aid available.*

SOONER CATHOLIC MAGAZINE COLLECTION 676
Photographs 1889–1920
21 items
Black-and-white copy prints of Catholic churches, schools, and monastic orders in Oklahoma. Also included are images of Osage and Quapaw Indians and scenes of the towns of Antlers, Ardmore, Boley, Chickasha, Fairfax, and Guthrie, Oklahoma. Personalities represented in this collection are Bacon Rind, Andrew Bighorse, Maria Teresa Jenkins, Fred Lookout, Henry Red Eagle, and Roan Horse. *Unpublished finding aid available.*

SOSEBEE, R. L. 677
Negatives 1922–1951
27 items
Black-and-white negatives of R. L. Sosebee and family in Wilson and Arkoma, Oklahoma. The images show R. L. Sosebee as a schoolboy at Ambrose Ward School in Wilson, Oklahoma; playing guitar and posing with the Junior Play Boys band; and at the Industrial Exposition Hall in Hiroshima, Japan. The collection also includes views of World War II aircraft and artillery shells, and a 1920s-era Coca-Cola delivery truck.
Unpublished finding aid available.

SOULE, WILLIAM S. (1836–1908) 678
Photographs 1869–1874
73 items
Black-and-white copy prints of Arapaho, Caddo, Cheyenne, Comanche, Kiowa, Kiowa-Apache, and Wichita Indians taken by Soule at Fort Sill, Indian Territory. Among the personalities in this collection are Big Tree, Black Hawk, Dull Knife, Kicking Bird, Little Bear, Little Big Mouth, Little Raven, Lone Bear, Lone Wolf, Otter Belt, Pacer, Poor Buffalo, Satank, Satanta, Shield, Son of Little Raven, Trailing the Enemy, White Horse, Woman Heart, and Yellow Bear.
Unpublished finding aid available.

SPORLEDER, DON 679
Photographs 1893–1910
26 items
Black-and-white copy prints of the towns of Davenport and Shamrock, Oklahoma; and of Chandler, Perry, and Stroud, Oklahoma Territory. The collection includes scenes of cotton marketing; streets; railroad construction; the Oklahoma National Guard; and tornado damage at Chandler, Oklahoma.
Unpublished finding aid available.

SPRANGEL, BERT 680
Photograph 1906
1 item
A black-and-white original panorama of Claremore, Indian Territory.

STAHL, A. L. 681
Photographs 1907
3 items
Black-and-white copy prints of the Tonkawa Auto Club at Newkirk and Billings, Oklahoma. Also included is a scene of Tonkawa, Oklahoma.
Unpublished finding aid available.

STANDARD OIL COMPANY OF NEW JERSEY COLLECTION 682
Photographs n.d.
188 items
Black-and-white copy prints of the petroleum industry, including oil wells, oil fields, drilling operations, refineries, laboratories, company employees, petroleum-based products, shipping, and pipeline construction. The collection also includes images of farming, and New York City, New York.
Unpublished finding aid available.

STANDIFER, ORION C. (ca. 1896–1972) 683
Photographs n.d.
3 items
Black-and-white copy prints of pen and ink drawings of C. W. Tedrowe, drawn by Cosmo Falconer.
Unpublished finding aid available.

STEFFENS, T. H. 684
Photograph n.d.
1 item
A black-and-white copy print of a lithograph of Charles Page.

STEINBOCK, DELMAR 685
Photograph 1934
1 item
A black-and-white original print of the University of Oklahoma football team, including Delmar Steinbock, in Washington, D.C.

STEPHENS COUNTY HISTORICAL MUSEUM COLLECTION 686
Photographs 1880–1980
128 items
Black-and-white copy prints of the towns of Comanche, Empire City, and Marlow, Oklahoma; and Duncan, Indian Territory. The collection includes photographs of businesses, farming, street scenes, firefighters, schools, banks, and the oil industry.
Unpublished finding aid available.

STEPHENS, ALEXANDER H. 687
Photographs 1866
2 items
Black-and-white original prints of Alexander H. Stephens.

STEPHENS, JOHN KIRKER 688
Postcards n.d.
4 items
Black-and-white and color postcards of locomotives, trolley cars, and a railroad-themed restaurant.
Unpublished finding aid available.

STEREOGRAPH CARDS COLLECTION 689
Stereograph cards n.d.
15 items
Black-and-white original stereograph cards of Apache, Cheyenne, and Comanche Indians. This collection also includes stereograph cards of U.S. Presidents George Washington and Ulysses S. Grant.
Unpublished finding aid available.

STEWARD, BIRDIE 690
Photographs n.d.
7 items
Black-and-white original prints of railroad construction near Okay, Oklahoma, and of mining activities near Bromide, Oklahoma.
Unpublished finding aid available.

STEWART, PAUL (1892–1950) 691
Photographs 1931–1947
28 items
Black-and-white original prints of Paul Stewart, who served in the U.S. House of Representatives and in the Oklahoma legislature. The collection features images of Stewart among his political colleagues; photographic montages of members of the Oklahoma State Senate; and sacks of feed grain in Texas. Notable individuals pictured are U.S. President Harry S. Truman, and Oklahoma politicians Victor Wickersham, Robert S. Kerr, Mike Monroney, and Lyle Boren.
Unpublished finding aid available.

STILES, CLEO 692
Photograph 1920
1 item
A black-and-white original print of Cleo Stiles working in her garden near Pauls Valley, Oklahoma.

STONE, LUCILE OLIVER 693
Photographs 1913–1951
13 items
Black-and-white copy prints of stage productions of the Tulsa (Oklahoma) Little Theater. The collection also includes a photograph of the Pioneer Woman Monument at Ponca City, Oklahoma.
Unpublished finding aid available.

STONE, U. S. 694
Photographs 1897–1905
5 items
Black-and-white original prints of University of Oklahoma students.
Unpublished finding aid available.

STOVALL, JOHN WILLIS (1891–1953) 695
Photographs 1927–1941
700 items
Black-and-white original prints of dinosaur fossil excavation sites in Colorado, Nebraska, New Mexico, Oklahoma, South Dakota, and Texas. Also included are photographs of dinosaur fossils; John Willis Stovall; Works Progress Administration workers; museum exhibits; and the University of Oklahoma.
Unpublished finding aid available.

STROUD HIGH SCHOOL COLLECTION 696
Photographs 1910–1922
11 items
Black-and-white copy prints of oil production facilities and equipment in the Drumright, Oklahoma, oil field. Also included are photographs of an oil well fire near Stroud, Oklahoma.
Unpublished finding aid available.

SULLIVAN, (Mrs.) JIM 697
Photographs n.d.
3 items
Black-and-white original and copy prints of a sawmill at Rathbone, Oklahoma, and the Wilkes family home.
Unpublished finding aid available.

SWEARINGEN, AUDLEY P. (1897–1951) 698
Photographs 1889–1905
140 items
Black-and-white original prints and glass plate negatives of the settlement of Guthrie, Oklahoma Territory. The collection includes images of street scenes; businesses; building construction; railroads; Guthrie as a tent city; and the U.S. Army at Guthrie. The majority of images in this collection were made by Harmon T. Swearingen.
Unpublished finding aid available.

SWEARINGEN, MARTHA 699
Photographs 1904–1930
42 items
Black-and-white original prints of Ramona, Indian Territory and Oklahoma, including scenes of businesses, ranching, and the construction of oil storage facilities.
Unpublished finding aid available.

TANNEHILL, (Mrs.) J. D. 700
Photographs 1896
2 items
Black-and-white original prints of students, faculty, and the campus of Tuskahoma Female Institute, a Choctaw Indian girls school at Tuskahoma, Indian Territory.

TANTLINGER, EDITH, and D. VERNON TANTLINGER (b. 1864) 701
Photographs 1896–1930
257 items
Black-and-white original prints of wild west show performers Edith and D. Vernon Tantlinger. The collection includes scenes of the Tantlingers performing with the Miller Brothers 101 Wild West Show, Tantlinger's Wild West Show, and the Tex-Mex Real Wild West Show. Also included are photographs of Joseph C. Miller, Princess Wenona, John Spain, and the Parry sisters.
Unpublished finding aid available.

TAYLOR, G. W. 702
Photograph n.d.
1 item
A black-and-white copy slide of a kindergarten class rehearsing a patriotic play.

TAYLOR, WILLIAM MERRITT **703**
Photographs 1886–1891
55 items
Black-and-white original prints of the U.S. Army at Fort Niobrara and Fort Robinson, Nebraska. The collection includes original prints by John Anderson, and photographs of Cheyenne and Sioux Indians and of scenes from the Battle of Wounded Knee, with individual portraits of Blunt Arrow, Gall, Goes to War, Rain in the Face, Sitting Bull, and Henry Turkey.
Unpublished finding aid available.

33rd REGIMENT U.S. VOLUNTEER INFANTRY **704**
ASSOCIATION COLLECTION
Photographs 1899
2 items
Black-and-white original prints of officers of the 33rd Regiment U.S. Volunteer Infantry in Presidio of San Francisco, California, and a reunion of unit members.

THOMAS, ELBERT D. (1883–1953) **705**
Photograph ca. 1944
1 item
A black-and-white original print of Elbert D. Thomas, U.S. senator from Utah.

THOMAS, ELMER (1876–1965) **706**
Photographs n.d.
2 items
Black-and-white and color original prints of two unidentified women, one wearing traditional American Indian clothing.

THOMAS, JOHN F. **707**
Photograph n.d.
1 item
A black-and-white original print of a government sale of north addition town lots in Lawton, Oklahoma. John F. Thomas is pictured on horseback.

THOMPSON, ALFRED M., SR. (1859–1948) **708**
Photographs 1901–1917
7 items
Black-and-white original prints of Walters, Oklahoma, including the town cotton gin and cotton market; a banquet for World War I volunteers; and a Confederate veterans' reunion at the city park in Dallas, Texas.
Unpublished finding aid available.

THOMPSON, McKINLEY　　　　　　　　　　　　　　**709**
Photograph 1880
1 item
A black-and-white copy print of Wheelock Academy, a school for Choctaw Indians
in what is now McCurtain County, Oklahoma.

THORNTON, H. V. (Hurschel Vern) (1900–1961)　　　**710**
Photographs ca. 1935–1949
16 items
Black-and-white original prints of the Oklahoma State Legislative Council, and
Oklahoma Boys State conference staff and participants.
Unpublished finding aid available.

TILGHMAN, WILLIAM MATTHEW (1854–1925)　　　**711**
Photographs 1889–1925
177 items
Black-and-white original and copy prints of Oklahoma marshals; outlaws; fron-
tier life; and farming; along with scenes of the communities of Fort Sill, Guthrie,
Oklahoma City, and Perry, Oklahoma. The collection also includes photographs
of Apache, Cherokee, Cheyenne, Comanche, Kiowa, Sioux, and Wichita Indians,
with individual portraits of Awful Thunder, Black Fox, William F. Cody, Bill
Doolin, Geronimo, William Goldsby, Jesse James, Rain in the Face, Henry Starr,
and Heck Thomas.
Unpublished finding aid available.

TIMMONS, ALICE (1914–2010)　　　　　　　　　　**712**
Photographs 1899–1975
20 items
Black-and-white copy prints of Boyce and Alice Timmons; Cherokee Indians;
Osage Indians; and the Tyner family, including Ed Meyer, James Andrew Mus-
grove, Alice Tyner, Fred Tyner, and James Tyner.
Unpublished finding aid available.

TIMMONS, ALICE (1914–2010), and BOYCE TIMMONS (1911–1996)　**713**
Photographs 1880–1975
19 items
Black-and-white copy prints of Arapaho, Cherokee, Cheyenne, and Osage Indians,
including an image of Cherokee Female Seminary teachers and students. Photo-
graphs of Frank Muskrat, Ed Red Hat, George Tyner, Jefferson Tyner, and Nancy
Tyner are among those noted in the collection.
Unpublished finding aid available.

TINKER, CLARENCE L. (1887–1942)　　　　　　　　714
Photograph n.d.
1 item
A black-and-white original print of Major General Clarence L. Tinker, the Oklahoma-born general for whom Tinker Air Force Base is named.

TISHOMINGO (Oklahoma) MURRAY STATE　　　715
COLLEGE COLLECTION
Photographs n.d.
3 items
Black-and-white original prints of Murray State College at Tishomingo, Oklahoma.
Unpublished finding aid available.

TITTLE, LEON H. "LEM" (b. ca. 1895)　　　　　716
Photographs 1882–1930
59 items
Black-and-white original prints of Mangum, Oklahoma Territory and state; and Greer County, Texas and Oklahoma Territory. Also included are scenes of the range cattle industry, businesses, schools, and farming.
Unpublished finding aid available.

TODD, JOE (1946–)　　　　　　　　　　　　717
Photographs ca. 1890
91 items
Black-and-white original glass plate negatives and copy prints of Caddo, Cheyenne, Crow, and Hopi Indians, including individual portraits of Josephine Goose and Sarah Yellow Eyes.
Unpublished finding aid available.

TOLBERT, RAYMOND A. (1890–1960)　　　　　718
Photographs 1924–1947
10,216 items
Black-and-white original prints and negatives of numerous Oklahoma cities and towns, including Anadarko, Chandler, El Reno, Guthrie, Hobart, Muskogee, Norman, Oklahoma City, Rush Springs, Stroud, Tulsa, and Watonga. The collection also contains scenes from Alaska, Arkansas, California, Kentucky, Missouri, New Mexico, New York, Tennessee, Texas, Santo Domingo, Dominican Republic, and Mexico. Included are photographs of buildings, events, landscapes, and people. Also in this collection is an original print of the Kiowa scout I See O with President Calvin Coolidge, Guy Quoetone, Spotted Bird, Albert Attocknie, Ahpeatone, Yellow Fish, and Otippoby, in Washington, D.C.
Unpublished finding aid available.

TOLLESON FAMILY COLLECTION 719
Postcards ca. 1908–1910
145 items
Color postcards illustrated with early twentieth-century holiday themes, cartoons
and caricatures, birthday wishes, and landmarks and tourist destinations in the
United States. Among the locations depicted are Checotah, Indian Territory; Hyde
Park, the Iowa Building, the Hinton Theater, the Muskogee Hotel, and Sequoyah
School in Muskogee, Oklahoma; and a postcard in Cherokee from Tahlequah,
Oklahoma.
Unpublished finding aid available.

TOMLINSON, W. E. 720
Photographs 1887–1901
37 items
Black-and-white original and copy prints of Lawton, Oklahoma Territory, includ-
ing street scenes, businesses, U.S. marshals, the Lawton police, and railroads.
Unpublished finding aid available.

TONKAWA PUBLIC LIBRARY COLLECTION 721
Photographs 1893–1918
169 items
Black-and-white original and copy prints of Tonkawa, Oklahoma Territory and
state, including scenes of farming, railroad construction, schools, and businesses.
The collection also includes photographs of Apache, Caddo, Cheyenne, Comanche,
Kiowa, Omaha, Tonkawa, and Wichita Indians.
Unpublished finding aid available.

TORREY, CHARLES CUTTER 722
Photographs 1919
3 items
Black-and-white original prints of a man wearing a U.S. Army uniform, posing
with a girl and a young man.
Unpublished finding aid available.

TOUR OF THE WORLD COLLECTION 723
Stereograph cards n.d.
353 items
Black-and-white original stereograph cards of national parks, cities, and famous
landmarks from around the world. Countries and territories include Algeria,
Argentina, Australia, Austria, Belgium, Bermuda, Brazil, British West Indies,

Cambodia, Canada, Canary Islands, Chile, China, Costa Rica, Cuba, Czecho-slovakia, Denmark, Dutch East Indies, Ecuador, Egypt, El Salvador, England, France, French West Indies, Germany, Hungary, India, Ireland, Israel, Italy, Japan, Malaya, Mexico, Netherlands, Nicaragua, Norway, Palestine, Panama, Peru, the Philippines, Portugal, Puerto Rico, Scotland, Spain, Sweden, Switzerland, Syria, Thailand, United States, Venezuela, Wales, and Yugoslavia. States include Arizona, California, Florida, Hawaii, Idaho, Minnesota, Montana, New Jersey, New Mexico, New York, North Dakota, Oregon, Pennsylvania, Utah, Virginia, Washington, D.C., and Wyoming.
Unpublished finding aid available.

TOWNSHEND, S. NUGENT 724
Photographs ca. 1880
62 items
Black-and-white original prints of railroad depots, rivers, and mountains in Colorado, Indian Territory, New Mexico, and Texas. Photographs of officers and buildings at Fort Elliot, Texas, are also included.
Unpublished finding aid available.

TRADER, (Mrs.) ROY 725
Photographs 1905
9 items
Black-and-white original prints and a panorama of Snyder, Oklahoma Territory. The collection includes scenes of tornado damage to the town.
Unpublished finding aid available.

TRAVEL IN THE WEST COLLECTION 726
Photographs 1898–1907
189 items
Black-and-white original prints and cyanotypes from a photograph album documenting a family's everyday life and travels in the American West, circa 1898–1907. The images show children and adults at various tourist destinations in the areas of Colorado, New Mexico, and Arizona, including Santo Domingo Pueblo (Kewa Pueblo), Petrified Forest National Park, and Garden of the Gods.
Unpublished finding aid available.

TRIMBLE, VANCE H. (1913–) 727
Photographs 1913–1993
384 items
Black-and-white and color original prints of journalist and author Vance Trimble working at the *Houston Post* and the *Kentucky Post* and at various annual

editors' meetings. The collection also includes photographs of Trimble with Gregory Peck on Vance Trimble Day in Houston (1960) and at press conferences in Washington, D.C.

Unpublished finding aid available.

TUCKER, MARSHALL A. (1906–1995) 728
Photographs 1904–1935
8 items

Black-and-white original prints of the Tucker family; a pharmacists' convention; street scenes and drug stores in Lawton, Oklahoma; and a train decorated in presidential campaign signs for Theodore Roosevelt.

Unpublished finding aid available.

TUCKER, R. TRUMAN (1905–2000) 729
Photographs 1887–1974
450 items

Black-and-white original prints of the Tucker family, who lived near Kenton, Oklahoma. Included are photographs of Truman and Fred Tucker as children celebrating Christmas in the early 1900s; street and business scenes of Kenton, Oklahoma; ranching and farming activities; and hunting scenes. The collection also contains photographs of Black Mesa, in the Oklahoma panhandle.

Unpublished finding aid available.

TUGGLE, C. R. 730
Photographs 1917
27 items

Black-and-white original prints of primarily unidentified infants and children, along with images of a farm, buggies, and the gravesite of Carroll Tuggle.

Unpublished finding aid available.

TULLIUS, HERB L. (1915–2003) 731
Photograph ca. 1905
1 item

A black-and-white copy print of Saint Joseph's Catholic Church in Norman, Oklahoma Territory.

TURLINGTON, MARCELLUS MARTIN (1868–1949) 732
Photograph 1917
1 item

A black-and-white original print of the first contingent of volunteers from Seminole County, Oklahoma, to leave for World War I.

TURNER, MARTIN LUTHER (1863–1921) 733
Photographs n.d.
6 items
Black-and-white original prints of U.S. Army general Frank D. Baldwin, J. S. Hogg, Nelson Morris, and L. M. Shaw.
Unpublished finding aid available.

TURNER, ROY J. 734
Photograph n.d.
1 item
A color original print of T. Royal Rupert 99th, 3520486, a Hereford bull bred by Turner Hereford Ranch in Sulphur, Oklahoma.

TURPIN, C. J. 735
Photographs 1921–1940
84 items
Black-and-white original prints of railroad construction near Floral, Oklahoma; yachts at the Mackinac Island Yacht Club; housing in California, Maryland, and Ohio; a street scene in Nuremburg, Germany; a flood near Marysville, Ohio; members of the Turpin family; and members of the New Century Club.
Unpublished finding aid available.

TWINE FAMILY COLLECTION 736
Photographs 1890–1950
79 items
Black-and-white copy prints of the William H. Twine family; Red Bird, Indian Territory; Muskogee, Indian Territory and Oklahoma; and African American businesses and schools.
Unpublished finding aid available.

TYE, HAZEL 737
Postcards 1908
2 items
Colored postcards showing University Boulevard in Norman, Oklahoma, and the Carnegie Library on the University of Oklahoma campus.

U.S. DISTRICT COURT COLLECTION 738
Photographs n.d.
9 items
Black-and-white original prints of the railroad depots at Orlando and Rocky, Oklahoma.
Unpublished finding aid available.

UNGER, MARION DRAUGHON MURRAY 739
Photographs 1924
47 items
Black-and-white original prints of the Johnston Murray family, the Murray Bolivian colony, Argentinean ranches, and Bolivian natives, soldiers, landscapes, housing, and agriculture.
Unpublished finding aid available.

UNIVERSITY HIGH SCHOOL COLLECTION 740
Photographs 1956–1963
107 items
Black-and-white original prints of homecoming activities at University High School at the University of Oklahoma in Norman, Oklahoma. Individuals pictured include Linda Atkins, John Benson, Favio DeMarta, Deonne Drake, Bob Hignite, Janna Hubbard, Della Huddleston, Faith Morgan, Maggie Orr, and others.
Unpublished finding aid available.

UNIVERSITY OF OKLAHOMA COLLECTION 741
Photographs 1892–1980
6,500 items
Black-and-white original and copy prints of the University of Oklahoma. The collection includes photographs of campus buildings; university presidents and senior administrators; faculty; staff; athletic activities and events; and university-related ceremonies, activities, conferences, and public programs. William Bennett Bizzell, David Ross Boyd, Joseph A. Brandt, James S. Buchanan, Walter S. Campbell, George Lynn Cross, Edward Everett Dale, Edwin C. DeBarr, Arrell M. Gibson, Roy Gittinger, Charles N. Gould, Robert Boyd Gunning, J. Herbert W. Holloman, Gustaf Fredrik Holmberg, Roy Temple House, Carleton Ross Hume, Oscar Jacobson, Harold Keith, Savoie Lottinville, Arthur McAnally, Jim Mackenzie, Julian C. Monnet, Jesse Lee Rader, Lynn Riggs, Paul Sharp, Morris L. Wardell, Thurman White, and Charles "Bud" Wilkinson are among the numerous university personalities in this collection. The collection finding aid should be consulted for a complete listing of people, buildings, and events found in this collection.
Unpublished finding aid available.

UNIVERSITY OF OKLAHOMA ASSOCIATION COLLECTION 742
Photograph n.d.
1 item
A black-and-white original print of Marlow High School, Marlow, Oklahoma.

UNIVERSITY OF OKLAHOMA ATHLETICS DEPARTMENT COLLECTION

743

Photographs 1901–1990

885 items

Black-and-white original prints of University of Oklahoma football action scenes, head football coach Bud Wilkinson, the stadium press box, head men's basketball coach Billy Tubbs, basketball action scenes and players, and news clippings.
Unpublished finding aid available.

UNIVERSITY OF OKLAHOMA BIZZELL MEMORIAL LIBRARY COLLECTION

744

Photographs 1930

24 items

Black-and-white original prints of photographs taken at the dedication of the William Bennett Bizzell Memorial Library. The collection includes interior views of the library.
Unpublished finding aid available.

UNIVERSITY OF OKLAHOMA CENTENNIAL COLLECTION

745

Photographs ca. 1915–1991

60 items

Black-and-white original and copy prints of OU football games against Missouri and Kendall in 1919 at Boyd Field. The RUF/NEKS are pictured, as well as the OU mascot, Mex the dog. Other photographs depict university bands, clubs, and buildings. The collection also includes numerous photographs of R. Boyd Gunning, a University of Oklahoma administrator.
Unpublished finding aid available.

UNIVERSITY OF OKLAHOMA COLOR TRANSPARENCY COLLECTION

746

Transparencies 1971–1990

4,524 items

Color transparencies of campus life, students, events, landscapes, aerial views, buildings, and construction projects at the University of Oklahoma. Individuals pictured include Stan Abel, William S. Banowsky, Thomas Carey, Tony Casillas, Sean Clark, Bart Conner, Kelly Garrison, Jennifer Horn, Frank E. Horton, Jacquetta Hurley, Martin C. Jischke, David Johnson, Charles Jones, David Little, Maura McHugh, Mike Mims, Jon Pannell, Darrell Reed, Vicki Street, Wayman Tisdale, William Tisdale, Billy Tubbs, and Tommy Tubbs. The groups and events shown are an African American beauty pageant; an air show at Max Westheimer Field;

Anchor Splash Swim Meet, basketball games, a Beach Boys concert; cheerleading and pompon squads; commencement, dance, music, and theatre performances; football games, Greek Games, the Medieval Fair, the Mexican American Student Association, the Pride of Oklahoma Marching Band, R.O.T.C., RUF/NEKS, Sooner Scandals, Top Dawg, and wrestling matches. Fraternities and sororities in the collection are Alpha Chi Omega, Delta Gamma, Kappa Delta, Kappa Kappa Gamma, Lambda Chi Alpha, Phi Kappa Psi, Sigma Chi, and Sigma Sigma Sigma. Exterior and aerial views of university lands include the majority of the Norman campus, its structures, and related areas, including construction projects for the Huston Huffman Center, the Health Sciences Center in Oklahoma City, an addition to Bizzell Memorial Library, and the E. T. Dunlap clock tower. Other buildings and places depicted include Adams, Buchanan, Burton, Collings, Carpenter, Copeland, Cross, Dale, DeBarr, Evans, Felgar, Gittinger, Hester, Holmberg, Jacobson, Kaufman, Lottinville, McCarter, Nielsen, Richards, Robertson, Sutton, and Whitehand halls; Boyd House, Brown's College Corner, Bud's Campus Shoppe, Campus Corner, Carnegie Building, Carson Engineering Center, Cate Center, Centennial Arch, Couch Center, Duck Pond (Brandt Park), Fears Structural Engineering Laboratory, Fine Arts Center, Goddard Health Center, Greek Row, Peggy V. Helmerich Garden, Fred Jones, Jr., Museum of Art, Korean War Memorial, Law Center, McCasland Field House, Lloyd Noble Center, Oklahoma Center for Continuing Education, Oklahoma Memorial Stadium, Oklahoma Memorial Union, Owen Field, Parrington (North) Oval, Physical Sciences Center, Sarkeys Energy Center, Murray Case Sells Swim Complex, Sooner House, the Spoon Holder, Stovall Museum, Unity Garden, University Bookstore, Van Vleet (South) Oval, Walker Tower, Thurman J. White Forum, and Yorkshire Apartments. Also pictured are campus trolleys, laboratory and computer equipment, the Sooner Schooner with Boomer and Sooner, the 1979 GM Test Car, the Budweiser Clydesdale horses, the Cleveland County Historical Society in Norman, Oklahoma, and statues of Julien Monnet, William Bennett Bizzell, and the Seed Sower.

Unpublished finding aid available.

UNIVERSITY OF OKLAHOMA DANCE COLLECTION 747
Photographs 1920–2002
30 items
Black-and-white original prints of modern and ballet dancers, choreographers, and performances by the Oklahoma Festival Ballet at the University of Oklahoma School of Dance. Noted individuals pictured include Kay Brummett, Tony Casillas, Yvonne Chouteau, Helen Gregory, Mary Margaret Holt, Isaac Stern, William Howard Taft, Miguel Terekhov, and Ko Yukihiro.

Unpublished finding aid available.

UNIVERSITY OF OKLAHOMA ELECTRONIC 748
MEDIA PHOTOGRAPHIC SERVICES COLLECTION
Photographs 1969–1984
500,000 items
Black-and-white and color negatives, prints, and slides of the University of Oklahoma. The collection includes photographs of the campus; OU presidents, senior administrators, faculty, and staff; student activities; student-related activities and clubs; athletes and athletic contests; the Pride of Oklahoma Marching Band; and university-sponsored activities and events. Among the personalities in this collection are Carl Albert, F. Lee Bailey, William S. Banowsky, David L. Boren, David Burr, Yvonne Chouteau, George L. Cross, Cleta Deatheridge, John S. Ezell, Chuck Fairbanks, Ivar Ivask, Ted Kennedy, Sul H. Lee, David W. Levy, J. R. Morris, Walter Neustadt, Tinker Owens, Greg Pruitt, Paul F. Sharp, Billy Simms, Barry Switzer, Gene Thrailkill, Boyce Timmons, and Billy Tubbs.
Unpublished finding aid available.

UNIVERSITY OF OKLAHOMA FINE ARTS COLLECTION 749
Photographs 1935–1989
40 items
Black-and-white and color original and copy prints of faculty, staff, and students from the Weitzenhoffer Family College of Fine Arts at the University of Oklahoma, including Joseph Benton, Mildred Andrews Boggess, Thomas Carey, and Ray Larson. This collection also includes images of fine arts events such as plays, dance and musical performances, and operas; and images of Ada Lois Sipuel Fisher, Grayce B. Kerr Gothic Hall, and Catlett Music Center.
Unpublished finding aid available.

UNIVERSITY OF OKLAHOMA HEALTH SCIENCES 750
CENTER COLLECTION
Photographs 1999–2004
2,123 items
Color prints of the University of Oklahoma Health Sciences Center campuses in Oklahoma City and Tulsa, Oklahoma. The photographs feature progress in landscaping and construction projects on the campus and surrounding areas. Buildings and areas at the Oklahoma City campus include student housing and centers, libraries, an intramural field, the Stanton L. Young Walk, the Don E. Hogg Greenhouse, and other research and administrative buildings. At the Schusterman Health Sciences Center in Tulsa, the structures pictured include Building One, Building Three, Building Four, Building Four West, Building Five, and Building Six.
Unpublished finding aid available.

UNIVERSITY OF OKLAHOMA LANDSCAPE COLLECTION 751
Photographs 2005–2007
103 items
Color prints and digital images of the University of Oklahoma campus following an ice storm in December of 2007. Buildings and areas include Asp Avenue, Catlett Music Center, Craddock Hall, Dale Hall, the dormitories, Elm Street, the Huston Huffman Center, Jenkins Avenue, Lindsey Street, Murray Case Sells Swim Center, Oklahoma Memorial Stadium, and the South Oval. Also included are images of Arbor Day picnics, mums on the South Oval, water fountains, and President David L. Boren and First Lady Molly Shi Boren.
Unpublished finding aid available.

UNIVERSITY OF OKLAHOMA PANHELLENIC 752
INTERFRATERNITY COUNCIL COLLECTION
Photographs 1951–1954
270 items
Black-and-white original and copy prints of fraternity and sorority houses, including Acacia, Alpha Chi Omega, Alpha Delta Pi, Alpha Epsilon Pi, Alpha Gamma Delta, Alpha Kappa Phi, Alpha Phi, Alpha Sigma Phi, Alpha Tau Omicron, Beta Theta Pi, Chi Omega, Delta Chi, Delta Delta Delta, Delta Gamma, Delta Kappa Sigma, Delta Tau Delta, Delta Upsilon, Gamma Phi Beta, Kappa Alpha, Kappa Alpha Theta, Kappa Delta, Kappa Delta Rho, Kappa Kappa Gamma, Kappa Sigma, Lambda Chi Alpha, Phi Delta Theta, Phi Gamma Delta, Phi Kappa Sigma, Phi Kappa Theta, Phi Psi, Pi Beta Phi, Pi Kappa Alpha, Pi Lambda Phi, Sigma Alpha Epsilon, Sigma Delta Tau, Sigma Nu, Sigma Phi Epsilon, Theta Kappa Phi, and Zeta Tau Alpha. The collection also includes images of parties, recreational activities, and OU sports information director Harold Keith. Group photographs include Acacia, Alpha Chi Omega, Alpha Delta Pi, Alpha Epsilon Pi, Alpha Gamma Delta, Alpha Sigma Phi, Alpha Tau Omega, Beta Theta Pi, Delta Delta Delta, Delta Gamma, Delta Kappa Epsilon, Delta Tau Delta, Delta Upsilon, Gamma Phi Beta, Kappa Alpha, Kappa Alpha Theta, Kappa Delta, Kappa Delta Rho, Kappa Kappa Gamma, Kappa Sigma, Lambda Chi Alpha, Lambda Kappa Sigma, Phi Delta Theta, Phi Gamma Delta, Phi Kappa Psi, Phi Kappa Theta, Phi Mu, Pi Beta Phi, Pi Kappa Alpha, Pi Lambda Phi, Sigma Alpha Epsilon, Sigma Chi, Sigma Nu, Sigma Phi Epsilon, Theta Kappa Phi, and Zeta Tau Alpha.
Unpublished finding aid available.

UNIVERSITY OF OKLAHOMA PHOTOGRAPH COLLECTION 753
Photographs 1904–1998
71 items
Black-and-white prints of athletes and athletic teams at the University of Oklahoma. Among the sports represented in the collection are football; track; men's basketball and gymnastics; and women's gymnastics, soccer, and volleyball. Individuals pictured include Bobby Boyd, Kurt Burris, Jimmy Carpenter, Richard Chaney, Bart Conner, Jim Davis, Eddie Fields, Ernest Haskell, Natalie Hixson, Leland Lamb, Billy Meacham, Heather Morrison, Arthur Sherman, and Kelly Garrison Stevens. *Unpublished finding aid available.*

UNIVERSITY OF OKLAHOMA PHOTOGRAPHIC 754
SERVICE COLLECTION
Photographs 1936–1958
32,574 items
Black-and-white original prints and negatives of the University of Oklahoma. The collection includes photographs of the university campus and its buildings; university presidents and senior administrators; faculty and staff; students and student activities; student-related organizations and clubs; athletes and athletic events; and university-sponsored activities and events. Among the university personalities in this collection are Joseph Benton, William Bennett Bizzell, David Ross Boyd, Joseph A. Brandt, Stratton D. Brooks, Walter Stanley Campbell, Roscoe Cate, Woodrow Crumbo, Edward Everett Dale, James H. Felgar, Roy Gittinger, Gustaf Fredrik Holmberg, Carleton Ross Hume, Oscar Brousse Jacobson, Robert S. Kerr, Edna McDaniel, Harold L. Muldrow, Benjamin Gilbert Owen, Jesse Lee Rader, Lewis Haines Wentz, Charles "Bud" Wilkinson, and Guy Y. Williams. Researchers should consult the inventory of this collection for a complete listing of the people, events, and places documented in it.
Unpublished finding aid available.

UNIVERSITY OF OKLAHOMA PRESS COLLECTION 755
Photographs 1920–1950
77 items
Black-and-white original prints of authors who have had books published by the University of Oklahoma Press. Included are photographs of Robert S. Cotterill, Angie Debo, Betty Kirk, Wilbur S. Nye, Cortez A. M. Ewing, William Bennett Bizzell, Carl Rister, Roy Gittinger, and Alice Marriott.
Unpublished finding aid available.

UNIVERSITY OF OKLAHOMA PUBLIC RELATIONS
BUREAU COLLECTION 756
Photographs 1904–1959
4 items
Black-and-white original prints of scenes at the University of Oklahoma, including Evans Hall, Holmberg Hall, Registrar George Wadsack, the university's first band, and male students beside a car with a sign that reads, "Beat Texas."
Unpublished finding aid available.

UNIVERSITY OF OKLAHOMA WOMEN'S COLLECTION 757
Photographs 1902–1958
32 items
Black-and-white original and copy prints of members of the OU Women's Athletic Association participating in various sporting activities: golf, archery, tennis, fencing, shuffleboard, and rifle shooting. The collection also includes photographs of a dormitory room and homecoming floats.
Unpublished finding aid available.

UNIVERSITY OF OKLAHOMA YMCA COLLECTION 758
Photographs 1920–1957
19 items
Black-and-white original prints of YMCA members engaged in social activities, conferences, outdoor worship services, and reenacting biblical stories; and students at an Apache Indian School in White River, Arizona.
Unpublished finding aid available.

UTLEY, ROBERT M. (1929–) 759
Photographs and postcards 1896–1949
199 items
Black-and-white and color original prints and postcards of Utley family members and friends, including Cora Carson, Clarence Mays, Nita (Juanita) Carson Mays, Helen Alexander Whistler, and Rex Whistler. Postcards are from Arkansas, Colorado, New Mexico, Oklahoma, Texas, Mexico, Mesa Verde National Park, and Yellowstone National Park.
Unpublished finding aid available.

VAN AUSDAL, HARVEY G. 760
Photograph 1900
1 item
A black-and-white original print of H. G. Van Ausdal's drugstore at Centralia, Indian Territory.

VAN CLEAVE, WILLIAM EDGAR (1877–1946) 761
Photographs 1890–1933
103 items
Black-and-white original prints of the Choctaw-Chickasaw Indian Hospital at
Talihina, Oklahoma. The collection also includes photographs of the Concho
Indian School; the Seneca Indian School; the Wyandotte Indian School; the
towns of McAlester, McCloud, Medicine Park, Spavinaw, and Stilwell, Oklahoma;
and scenes of businesses and a cotton gin.
Unpublished finding aid available.

VINITA LIONS CLUB COLLECTION 762
Photographs 1948–1949
2 items
Black-and-white original prints of Lions Club members at a conference and at
Grand Lake, Oklahoma.
Unpublished finding aid available.

VIRDEN, JOHN M. (1908–1968) 763
Photographs 1960–1963
45 items
Black-and-white and color original and copy prints of the Pea Ridge battlefield in
Arkansas. The collection also includes photographs of paintings that depict Irish
landscapes and sea scenes, drawings of battlefields, and maps of battlefields.
Unpublished finding aid available.

VOIGNIER-MARSHALL, JACQUELINE 764
Photographs ca. 1943–1949
63 items
Black-and-white original prints of New York City, New York, including bridges,
buildings, Central Park, Grand Central Station, and Yankee Stadium. The col-
lection also includes images of the United States–Canadian border in Stanhope,
Quebec, and Norton, Vermont; Victoria, British Columbia; Boston, Massachusetts;
Washington state; and Franklin D. Roosevelt.
Unpublished finding aid available.

VOSS, JOHN H. 765
Photograph 1921
1 item
A black-and-white copy print of the family of Dr. and Mrs. John H. Voss.

WADLEY, (Mrs.) JAMES L. 766
Photograph 1899
1 item
A black-and-white copy print of the first graduates of the University of Oklahoma's
music program.

WALKER, ANDREW BEATTIE 767
Photographs 1903–1910
7 items
Black-and-white original prints of Fairview, Oklahoma Territory. Included are
scenes of parades, businesses, and a fair.
Unpublished finding aid available.

WALKER-PATISON COLLECTION 768
Photographs 1950–1958
33 items
Black-and-white original prints of the University of Oklahoma campus and build-
ings, including Carpenter, Ellison, Jacobson, and Kaufman halls.
Unpublished finding aid available.

WALRAVEN, (Mrs.) O. D. 769
Photographs 1900
4 items
Black-and-white original prints of a blacksmith shop in Tuttle, Oklahoma Terri-
tory; a home in Norman, Oklahoma Territory; and a Sunday school class in Noble,
Oklahoma Territory.
Unpublished finding aid available.

WALTON, JACK C. (1881–1949) 770
Photographs ca. 1923
19 items
Black-and-white original prints of Oklahoma Governor Jack C. Walton, and George
G. Garret, engaged in activities for Walton's gubernatorial campaign.
Unpublished finding aid available.

WARD, CLYDE 771
Photographs 1900–1940
12 items
Black-and-white copy prints of the Waters family, and of Marlow, Oklahoma.
Unpublished finding aid available.

WARD, D. C. 772
Photographs 1889–1939
49 items
Black-and-white original and copy prints of Apache, Comanche, and Kiowa Indians, along with scenes of the town of Apache, Oklahoma, and of nearby Cache Creek Mission. Among the individuals in the collection are Albert Attocknie, Della Killsfirst, Rolling Pony, and Howard Whitewolf.
Unpublished finding aid available.

WARD, PEARL 773
Photographs 1913–1922
17 items
Black-and-white copy prints of automobiles, musical groups, and scenes from the towns of Byars, Johnson, and Purcell, Oklahoma.
Unpublished finding aid available.

WARDELL, MORRIS L. (1889–1957) 774
Photograph n.d.
1 item
A black-and-white original print of the first Hereford cattle brought into the Oklahoma panhandle.

WARNE, RHODA FOSTER (1890–1964) 775
Photograph 1905
1 item
A black-and-white original print of the Foster brothers' livery stable at Helena, Oklahoma Territory.

WARNER, CAROLYN REXROAT (1930–) 776
Photographs ca. 1897–1929
5 items
Black-and-white original prints of Iron Top School in Healdton, Oklahoma; and Uriah Thomas Rexroat, and Mary Wilma Tullis Rexroat.
Unpublished finding aid available.

WARREN, MYRTLE 777
Photographs 1894–1908
14 items
Black-and-white original and copy prints of Guthrie and Pawhuska, Oklahoma Territory, and of Dewey, Indian Territory.
Unpublished finding aid available.

WATSON, (Mrs.) GEORGE 778
Photographs n.d.
12 items
Black-and-white original prints of children and families posing for photographs on porches and near buildings.
Unpublished finding aid available.

WATSON, GRACE M. 779
Photographs 1902
2 items
Black-and-white original prints of Beggs, Indian Territory.
Unpublished finding aid available.

WATSON, RUTH WALCOTT (1898–1989) 780
Photographs 1891–1915
39 items
Black-and-white copy prints of Olustee, Oklahoma, including scenes of businesses and schools. The collection also contains photographs of the Walcott family.
Unpublished finding aid available.

WATTS, CHARLES GORDON, SR. (1875–1964) 781
Photographs ca. 1920
2 items
Black-and-white original prints of Charles G. Watts's law office and courtroom at Wagoner, Oklahoma.

WAUBAY, DAY COUNTY, SOUTH DAKOTA, COLLECTION 782
Photographs ca. 1898
96 items
Black-and-white original prints of businesses, recreational activities, residences, and street scenes in Waubay, South Dakota. The collection also includes wedding photographs and family portraits.
Unpublished finding aid available.

WELCH, PAULINE 783
Photographs 1909–1918
24 items
Black-and-white copy prints of Rocky, Oklahoma, including scenes of businesses, churches, and schools.
Unpublished finding aid available.

WELDON, BETTIE 784
Photographs 1918
2 items
Black-and-white copy prints of a parade of women members of the Ku Klux Klan
at El Reno, Oklahoma.
Unpublished finding aid available.

WELLS, DICK 785
Photographs 1906–1911
9 items
Black-and-white original prints of Manitou, Oklahoma Territory and state, includ-
ing scenes of businesses, railroads, and a baptism.
Unpublished finding aid available.

WELSH, LOUISE 786
Photographs 1897–1920
8 items
Black-and-white copy prints of students and faculty of the Emahaka Indian School;
a Seminole Indian stickball game; schoolchildren on a Seminole, Oklahoma, school
playground; and a group photograph of baseball players from Seminole, Oklahoma.
Unpublished finding aid available.

WENNER, FRED LINCOLN (1865–1950) 787
Photographs 1889–1920
195 items
Black-and-white original and copy prints of the towns of Anadarko, Edmond, El
Reno, Guthrie, Kingfisher, Oklahoma City, and Perry, Oklahoma Territory and
state. Scenes of farming, railroads, mining, outlaws, the U.S. Army, Boomers, the
University of Oklahoma, and businesses are included, along with photographs of
Apache, Cheyenne, Comanche, Iowa, Iroquois, Kickapoo, Kiowa, Osage, Pawnee,
Ponca, Potawatomi, Seminole, Shawnee, Wichita, and Wyandotte Indians. The col-
lection also contains individual portraits of the Daltons, Kiowa Annie, Lone Bear,
Joel Mayes, Lucille Mulhall, and Martha Napawat.
Unpublished finding aid available.

WESSEL, R. H. 788

Photographs 1902–1949

49 items

Black-and-white original prints of Frederick and Manitou, Oklahoma, including scenes of businesses, farming, and city streets. The collection also contains a photograph of Theodore Roosevelt and his friends on a wolf hunt near Frederick, Oklahoma, in 1905.

Unpublished finding aid available.

WEST, CORA C. 789

Photographs 1884

6 items

Black-and-white copy prints and tintypes of Pawnee and Wichita Indians, including Chester Collins, Carl Gray, Charles Ross, and Charlie Swift.

Unpublished finding aid available.

WESTERN OKLAHOMA AMERICAN BAPTIST 790
INDIAN ASSOCIATION COLLECTION

Photographs 1930–1983

73 items

Black-and-white copy prints of members, churches, and activities of the Western Oklahoma American Baptist Indian Association. Included are photographs of the Rainy Mountain Church; Saddle Mountain Church; Post Oak Mission at Indiahoma, Oklahoma; and the Deyo Mission at Lawton, Oklahoma. The collection also contains photographs of Baptist churches at Anadarko, Fort Cobb, Geary, Hobart, and Mountain View, Oklahoma.

Unpublished finding aid available.

WHEATLEY, THOMAS W. 791

Photographs 1918

8 items

Black-and-white original prints of coal mining activities at McAlester, Oklahoma.

Unpublished finding aid available.

WHEELER, F. J. 792

Photographs 1930

4 items

Black-and-white original prints of a mass burial for victims of a coal mine explosion near McAlester, Oklahoma.

Unpublished finding aid available.

WHEELER, (Mrs.) TODD 793
Photographs 1910–1915
20 items
Black-and-white original prints of ranching, camping, women on horseback, and cowboys in Colorado.
Unpublished finding aid available.

WHITE, (Mrs.) J. R. 794
Photographs 1902–1912
12 items
Black-and-white original prints of Idabel, Indian Territory and Oklahoma. Included are photographs of Main Street, businesses, the railroad depot, and hunting scenes.
Unpublished finding aid available.

WHITE, LIDA 795
Photographs 1890–1900
57 items
Black-and-white original prints of Norman and Orlando, Oklahoma Territory, including schools, schoolchildren, teachers, and businesses.
Unpublished finding aid available.

WICHITA MOUNTAINS PAGEANT ASSOCIATION COLLECTION 796
Photographs 1935–1947
67 items
Black-and-white original prints of the Wichita Mountains Easter pageant service, and one image of the Church of the Nativity in Israel.
Unpublished finding aid available.

WICKERSHAM, VICTOR (1906–1988) 797
Photograph ca. 1960
1 item
A black-and-white original print of Oklahoma politician Victor Wickersham during his campaign for election to the U.S. House of Representatives.

WIELAND, CHARLES, and A. G. WIELAND FAMILY COLLECTION 798
Photographs ca. 1897–1898
284 items
Black-and-white original prints of Wieland family vacations to Catalina Island and Mira Monte, California, aboard *The Aggie*. This collection also contains images of sailboats, yachts, parties, the Teal Shooting Club, duck hunting, and swimming.
Unpublished finding aid available.

WILLIAMS, ARTHUR JAMES (1877–1954) 799
Photographs 1910–1940
954 items

Black-and-white original prints of sawmills, quarries, lime kilns, lumberyards, glass factories, smelters, oil wells and storage tanks, and ranches in Oklahoma. The collection includes photographs of numerous Oklahoma cities and towns; of the University of Oklahoma; of railroads, automobiles, and airplanes; of Apache, Cheyenne, Comanche, Kiowa, Sioux, and Wichita Indians; of limestone and gypsum deposits in Oklahoma; and of the Oklahoma salt plains. Quanah Parker, Wanda Parker, Hollow Horn Bear, Hunting Horse, Mad Wolf, Geronimo, Bear Claw, and Amy Toughfeathers are among the photographs of individuals in the collection. *Unpublished finding aid available.*

WILLIAMS, CLIFF 800
Photographs 1906–1950
2 items

Black-and-white copy prints of the New Lumber Company in Nowata, Indian Territory, and the Williams Lumberyard, also in Nowata.

WILLIAMS, GUY Y. (1881–1968) 801
Photographs 1900–1940
23 items

Black-and-white original prints of Guy Y. Williams; the University of Oklahoma class of 1906; and the first jail in Enid, Oklahoma Territory. *Unpublished finding aid available.*

WILLIAMS, MEREDITH NEWTON (1904–1949) 802
Photographs n.d.
8 items

Black-and-white original prints of the Meredith N. Williams family. *Unpublished finding aid available.*

WILLIAMS, MICHAEL 803
Photographs 1908–1981
61 items

Black-and-white copy prints of railroad depots in Afton, Altus, Alva, Antlers, Arapaho, Ardmore, Bartlesville, Blackwell, Braman, Bristow, Burlington, Butler, Cache, Capron, Carmen, Checotah, Cherokee, Chickasha, Crescent, Cushing, Custer City, Davis, Dougherty, Douglas, Hominy, Inola, Marietta, Marland, Marshall, Maysville,

Oklahoma City, Okmulgee, Pauls Valley, Pawhuska, Pawnee, Perry, Ponca City, Purcell, Ralston, Red Rock, Roff, Ryan, Sapulpa, Sayre, Shattuck, Snyder, Stillwater, Tonkawa, Vinita, Wagoner, Walters, Waurika, Waynoka, Weatherford, Wewoka, Woodward, Wynnewood, and Yewed, Oklahoma.
Unpublished finding aid available.

WILLIAMS, SAMUEL 804
Photographs 1908–1919
20 items
Black-and-white original prints of cotton marketing and ginning activities in the towns of Cordell, Elk City, Erick, Frederick, Sayre, and Texola, Oklahoma; and Shamrock, Texas.
Unpublished finding aid available.

WILLIAMS, T. S. 805
Photograph 1915
1 item
A black-and-white original print of Dr. T. S. Williams in his office at Stillwell, Oklahoma.

WILLIE, JOHN 806
Negatives ca. 1930
2 items
Black-and-white negatives of Choctaw women weaving, and Choctaws at a picnic in Hugo, Oklahoma.

WILLOUR, J. A. 807
Photograph 1907
1 item
A black-and-white original print of the interior of Gus A. Gill's office at McAlester, Oklahoma.

WILSON, GEORGE HOWARD 808
Photograph 1950
1 item
Black-and-white copy print of U.S. Representative George Howard Wilson.

WILSON, McCLELLAN 809
Photographs 1953
3 items
Black-and-white original and copy prints of Dr. McClellan Wilson's home in
McAlester, Oklahoma; and people posing near mining equipment at the Lyon
Lode near Wildman, Oklahoma.
Unpublished finding aid available.

WILSON, TIMOTHY 810
Photographs 1909–1923
63 items
Black-and-white copy prints of the Wilson family and farming activities.
Unpublished finding aid available.

WINDOLPH, J. T. 811
Photographs 1900–1912
19 items
Black-and-white copy prints of the Windolph family; the Windolph family home-
stead near Cestos, Oklahoma Territory; and the Bank of Vici, Oklahoma Territory.
Unpublished finding aid available.

WINTERS, CHARLES E. 812
Photographs 1902–1940
63 items
Black-and-white original and copy prints of railroads in Oklahoma and Arkansas.
The collection also contains scenes of Fort Smith and Western Railroad locomo-
tives and rolling stock.
Unpublished finding aid available.

WITHROW, PHIL C. 813
Photographs 1920–1938
36 items
Black-and-white copy prints of oil-drilling activities near the towns of Oklahoma
City, Seminole, and Three Sands, Oklahoma.
Unpublished finding aid available.

WITT, JUNE 814
Photographs 1909–1937
4 items
Black-and-white original prints of railroad workers at Shawnee, Oklahoma, and
of locomotives.
Unpublished finding aid available.

WOMACK, JOHN (1911–1987) 815
Photographs 1880–1978
53 items
Black-and-white copy prints of early settlers in Norman, Oklahoma Territory; the interurban railroad between Norman and Oklahoma City, Oklahoma; construction of the post office in Norman, Oklahoma; and John Womack at the site of the Seminole Nation council house.
Unpublished finding aid available.

WOMEN'S STUDIES DEPARTMENT COLLECTION 816
Photographs 1978–2004
188 items
Black-and-white and color original and copy prints of faculty and students of the Women's Studies Department at the University of Oklahoma. The collection contains photographs from many conferences, including the 1996 and 1997 National Women's Studies Association conferences, the 1978 Women and the Workplace Conference, and the 1982 Women and Mental Health Conference. Notable individuals pictured are Judy Chicago, Betty Harris, Allison Joseph, and Jane O. Wayne.
Unpublished finding aid available.

WOODARD, FRED BARTON (1871–1956) 817
Photographs 1866–1906
6 items
Black-and-white copy prints of Bartlesville, Indian Territory, and the 1866 Delaware-Cherokee congressional delegation to Washington, D.C.
Unpublished finding aid available.

WOODWARD COUNTY COLLECTION 818
Photographs 1893–1915
219 items
Black-and-white copy prints of towns in Woodward County, Oklahoma, including Curtis, Haskew, Mooreland, Mutual, Richmond, Tangier, and Woodward. The collection also contains photographs of agriculture; businesses; cowboys; the range cattle industry; schools; the U.S. Cavalry; and Enid, Oklahoma.
Unpublished finding aid available.

WOODWARD, VICKY 819
Photographs 1924
4 items
Black-and-white original prints of baseball teams from Cushing, Lone Wolf, and Duncan, Oklahoma; and La Junta, Colorado.
Unpublished finding aid available.

WORCESTER ACADEMY COLLECTION 820
Photographs 1883–1967
8 items
Black-and-white copy prints of Worcester Academy at Vinita, Indian Territory, including photographs of the school, a graduating class, and the dedication of a historical marker in 1967.
Unpublished finding aid available.

WRIGHT, ALBERT DANIEL (1863–1949) 821
Photographs 1891–1910
3 items
Black-and-white original prints of Chandler, Oklahoma Territory and state.
Unpublished finding aid available.

WYATT, ROSE MARY BURT (b. 1871) 822
Photographs 1900–1918
14 items
Black-and-white original prints of oil wells, railroad construction, and the towns of Kiefer and Shamrock, Oklahoma. The collection also includes scenes of Sacred Heart Mission.
Unpublished finding aid available.

WYNNEWOOD GAZETTE COLLECTION 823
Photographs 1910–1948
4 items
Black-and-white original prints of Wynnewood, Oklahoma.
Unpublished finding aid available.

WYSKUP, ELENORE 824
Photographs 1903–1914
15 items
Black-and-white copy prints of Polish Americans from central Oklahoma. The collection contains individual studio portraits, along with scenes of weddings, businesses, and farming.
Unpublished finding aid available.

Photographs 1922–1950

205 items

Black-and-white original prints of conferences, YMCA and YWCA leaders, the University of Oklahoma campus, Will Rogers, and Carl Albert. The collection also includes photographs of YWCA activities under Caroline Duval Smith in Mexico City, Mexico.

Unpublished finding aid available.

YOUNGER, R. A. 826

Photographs 1918–1939

38 items

Black-and-white original prints and panoramas of the Grand River Dam; mining and smelting in the Picher, Oklahoma, area; the town of Miami, Oklahoma; and businesses. Also included are photographs of Will Rogers and of Quapaw and Seneca Indians.

Unpublished finding aid available.

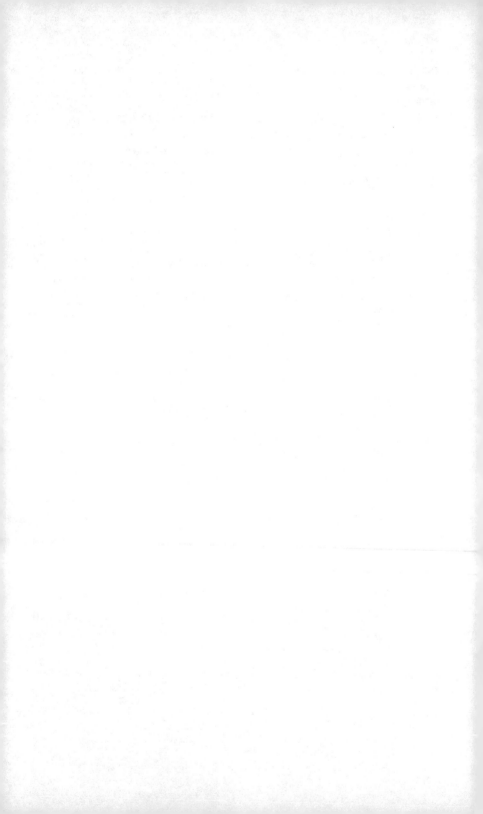

INDEX

Numbers in the index refer to entry numbers, not to page numbers. Entry numbers in boldface type refer to a collection of the same name as the index entry.

Catholic Church, 731; convents, 445; schools, 445. *See also* Churches; Missions

Catlett Music Center, University of Oklahoma, 749, 751

Catlin, George, drawings and paintings by, 55

Cattle, 148, 170, 199, 202, 227, 295, 313, 400, 482, 551, 734, 774; judging of, 147

Cayuga Indians, 616

Cayuse Indians, 616

Celebrations: banquet for World War I volunteers, 708; Christmas ca. 1900, 729; corn carnival (Minco, Okla.), 661; Democratic Party (Wewoka, Okla.), 653; opening of Cherokee Outlet to settlement, 376; statehood anniversary, 340, 552; statehood semi-centennial exhibitions, 561; statehood semi-centennial performances, 561

Cement, Okla., 474, 505

Cemeteries, Arkansas, 34

Centenarian Club of Oklahoma, 34

Center Point, Okla., 179

Central Grocery Store (Dillard, Okla.), 379

Central Park (N.Y.), 764

Centralia, Indian Terr., 513; Van Ausdal drugstore, 760

Century, Indian Terr., 202

Cestos, Okla. Terr., 811

Chaat, Robert P., **114**

Chaco Indians, 135

Chandler, Jeff, 226

Chandler, Okla., 559, 584, 718, 821; tornado damage, 679

Chandler, Okla. Terr., 821; speech by Senator W. B. Pine, 598; street scenes, 679

Chandler, William Herbert, 80

Chaney, Warren P., **115**

Chapman, T. Shelby, **116**; family of, 116

Charleston, Okla.: businesses, 87; schools, 87

Charlton, (Mrs.) H. F., **117**

Checotah, Indian Terr., 719

Checotah, Okla., 559; railroad depot, 803

Checote, Samuel, 265

Chee, (Mr. and Mrs.) Ralph, 290

Chelsea, Indian Terr., Massey's store, 459

Chelsea, Okla.: businesses, 185, 459; schools, 185; street scenes, 185, 327

Chelsea Coal Company (Chelsea, Okla.), 185

Chennault, Claire Lee, 352

Cherokee, Okla., 436, 559; railroad depot, 803

Cherokee Female Seminary (Park Hill, Indian Terr.), 32, 33, 104, 232, 349, 358, 595, 713

Cherokee Indians, 32, 135, 174, 202, 232, 235, 238, 294, 349, 381, 424, 435, 452, 513, 523, 551, 559, 592, 595, 616, 619, 672, 711, 712, 713; chiefs, 450, 482, 672; Civil War participants (U.S.), 381; delegation to Washington, D.C. in 1866, 817; families, 232; housing, 232; Park Hill Mission, 232; schools, 32, 33, 104, 232, 349, 358, 595, 713; tribal government officials, 32, 294, 450, 482, 523, 672

Cherokee language, postcard, 719

Cherokee Male Seminary (Park Hill, Indian Terr.), 32, 232, 358, 595

Cherokee Nation: council of, 294; ferries, 232; senate, 294, 523, 672; state of the nation address in 1995, 450

Cherokee Outlet ("Strip"): Caldwell, Kans., street scenes, 385; farming scenes, 204; historical celebrations of opening, 376; opening to white settlement in 1893, 88, 160, 204, 385, 412, 485, 552

Cherokee Strip Cow Punchers Association, 172

Cherokee Town, Indian Terr., 659

Chew, Muriel, **118**

Cheyenne, Okla., 60

Cheyenne, Okla. Terr., 544

Cheyenne Indians, 3, 24, 55, 174, 178, 202, 235, 252, 299, 309, 331, 421, 518, 532, 533, 544, 551, 592, 616, 644, 662, 669, 678, 689, 703, 711, 713, 717, 721, 787, 799; baskets, 452; ceremonies, 175; clothing and dress, 105; dances, 175; performers in wild west shows, 531; societies, 175; sun dance, 175, 312

Clark, Ruth, **127**
Clark, Sean, 746
Clark, William, **127**
Clark & Keller Seed Store (Shawnee, Okla.), 389
Clarkson, Addie W., **128**
Class of 1900 Collection (University of Oklahoma), **129**
Class of 1906 Collection (University of Oklahoma), **130**
Class of 1911 Collection (University of Oklahoma), **131**
Clay, Gen. Lucius D., 475
Clayton, Okla., 192
Clearview, Okla., 164
Clelland, J. J., **132**
Cleo Springs, Okla., 559; Cleo State Bank, 133
Cleo State Bank Collection, **133**
Clergymen, Presbyterian, 362
Cleveland, Okla., street scenes, 321
Cleveland County, Okla., 231; courthouse, 545
Cleveland County Historical Society (Norman, Okla.), **134**, 746
Clinton, Okla., 551, 559, 645; churches, 24, 156; Indians, 24; parades, 428; powwows, 24; schools, 156; street scenes, 321, 428
Clinton, Okla. Terr., dentist office, 553
Cloud Chief, 3
Cloud Chief, Okla. Terr., businesses, 575
Clough, Lucille, **135**
Coal miners, 630
Coal mines: interior of, 497; Samples No. 2 (McAlester, Okla. area), 145
Coal mining: burial of mine explosion victims, 792; coal carts, 218; scenes, 383, 643; scenes near Chelsea, Okla., 327; scenes near McAlester, Okla., 791
Coalgate, Indian Terr., 202
Coalville, Utah Terr., 230
Cobb, Isabel, **136**
Coca-Cola, delivery trucks, 677
Cocopa Indians, 532
Cody, William F. (Buffalo Bill), 105, 135, 202, 226, 240, 431, 633, 711
Coe, Mark, **137**
Coeur d'Alene Indians, 178

Coffee, John, 125
Colby automobiles, manufacturing of, 38
Colby Motor Company, 38
Colcord, Charles Francis, **138**
Cold Springs, Okla., 407
Cole, C. W., **139**
Cole, Helen, **140**
Cole, Lawrence Wooster, 265
Coleman, Emma Alberta White, **141**
College students: Bacone College, 22; Indian Territory, 6. *See also* University of Oklahoma
Collings Hall, University of Oklahoma, 746
Collins, Arza Bailey, **143**
Collins, Chester, 789
Collins, H. Dale, **144**
Collins, W. H., **145**
Collins Institute (Indian Terr.), 358
Collins Ranch, **142**
Collinsville, Okla., 186, 559
Collon, James, **146**
Collums, Garner G., **147**
Colombia, petroleum industry, 123
Colony, Okla., 105; Indian village near, 182
Colorado, 486, 726; baseball team, 819; cities and towns, 474, 726; mountains in, 148, 192, 724, 726; petroleum industry, 123; postcards, 759; power plant, 148; railroads, 436
Colorado Mining Collection, **148**
Colorado River, 569
Colorado Springs, Colo., mining scenes, 148; postcard, 42
Columbia, Calif., 59
Columbia River Highway (Ore.), 384
Columbus, Mont., 473
Comanche, Okla., 559; businesses, 686; street scenes, 686
Comanche, Tex., 623
Comanche Indians, 48, 135, 178, 198, 200, 202, 203, 228, 235, 238, 267, 275, 278, 309, 331, 350, 361, 371, 407, 485, 551, 559, 592, 616, 664, 678, 689, 711, 721, 772, 787, 799; baptisms of, 275; churches of, 275; clothing and dress, 105, 637; missions, 200, 275; performers in wild west shows, 531; studio portraits of, 423
Comanche Jack, 331

Comanche Mission Church (Lawton, Okla.), 114
Combest, George Marion, **149**
Comfort, E. Nicholas, 560
Concho Indian School (Okla.), 662, 761
Confederate States Army: Indian soldiers, 381; officers, 381; reunion, 708; soldiers, 257; veterans of, 188, 304, 708
Confederate Veterans Home (Ardmore, Okla.), 468
Conferences, geology, 284
Conkling, Richard A., **150**
Conley, Mable, **151**
Connecticut, postcards, 424
Conner, Bart, 746
Connor, William J., **152**
Conteau, Mabel, 675
Cook, F. L., **153**
Cookson, Okla., 409
Coolidge, Calvin, 718
Cooper, Douglas Hancock, 265
Cooper, Tex, 83, 226
Cooperton, Okla., 407
Copeland, Walter, **154**
Copeland Hall, University of Oklahoma, 746
Copeland Hardware Store (Welch, Indian Terr.), 154
Corbin, Ouida L., **155**
Corbin, William S., 155
Cordell, Okla.: businesses, 26, 501, 575; cotton gins, 804; cotton markets, 804; schoolchildren at, 365; street scenes, 321, 501; tornadoes, 26
Corey, Wendell, 226
Corn, Okla.: 105; churches, 156; schools, 156; street scenes, 321
Corn Historical Society Collection, **156**
Corndropper, Frank, 437
Cornelius, E. D., **157**
Corrigan, Douglas (Wrong Way), 638
Costa Rica, 723
Cotten, (Mrs.) Claude, **158**
Cotterill, Robert S., 755
Cotton gins, 178, 270, 301, 323, 340, 391, 407, 427, 438, 538, 545, 650, 653, 655, 664, 668, 675, 708, 761, 804
Cotton harvesting, near Cordell, Okla., 501

Cotton markets, 60, 171, 255, 380, 492, 502, 505, 571, 622, 679, 708, 804
Couch Center, University of Oklahoma, 746
Court, Nathan Altshiller, **159**
Courthouses, 15, 137, 178, 217, 238, 395, 545
Courtrooms, 781
Courts, Indian Territory, 624
Covey, Arthur S., **160**
Cowboys, 23, 104, 202, 227, 252, 295, 299, 313, 544, 633, 642, 793, 818
Coweta, Indian Terr., 505
Cowgirls, 313
Cows. *See* Cattle
Coyle, Okla., 202, 343
Coyote, Mary, 669
Crable, A. L., 265
Craddock Hall, University of Oklahoma, 751
Crane, Karen, **161**
Crane, Roy, 516
Craterville Park (Okla.), 200, 203, 637
Crawler, Hector, 135
Crazy Bear, 605
Crazy Snake, 592
Crazy Snake Rebellion in 1909, 308
Cree Indians, 135
Creek Indian school (Wetumka, Indian Terr.), 495
Creek Indians, 174, 178, 200, 202, 235, 270, 328, 495, 513, 518, 523, 551, 592, 633, 664; dances, 200; games, 200; schools, 495
Creek Nation, council members, 328
Creel, (Mrs.) William H., **162**
Cremony, John C., 265
Crescent, Okla., 343, 376; Men's Bible Class, 660; railroad depot, 803
Cripple Creek, Colo., mining scenes, 148
Criswell, A. A., **163**
Crockett, Norman, **164**
Cromwell, Okla., 270
Crook, Kenneth E., **165**
Cropper, Okla., physician's office, 673
Cross, George Lynn, 12, 68, **166**, 741, 748
Cross Hall, University of Oklahoma, 746
Croston, George C., **167**
Crow, John, 152
Crow Creek Agency (S.Dak.), 634

Crow Indians, 135, 530, 532, 533, 592, 616, 633, 717; clothing and dress, 105; performers in wild west shows, 531
Crowder, Okla., 463
Crowder City, Indian Terr., 546
Cruce, Lorena, 265
Crumbo, Woodrow, 754
Cuba, 723
Cull, Bob, **168**
Cunningham, Robert E., **170**
Cunningham, Tom, **171**
Cunningham family, 171, 339
Cunningham Indian Photographs Collection, **169**
Cunningham-Dillon Collection, **172**
Cunningham-Flowers Collection, **173**
Cunningham-Prettyman Collection, **174**
Curley, 616
Curren family, 461
Curtis, Charles, 47
Curtis, Edward S., **175**, 228
Curtis, Ken, 226
Curtis, Okla., 818
Cushing, Okla., 72, 170, 319, 559; hotels, 538; baseball team, 819; petroleum industry scenes, 123; railroad depot, 803
Cushing, Okla. Terr., railroad depot, 336
Cushman, Pauline, 265
Custer, George Armstrong, 633
Custer City, Okla., 190; construction at, 393; railroad depot, 803
Custer City, Okla. Terr.: parades, 151; schools, 151; street scenes, 151
Cut Ears, 3
Cut Finger, 616
Cut Nose, 518, 592, 616
Cutlip, C. Guy, **176**
Czech Americans: churches, 548; family portraits, 193; farming scenes, 548; in Oklahoma, 193, 307, 548, 606; schools, 548; weddings, 548
Czechoslovakia, 723

Dach-O-Me-Yo, 3
Dacoma, Okla.: businesses, 87; schools, 87
Daguerreotypes, 257
Dalby, P. H., **177**
Dale, Edward Everett, **178,** 179, 235, 741, 754

Dale, Rosalie Gilkey, **179**
Dale Hall, University of Oklahoma, 746, 751
Dalquest, (Mrs.) B. L., **180**
Dalton, William M., 10
Dalton brothers, 633, 787
Damon, Okla., 505
Dams and lakes (Okla.), 826
Danner, Clyde, **181**
Danner Brothers Hardware Store (Anadarko, Okla.), 181
Darlington, Okla., 455, 559
Darlington Indian Agency (Okla. Terr.), 662
Darnell, E. E., **182**
Darvell, Jane, 226
Daugherty, Frank, 370
Davenport, Indian Terr.: businesses, 403; parades, 403; petroleum industry scenes, 403
Davenport, Okla., 559; businesses, 403; parades, 403; petroleum industry scenes, 403; street scenes, 679
Davidson, Okla., 505
Davis, Alice Brown, 650
Davis, Gertrude, **183**
Davis, Joan, 226
Davis, Okla., 202, 559; railroad depot, 803
Dawes Commission, agents of, 115
Dawson, J. Silas, **184**
Dawson, Raymond, 184
Dawson Creek, British Columbia, 4
Dayton School (Grant County, Okla. Terr.), 315
Deal Studio Collection, **185**
Dean, Lloyd E., **186**
Dean, Samuel C., **187**
Deason, (Mrs.) S. J., **188**
Deatheridge, Cleta, 748
DeBarr, Edwin C., **189**, 265, 741
DeBarr Hall, University of Oklahoma, 746
Debo, Angie Elbertha, 235, 755
DeBord, Leland A., **190**
DeCamp Consolidated Glass Casket Company, **191**; stockholders meeting, 191
Decker, Charles Elijah, **192**
Deeds, Helen, **193**
Del Rio, Dolores, 226

Delaware Indians, 152, 178, 235, 592, 616; baskets, 452; delegation to Washington, D.C. in 1866, 817
Deloria, Philip, 634
Delta Chi, 752
Delta Delta Delta, 752
Delta Gamma, 746, 752
Delta Kappa Epsilon, 752
Delta Kappa Sigma, 752
Delta Tau Delta, 752
Delta Upsilon, 752
DeMarta, Favio, 740
Democratic National Party, 1938 convention, 593
Dempsey, Jack, 226
Denman, Heber, 497
Denmark, 723
Dennis, Frank Landt, Sr., **194**
Denoya, Okla.: churches, 416; parades, 416
Dentist offices, 553; interiors, 553
Denton family, 339
Denver, James William, **195**
Depenbrink, Ada, **196**
Depenbrink family, 196
Depew, Okla., 436
Dermatitis, 85
Dermatology, 85
Des Champs, John Lefeber, **197**
Detrick, C. H., **198**
Deupree, William, **199**
DeVenney, Sam, **200**
Devil's Den (Okla.), 215
Devil's Lake (N.Dak.), 38
Devine, Andy, 226
Devol, Okla., 551
Dewey, Indian Terr., 8, 777; schoolchildren, 111; street scenes, 111
Dewey, Okla., 551, 559, 617; oil well drilling near, 111; schoolchildren, 111; schools, 499; street scenes, 111
Dewey, Wesley E., 122
Dewey Airplane Company (Dewey, Okla.), 111
Dewey County Public Library Collection, **201**
Deyo Mission (Lawton, Okla.), 203, 790
Dicaperl Minerals Corporation (Noble, Okla.), 402
Dickens, Mary, 201

Dickens, Otto, 201
Dickerson, H. T., 265
Dillard, Okla., businesses, 379
Dillon, Vince, 83, 226; photographs by, 172
Dilworth, Okla., 535; petroleum industry scenes, 123, 535
Dinosaur fossils, 192, 695
Diseases, 85
Division of Manuscripts Collection, **202**
Division of Manuscripts-Southwest Oklahoma Collection, **203**
Dixon, Leoa, 581
Dobie, J. Frank, 105
Dobson, Gladys, **204**
Doby Springs, Okla.: businesses, 87; schools, 87
Dodge City, Kans., 105
Doherty, Henry L., 123
Domino, Fats, 226
Donnelley, Herndon Ford, **205**; family of, 205
Doolin, Bill, 711
Dorrance, Lemuel, **206**, 649
Dougherty, Okla., railroad depot, 803
Douglas, Okla., railroad depot, 803
Dow, Indian Terr., coal miners, 630
Dow, Okla., coal mining near, 218, 643
Downing, Lewis, 265
Downing, T. B., 294
Doxey, Okla. Terr., businesses, 51
Drake, Deonne, 740
Drake, Noah Fields, **207**
Drugstores, 109, 222, 225, 306, 760
Drumright, Everett F., **208**
Drumright, Florence Teets, 208
Drumright, Okla., 544, 551, 559; oil field near, 538, 696
Dryden, Okla.: businesses, 339; parades, 339; postal services, 339; schools, 339
Dubois, Wyo., 105
Duck hunting, 798
Duck Pond, University of Oklahoma, 746
Duff, H. R., **209**
Duke, Doris, **210**
Dull Knife, 105, 678
Dulles, John, 208
Duluth, Minn., 59

Fiddleback Kid, 71
Fields, H. W., **236**
Fine Arts Center, University of
 Oklahoma, 746
Fink, John Berlin, **237**
Fink, John Berlin, Postcard Collection, **238**
Finley, (Mrs.) C. D., **239**
Finney, Frank F., 123, **240**
Finney, Thomas M., **240**
Firefighters, 141, 255, 380, 492, 505, 519,
 686; fire departments, 343
Fires and fire damage, 255, 348, 462,
 483, 534, 535, 629, 696
Fireshaker, 605
Fisher, Ada Lois Sipuel, **241**, 749
Fisher, Clyde, **242**
Fisher, Daniel G., **243**
Fisher, Te Ata, 242, **244**
Fishing scenes, 473, 517
Fitch Collection, **245**
Fite, F. B., **246**
Fite, Gilbert C., **247**
Flathead Indians, 178; clothing and
 dress, 105
Fletcher, Dan, **248**
Fletcher, Deafy, 3
Flippin, Mabelle, **249**
Flood scenes, 61, 158, 168, 185, 382;
 New Mexico, 313; South Canadian
 River in 1904, 416
Flora, Snowden Dwight, **250**
Floral, Okla., railroad construction, 735
Florida, 723; petroleum industry, 123;
 postcards, 424
Floyd, Audry May, 274
Folsom, Israel, 599
Folsom, Joseph P., 599
Folsom, Marilda, 471
Folsom Training School (Smithville,
 Indian Terr.), **251**
Football games, 505; University of
 Oklahoma, 54, 130, 209, 743, 745,
 746, 748
Football teams: Apache, Okla.,
 426; Kansas State Agricultural
 College, 508; Ramona, Okla., 614;
 Southwestern Normal School (Okla.),
 377; University of Oklahoma, 130,
 131, 147, 162, 442, 458, 612, 642, 666,

685, 745, 746, 748, 753
Forbes, Andrew Alexander, **252**
Ford, Henry, 140, 226
Ford, Wallace, 226
Foreign Service, 208
Forster Brothers Livery Stable, 775
Fort Apache, Ariz., 169, 359
Fort Clark, Tex., 149
Fort Cobb, Okla.: Baptist church, 203,
 790; Chickasha Milling Company
 Offices, 120; Methodist church, 660
Fort Davis, Tex., 202
Fort Defiance, Ariz., 634
Fort Elliot, Tex., 724
Fort Gibson, Indian Terr., 32, 232
Fort Gibson, Okla., 202, 299, 559
Fort Nelson, British Columbia, 4
Fort Niobrara, Nebr., 703
Fort Reno, Okla., 639, 664
Fort Reno, Okla. Terr., 433, 662;
 architectural drawings of, 325
Fort Riley, Kans., 299; U.S. Army scenes,
 390
Fort Robinson, Nebr., 703
Fort Sill, Okla., 28, 105, 127, 202,
 279, 299, 395, 494, 559, 711;
 archaeological work sites near, 452;
 artillery school at, 127; assistance in
 miners' strike, 221; Indian school,
 27, 104, 198, 203, 278; Post Oak
 Cemetery, 48
Fort Smith, Ark., 664
Fort Smith and Western Railroad:
 locomotives, 606, 812; rolling stock, 812
Fort St. John, British Columbia, 4
Fort Supply, Okla., 559
Fort Thompson, S.Dak., 634
Fort Towson, Okla., 551
Fort Union, N.Mex., 639
Fort Washita, Indian Terr., 566; ferry
 near, 504
Fort Yellowstone, Wyo., 473
Forts, 105, 127, 149, 169, 183, 202, 216,
 238, 278, 279, 325, 390, 433, 473, 494,
 566, 662, 664, 711
45th Infantry Division Collection, **253**
Foss, Okla., businesses, 575
Fossils, 192, 695
Foster, Henry Vernon, **254**

Given family, **278**
Glasby, Stephen Kirk, **279**
Glasby family, 279
Glass factories, 799
Glass plate negatives, 173, 174, 228, 252, 266, 351, 578, 592, 642, 662, 698, 717
GM Test Car, at University of Oklahoma, 746
Goddard Health Center, University of Oklahoma, 746
Goes to War, 703
Goessel, Kans., 156
Goff, Bruce, house designed by, 322
Goins, Charles R., **280**
Gold mining, hydraulic (Calif.), 230
Goldsby, William, 235, 349, 711
Goldwater, Barry, 226
Golf tournament, 1979, 482
Goltry, Okla., Czech Americans in, 548
Good, Nancye, **281**
Good Eagle, 166
Good Shepherd Mission (Fort Defiance, Ariz.), 634
Gooding, Henry, 265
Goodland Indian School (Hugo, Okla.), **282**, 309; campus of, 282; faculty, 282; students, 282
Goodwill Industries of Southwest Oklahoma and North Texas, Inc., 395
Goose, Josephine, 717
Gore, Thomas P., 265, **283**, 324
Gotebo, 592, 616
Gotebo, Okla.: businesses, 492, 575; cotton markets, 492; firefighters, 492; medical offices, 492; street scenes, 492
Gotebo, Okla. Terr.: businesses, 492; Chickasha Milling Company offices, 120; firefighters, 492; medical offices, 492; street scenes, 492
Gould, Charles Newton, **284**, 321, 741
Gould, (Mrs.) M. J., **285**
Gould family, 284
Government Department Collection, **286**
Governor's mansion, Chickasaw Nation, 57
Governors of Oklahoma, 16, 68, 178, 264, 281, 314, 482, 522, 523, 524, 525, 558, 593, 770

Governors of Oklahoma Territory, 404
Gracemont, Okla.: Chickasha Milling Company offices, 120; Methodist church, 660
Graf Spee (battleship), 441
Graham, Okla., petroleum industry, 422
Grain storage facilities, 139, 407, 507
Grammer, Henry, 226
Grand, Okla. Terr., 537
Grand Canyon, 569
Grand Central Station (N.Y.), 764
Grand Forks, N. Dak., 38
Grand Lake (Okla.), 762
Grand River Dam (Okla.), 826
Grande Prairie, Alberta, Canada, 4
Grant, Ulysses S., 226, 240, 689
Grass, Frank, **287**
Grass, John, 105, 592
Grass, Patty, **287**
Grass, Silas, 143, 173
Gray, Carl, 789
Gray, H. O., **288**
Gray, Melvin, **289**
Gray, Okla., 628
Gray Horse, Okla., 240; Osage camp near, 83
Grayson, Anna, 265
Grayson, Katherine, 226
Grayson, Walter C., 265
Grayson, Washington, 265
Greasewood Indian Day School (Ariz.), **290**
Great Falls, Mont., 638
Greece, tourist scenes of, 58
Green, Elizabeth, 79
Green, Paul, 79
Greene, William Nelson, 265
Greenhouses, interior of, 162
Greenshields, Altha, **291**
Greenshields, Tea, **291**
Greenshields Typewriter Co. (Norman, Okla.), 291
Greer County, Okla. Terr., ranching scenes, 76
Gregory, Helen, 747
Griffis, Molly Levite, **292**
Griffitts, (Mrs.) James Addison, **293**
Griffitts family, 293
Grisso, Walter D., **294**

Havasupai Indians, 178; baskets, 452
Haverstock Collection, **316**
Haverstock family, 316
Hawaii, 208, 723
Hawarden, Iowa, 299
Hawkins, Brad, **317**
Haworth, Okla., businesses, 470
Hayden, Iola, 562
Hayes, Gabby, 226
Haynes, Thomas M., 164
Hazel, Okla.: businesses, 656; schools, 656
Headrick, Okla., 551
Healdton, Okla., schools, 776
Health resorts, 513, 555
Health Sciences Center, University of
 Oklahoma, 746, 750
Healy, Frank Dale, Jr., **318**
Healy Brothers ranch, 318
Heap of Birds, 105
Heck, Jesse W., **319**; family of, 319
Hedges, Homer, **320**
Heffner, Roy E., **321**
Helena, Okla., 205
Helena, Okla. Terr., livery stable, 775
Helmerich, Peggy V., Garden, University
 of Oklahoma, 746
Hemingway, Ernest, 17
Henderson, Arn, **322**
Henderson, Hurley L., **323**
Hennessey, Okla., 547, 559
Hennessey, Okla. Terr., 547
Hennigh, Earl L., **324**
Henning, William, 626
Henry, O., 243
Henryetta, Okla., 202, 308, 376, 559, 592
Hensley, Claude, **325**
Herbert, Harold Harvey, **326**
Herbert, Hugh, 226
Hereford cattle, 734, 774
Herring, Alvin J., **327**
Hervey, John, 274
Hester Hall, University of Oklahoma, 746
Heydrick, L. C., **328**
Hiaphong Harbor, North Vietnam, 441
Hiawatha, Kans., postcard, 42
Hibbing, Minn., postcard, 42
Hickok, James Butler (Wild Bill), 592, 633
Hicks, Leon M., **329**
Hicks, Tim, **330**

Hidatsa Indians, 616
High Chief, 3
Higham, Annie Stewart, **331**
Highways, construction scenes (Okla.), 524
Hignite, Bob, 740
Hill, (Mrs.) Evans Montgomery, **332**
Hill, (Mrs.) Wayne, **333**
Hillside Mission, Indian Terr., Society of
 Friends school at, 293
Hine, L. T., **334**
Hine, (Mrs.) L. T., 334
Hingham, Mass., postcard, 42
Hinton, Okla., 559
Hinton Theater (Muskogee, Okla.), 719
Hiroshima, Japan, 677
Hobart, Okla., 36, 559, 718; Baptist
 church, 203, 790
Hobart, Okla. Terr., 407
Hobson, Mabel Thacker, **335**
Hodiak, John, 226
Hofsommer, Don L., **336**
Hogans, 290
Hogg, Don E., Greenhouse, University
 of Oklahoma, 750
Hogg, J. S., 733
Hogue, J. R., 265
Hokeah, Jack, 366
Holden, LaSalle, **337**
Holdenville, Indian Terr.: businesses,
 594; dentist office, 553
Holdenville, Okla., 161, 202, 559
Holland, postcards, 424
Hollem, Anna Iverson, **338**
Hollis, Okla., 95, 202, 559; businesses,
 285, 339, 340; camp meetings, 340;
 celebrations, 340; cotton gins, 340;
 home of J. E. Jones, 117; parades, 339;
 postal services, 171, 339; schools,
 339; street scenes, 285, 340
Hollis, Okla. Terr., 329; businesses, 340;
 camp meetings, 340; celebrations,
 340; cotton gins, 340; cotton
 marketing at, 171; street scenes, 340
Hollis, William, **340**; family of, 340
Hollis family, 339
Hollis Public Library Collection, **339**
Holloman, Herbert W., 741
Hollow Horn Bear, 533, 799
Holloway, William Judson, 178

post office, 127; Presbyterian church, 362; railroad depot, 127; schools, 127; Simpson cotton gin, 668; Simpson store, 668

Lawton, Okla. Terr., 97, 465, 707; businesses, 88, 279, 418, 720; dentist office, 553; police, 720; Red Store, 417; settlement scenes, 88, 707; street scenes, 720

Lawton Chamber of Commerce Collection, **418**

LDSH Collection, **419**

Leadville, Colo., mining scenes, 148; railroads, 436

League of Women Voters, 515

Lebanon, Ohio, 639

Lee, Josh, 202, 265

Lee, (Mrs.) Ottie, **420**

Lee, R. Crockett, 420

Lee, Sul H., 68, 748

Leedey, Okla., 567

Lefler Studio Collection, **421**

LeFlore, M. H., 309

Left Hand, 3

Left Hand, Grant, 3

Left Hand, Minnie, 3

Left Hand Bear, 592

Leggett, Bishop G. C., **422**

Legionnaires. *See* American Legion

LeGrand, Buck, 226, 227

Lehigh, Indian Terr., 202

Lenders, Emil W., 265, **531**

Lenny and Sawyers Collection, **423**

Lenski, Lois, Postcard Collection, **424**

Lentz, Daniel Morgan, **425**

Levite, George Washington, **426**

Levite family, 292

Levy, David W., 748

Lewis, Kate, **427**

Lexington, Okla., 592; businesses, 134; churches, 134; schools, 134; street scenes, 134; temperance society meeting, 610

Lexington, Okla. Terr., 202

Liard River (Canada), 4

Libraries, 183, 559; interiors of, 478, 744

Lighthorse Mounted Police, 63

Lightning, 250

Ligon, Mary Louise, **428**

Liljedahl, R., **429**

Lillie, Foress B., **430**; family of, 430

Lillie, Gordon William (Pawnee Bill), 83, 202, 228, 240, **431**; family of, 431; friends of, 431; traveling with Indians to inauguration of Herbert Hoover, 431

Lillie, May, 228, 431

Lillooet Indians, baskets, 452

Lime kilns, 799

Lincoln, Myrtle (Howling Buffalo), **432**

Lincoln, Neb., 59

Lincolnville, Okla., 152; schools, 457

Lindbergh, Charles A., 352,

Lindsay, Agnes, 134

Lininger, Herbert K., **433**

Lions clubs (Okla.), 762

Lithographs, 533

Little, David, 746

Little Bear, 3, 678

Little Big Horn battlefield (Mont.), 105, 633

Little Big Mouth, 678

Little Bird, 518

Little Chief, 3

Little Jim, 228

Little Owl, 662

Little Raven, 678; son of, 678

Little Richard, 226

Little Soldier, 616

Littlefield, James M., 440

Littleman, Alice, **434**

Litton, Gaston, **435**

Livery stables, 775

Lockart, Bill, **436**

Locke-Jones War, participants in, 63

Locomotives, 30, 37, 122, 230, 237, 263, 336, 606, 688, 812, 814

Logan, Mary, 437

Logan, Oscar, **437**

Logging scenes (McCurtain County, Okla.), 470

London, England, U.K., 398

Lone Bear, 3, 431, 678, 787

Lone Wolf, 203, 267, 678

Lone Wolf, Delos, 407, 592

Lone Wolf, Okla., 407; baseball team, 819

Lone Wolf, Okla. Terr., 407

Lonewolf, D. K., 361

Long, George, **439**

Maryland, housing, 735; postcards of, 372, 424
Marysville, Ohio, flood scene, 735
Mashburn, J. H., 265
Mason, Ida, **456**
Mason, Viola, **457**
Masonic temples (McAlester, Okla.), 145
Massachusetts, cities and towns, 398, 424, 430, 764; petroleum industry, 123; postcards, 424
Massad, Ernest L., **458**
Massey, Fred, **459**
Massey Store (Chelsea, Indian Terr.), 459
Masterson, William Barclay, 202
Mathews, Maggie, 143
Matthews, Sam P., **460**
Mature, Victor, 226
Matzene, Richard Gordon, 226
Maud, Indian Terr., 650
Maud, Okla., 650
Maupin, Mary B., **461**
Mayes, Joel B., 265, 787
Mayes, Patsy, 32
Mayes, Samuel Houston, 265, 349, 592
Mayes, William, 294
Mays, Clarence, 759
Mays, Nita (Juanita) Carson, 759
Maysville, Okla., 202; railroad depot, 803
McAfee, Elmo, 186
McAfee, Mary Elizabeth, 186
McAlester, Indian Terr., 63, 463, 471; Elkhouse Hotel, 632; fire, aftermath of, 462; Osage Mining Corporation officers, 132
McAlester, J. J., 37
McAlester, Okla., 37, 231, 352, 463, 546, 559, 584, 592, 809; bands, 577; burial of coal mining disaster victims, 792; businesses, 761, 807; coal mines and miners near, 145; coal mining scenes near, 791; Masonic Temple on Mt. Moriah, 145; physicians, 116; railroad depot damaged by 1908 explosion, 577; streetcars, 476; theaters, 577
McAlester Chamber of Commerce, **462**
McAlester Public Library Collection, **463**
McAllister, J. D., **464**
McAnally, Arthur, 741
McCabe, Edward P., 164

McCall, Bob, **465**
McCarter Hall, University of Oklahoma, 746
McClain, R. S., **467**
McClain County Historical Society, **466**
McClerg, Victory, **468**
McCloud, Okla., 376; businesses, 761
McComb, Okla., 64
McCoy, Isaac, 675
McCoy, James Stacy, **469**
McCoy, Tim, 226
McCurtain, Cora, 471
McCurtain, David Cornelius, 471
McCurtain, Green, 63, 309, **471**, 592
McCurtain, Scott, 471
McCurtain County Historical Society Collection, **470**
McCurtain family, 471
McDaniel, Edna, 754
McDaniel, George, 294
McElhany, S. H., **472**
McElhany family, 472
McFarlin Memorial Auditorium (Tex.), 560
McGee, Dean, 401
McGinnity, Joe, funeral, 145
McGrath, James A., 634
McHugh, Maura, 746
McHugh, Owen, 239
McIntire, John S., **473**
McIntosh, John, 471
McIntosh, Roley, 265
McIntosh County, Okla., 231
McKenzie, (Mr. and Mrs.) W. H., **474**
McKinley, William, 371
McKinney, Robert Moody, **475**
McLaughlin, Victor, 226
McLaurin, George W., 241
McMurdo, George, **476**
McMurray, Daniel, **477**
McPherson, Aimee Semple, 265
Medford, Okla., 559; public library, 478
Medford Progress Club Collection, **478**
Medical associations, 7, 19
Medical equipment, 36, 414, 541
Medical offices, 35, 36, 86, 116, 413, 414, 492, 673. See also Hospitals
Medical procedures, surgery, 546
Medical schools, 107, 413, 746, 750
Medicine Lodge, Kans., bank robbers captured at, 31

Pawnee Indians, 3, 105, 169, 172, 173, 174, 228, 238, 424, 431, 531, 551, 559, 592, 616, 633, 662, 675, 787, 789; clothing and dress, 105; performers in wild west shows, 531; traveling with Pawnee Bill to Herbert Hoover's inauguration, 431
Pawneenopahshe, Joseph, 265
Paxton, Joseph Francis, **582**
Payne, David L., 66, 202, 592
Payne, W. L., **583**
Payson, Okla. Terr., railroad depot, 336
Pea Ridge Battlefield (Ark.), 763
Peace River, Canada, 4
Peach, Guine, **584**
Pearson, Leb E., **585**
Pearson, Lola Clark, **586**
Peck, Gregory, 727
Pecos, Tex., businesses, 287
Peek, Okla., 505
Penitentiaries (Okla.), medical procedures at, 546
Pennsylvania, 563, 723; cities and towns, 237, 238; postcards, 424
Peno, Okla., cotton gin, 440
Penobscot Indians, baskets, 452
Peoria, Okla., 600
Peoria Indians, 152, 616
Perez, Manuel, Jr., **587**
Perkins, Amy, **588**
Perkins, J. T., **588**
Perkins, Okla., 170
Perlite, 402
Perry, Okla., 170, 551, 559, 711, 787; railroad depot, 803
Perry, Okla. Terr., 138, 787; businesses, 88; Cherokee Strip celebration in 1903, 376; Hainer home, 298; settlement scenes, 88; street scenes, 679
Perryman, L. C., 265
Perryton, Tex., grain elevators, construction of, 607
Pershing, John J., 105, 226, 363
Peru, 723; president, 69
Peters, Kay, **589**
Peterson, Jessie Pearl, **590**
Peterson, Robert O. H., **591**
Petrified Forest National Park (Ariz.), 726
Petroleum industry, 170, 172, 185, 238,

505; Alabama, 123, 401; Alaska, 123, 401; Arizona, 401; Arkansas, 123; California, 123, 401, 422; Canada, 123; Cities Service Corporation employees and facilities, 123; Colombia, 123; Colorado, 123; Cushing oil field, 671; equipment, 696; field operations, 447, 523; Florida, 123, 401; Georgia, 123; Gulf of Mexico, 401; Healdton, Okla., 447; Idaho, 401; Illinois, 123; Indian Territory, 540; Iran, 401; Japan, 401; Kansas, 123; Louisiana, 123, 401; Massachusetts, 123; Mexico, 305; Mississippi, 123, 401; Missouri, 123, 401; Montana, 123; Nevada, 401; New Jersey, 123, 682; New Mexico, 401; New York, 123; North Carolina, 123; Ohio, 123; oil field camps (Okla.), 483; oil fields, 407, 555, 650; oil fields in Oklahoma, 254, 483, 538; oil fields in Oklahoma City, Okla., 671; oil fields in Tonkawa, Okla., 671; oil industry operations, 592; oil storage facilities in, 696, 799; oil storage facilities in Mexico, 305; oil storage facilities in Ramona, Okla., 699; oil storage facilities in Venezuela, 305; oil terminals in, Mexico, 305; oil terminals in Venezuela, 305; oil well drilling scenes, 813; oil well drilling scenes in Osage County, Okla. Terr., 617; oil well drilling scenes in Weber Pool (Okla.), 111; oil well fires, 483, 629; oil well fires, Stroud, Okla., 696; oil wells, 174, 178, 279, 401, 430, 483, 535, 540, 555, 559, 588, 596, 664, 799, 822; oil wells in Apache, Okla., 101; oil wells in Dilworth, Okla., 535; oil wells in Drumright field, 538, 696; oil wells near Garber, Okla. Terr., 589; oil wells in Mexico, 305; oil wells in Ramona, Okla., 118; oil wells in Venezuela, 305; Oklahoma, 72, 77, 101, 111, 118, 123, 254, 401, 403, 416, 422, 447, 482, 483, 535, 538, 540, 589, 603, 617, 651, 671, 696, 699; operations, 407, 686; pipe lines in,

bridges near, 615; churches, 416; parades, 416; petroleum industry scenes, 123; Pioneer Woman Monument, 58, 639, 693; railroad depot, 803
Ponca City Dodgers, 229
Ponca City Round Up, 227
Ponca Indians, 135, 172, 174, 228, 331, 532, 551, 559, 592, 605, 616, 619, 633, 787; performers in wild west shows, 531
Pond Creek, Okla., 36
Ponziglione, Rev. Paul Mary, 489
Poor Buffalo, 678
Poplar Bluff, Mo., postcard, 42
Porter, Frank M., 123
Porter, Okla., 1919 tornado damage, 601
Porter, Phyllis, 488
Porter, Pleasant, 265
Porter (Okla.) First National Bank Collection, 601
Portland, Ore., 232, 384
Portugal, 723
Porum, Indian Terr., businesses, 268
Porum, Okla., businesses, 268
Posey, Alexander, 592; family of, 495
Post, Wiley, 366, 388
Post Oak Cemetery (Fort Sill, Okla.), 48, 97, 169
Post Oak Mission (Indiahoma, Okla.), 203, 790
Post offices, 122, 127, 137, 165, 171, 238, 366, 395, 527, 815
Postal employees, 190; in Oklahoma, 122, 165
Postal services, 122, 330, 339; early airmail service to Oklahoma City, Okla., 455
Postcard Collection, 602
Postcards, 42, 59, 122, 135, 137, 226, 238, 372, 384, 424, 466, 479, 559, 567, 602, 688, 719, 737, 759; Kansas town scenes, 59; Oklahoma schools and colleges, 372; Oklahoma town scenes, 59
Potawatomi Indians, 152, 532, 616, 675, 787; clothing and dress, 105; performers in wild west shows, 531
Poteau, Okla., 559

Pottawatomie County Historical Society office, interior of, 213
Power, Tyrone, 226
Powers, J. A., family of, 304
Powwows. See Indians of North America
Prado, Manuel, 69
Prague, Okla.: businesses, 606; Czech Americans from, 548; Sokol Society members, 606
Prague, Okla. Terr., 606
Prairie Center School (Garfield County, Okla. Terr.), 315
Prairie Flower, 592
Prairie Oil and Gas Company, 603
Presbyterian Church, missions to Cherokee Indians, 232
Presidio of San Francisco (Calif.), 704
Preston, Robert, 226
Prettyman, William, 228
Price, Ray, 226
Price Falls, Okla., 479
Prickett, Theodocia Cralle, 604
Primeaux, Floyd, 605
Princess Wenona, 701
Princeton, N.J., 105
Prisons (Okla.), 551
Pritchett, Roger, 606
Pruitt, Gregg, 748
Pryor, Okla., 186, 559
Psoriasis, 85
Puckett, E. N., 607
Pueblo, Colo., mining scenes, 148
Pueblo Indians, 105, 135, 245, 299, 424, 452, 532, 533, 592, 602, 616, 633, 634; baskets, 452; clothing and dress, 105, 242; dances, 242; food preparation, 242
Puerto Rico, 723
Purcell, Okla., 394, 466, 559, 592, 773; businesses, 466; churches, 416, 466; Main Street, panorama of, 220; parades, 416; railroad depot, 803; schools, 466
Purcell, Indian Terr., 202
Push Ma Ta Ha, lithograph of, 265
Pushmataha County, Okla., settlement, 269
Pushmataha County Historical Society Collection, 608

and dress, 105; farming scenes, 143; housing, 143; performers in wild west shows, 531

Sacred Heart Abbey (Okla.), 640

Sacred Heart College (Okla.), 640

Sacred Heart Mission: Indian Territory, 675; Oklahoma, 640, 822

Saddle Mountain Church (Okla.), 203, 790

Sailing, 798. *See also* Yachts

Saint Benedict's Mission (Okla.), 640

Saint Gregory's Abbey Collection, **640**

Saint Gregory's College (Okla.), 640

Saint Joseph's Catholic Church (Norman, Okla. Terr.), 731

Saint Mary's Catholic School (Quapaw, Okla.), 609

Saint Patrick's Mission (Okla.), 640

Salish Indians, 178, 228, 616

Sallisaw, Okla., 231, 559

Saloons, 235

Salt Lake City, Utah, 122, 512

Salt Lake City, Utah Terr., 230; Mormon Tabernacle, 230; Mormon Temple, 122, 512

Salter, Henry Hyde, **641**

Salter, Katherine, 386

Salter, Lewis Spencer, **642**

Salzburg, Austria, 398

Samoa, 243

San Antonio, Tex., 42, 59; archaeological work sites near, 452

San Carlos Agency, Ariz., 429

San Diego, Calif., 674

San Diego Mission (Calif.), 96

San Francisco, Calif., 674; earthquake of 1906 scenes, 93

San Francisco de Asis Mission (Calif.), 96

San Ildefonso, N.Mex., archaeological work sites near, 452

San Ildefonso Pueblo (N.Mex.), 242

San Jose, Calif., 71

San Juan Capistrano Mission (Calif.), 96

San Juan Pueblo (N.Mex.), 178

San Juan River, 569

Sanborn, Frank, 140

Sand Springs, Okla., 559

Sanders family, 6

Sanitariums, N.Mex., 79; Okla., 468, 545, 597

Santa Catalina Island, Calif., 59

Santa Clara Indians, 135

Santa Clara Pueblo (N.Mex.), 178, 634

Santa Fe, N.Mex., 59, 79, 105, 176, 178; archaeological work sites near, 452

Santa Fe New Mexican, The, editor, 475

Santo Domingo, Dominican Republic, scenes, 718

Santo Domingo Pueblo (N.Mex.), 178, 726

Sapulpa, Indian Terr., 319, 664; dentist office, 553; Euchee Mission, 664

Sapulpa, Okla., 551, 559, 664; railroad depot, 803

Sarkeys Energy Center, University of Oklahoma, 746

Satank, 105, 592, 678

Satanta, 592, 616, 678

Savonburg, Kans., 87

Sawmills, 656, 697, 799

Sayre, Okla., 51, 176, 377, 559, 656, 803, 804; businesses, 377, 656; cotton gins, 804; cotton markets, 804; railroad depot, 803; schools, 377, 656

Sayre, Okla. Terr.: businesses, 377; schools, 377

Scherman, (Mrs.) William, **643**

Schmitt, Iva, **644**

Schmitt, Karl, **644**

Schmuels, Virginia, 274

Schonwald, Fred P., 392

Schools, 178, 237, 238, 299, 395, 592, 702; African American, 525, 736; Catholic, 445, 609, 640, 676; children at, 87, 111, 268, 292, 330, 339, 365, 411, 456, 480, 571, 578, 786; Custer County, Okla., 190; Dewey County, Okla., 411; girls, 333, 349, 700, 786; Indian, 32, 33, 104, 152, 251, 282, 290, 309, 333, 349, 358, 378, 382, 435, 439, 480, 495, 555, 594, 595, 640, 647, 650, 662, 665, 675, 700, 709, 713, 758, 761, 786, 820; Indian Territory, 32, 33, 104, 293, 333, 337, 349, 480, 487, 498, 594, 713, 736, 820; Oklahoma, 1, 13, 87, 127, 134, 170, 185, 202, 212, 235, 251, 326, 338, 339, 345, 377, 380, 415, 457, 466, 471, 487, 499, 502, 506, 519, 545, 548, 551, 557, 575, 581, 588, 608, 617, 650, 656, 661, 664, 686, 716,

Vermont, 764; postcards, 424
Veterans Administration Hospital
(Muskogee, Okla.) managers of, 491
Vici, Okla. Terr., banks, 811
Vicksburg, Miss., postcard, 42
Victor, Colo., mining scenes, 148
Victoria, British Columbia, 764
Vietnam War, minesweeping
operations, 441; offshore operations,
441, 482
Villa, Pancho, 226, 227
Villagra Book Shop (N.Mex.), 79
Vineyards (Okla.), 428
Vinita, Indian Terr., Worcester
Academy, 820
Vinita, Okla., 20, 505, 559; railroad
depot, 803
Vinita Lions Club, **762**
Virden, John M., **763**
Virginia, 723; postcards, 424
Voignier-Marshall, Jacqueline, **764**
Voss, John H., **765**
Voting, 170

Wadley, (Mrs.) James L., **766**
Wadsack, George, 756
Wagon trains, 88
Wagon yard, 499
Wagoner, bridges near, 615
Wagoner, Indian Terr., dentist office, 553
Wagoner, Okla., 559; railroad depot, 803
Wagons, 15, 35; freight, 347
Wahlen, Friedrich Traugott, 475
Wailaki Indians, baskets, 452
Wainwright, Jonathan, 352
Wakita, Okla.: businesses, 87; schools, 87
Walcott family, 780
Walden Pond (Mass.), 140
Wales, 723
Walker, Andrew Beattie, **767**
Walker, Robert Sparks, 595
Walker Tower, University of Oklahoma,
746
Walker-Patison Collection, **768**
Walking Woman, 3
Walla Walla Indians, 616
Walraven, (Mrs.) O. D., **769**
Walters, Okla., 77, 202, 559; banquet for
World War I volunteer soldiers, 708;

cotton gin, 708; cotton market, 708;
railroad depot, 803
Walters, Okla. Terr., 222
Walton, John C. (Jack), 281, **770**
Wanette, Okla., post office, 527
Wanette, Okla. Terr., railroad depot, 336
Ward, Ambrose, School (Wilson, Okla.),
677
Ward, Clyde, **771**
Ward, D. C., **772**
Ward, Pearl, **773**
Wardell, Morris L., 741, **774**
Ware, Lewis, 267
Warne, Rhoda Foster, **775**
Warner, Carolyn Rexroat, **776**
Warren, Abel, 265
Warren, David, 634
Warren, Mary A., 265
Warren, Myrtle, **777**
Wasco Indians, 178, 592; baskets, 452
Washington, 384, 764; petroleum
industry, 123; postcards, 424
Washington, Booker T., 164
Washington, D.C., 122, 237, 371, 398,
685, 723; American Indians in, 718;
Delaware-Cherokee delegation of
1866, 817; Howard University, 42;
mural by Woody Crumbo in, 366;
press conferences, 727
Washington, George, 689
Washita River (Indian Terr.), 504
Washita River (Okla.), 515
Washo Indians, 360; baskets, 452
Water resources management, in
Oklahoma, 399
Waters family, 771
Waterspouts, 250
Watertown, S.Dak., postcard, 42
Watie, Buck, 32
Watie, Saladin, 435
Watie, Sarah C., 592
Watie, Stand, 294, 551, 592
Watonga, Okla., 202, 518, 551, 559, 718;
Baptist church, 203; courtrooms, 781;
Indian fair at, 639; law offices, 781
Watson, Burl, 123
Watson, Grace M., **779**
Watson, (Mrs.) George, **778**
Watson, Ruth Walcott, **780**

CPSIA information can be obtained at www.ICGtesting.com
Printed in the USA
LVOW06s0924291213

367291LV00001B/1/P